Frate Francesco. Friar Francis

Frate Francesco. Friar Francis

Traces, Words, Images

SKIRA

Cover
Laudes creaturarum (or *Cantico di frate sole*
or *Cantico delle creature*)
Assisi, Fondo Antico Comunale, Biblioteca
del Sacro Convento, MS. 338, f. 33r

Back Cover
The habit of Saint Francis
Assisi, Basilica di San Francesco,
Cappella delle Reliquie
(Photo by Michelangelo Spadoni)

Art Director
Marcello Francone

Design
Luigi Fiore

Editorial Coordination
Emma Cavazzini

Editing
Maria Conconi

Layout
Marina Boer

Translations
Huw Evans, Robert Burns, Jeffrey Jennings,
Lorenzo Sanguedolce on behalf
of Language Consulting Congressi, Milan
Lindsay Eufusia

First published in Italy in 2014 by
Skira Editore S.p.A.
Palazzo Casati Stampa
via Torino 61
20123 Milano
Italy
www.skira.net

© 2014 Associazione Culturale Antiqua
© 2014 Photographic Archive of the Sacro
Convento di San Francesco, Assisi
© 2014 Skira editore

Printed and bound in Italy. First edition

ISBN: 978-88-572-2666-8

Distributed in USA, Canada, Central & South
America by Rizzoli International Publications,
Inc., 300 Park Avenue South, New York, NY
10010, USA.
Distributed elsewhere in the world by Thames
and Hudson Ltd., 181A High Holborn,
London WC1V 7QX, United Kingdom.

Frate Francesco. Friar Francis
Traces, Words, Images

United Nations Headquarters
1st Ave and 42nd Street – New York
17 – 28 November 2014

Brooklyn Borough Hall
209 Joralemon Street – Brooklyn, NY
2 December 2014 – 14 January 2015

Sacro Convento di San Francesco in Assisi
28 March – 31 May 2015

Partners

FONDAZIONE TELECOM ITALIA

GIORGIO ARMANI

With the Financial Support of

DELVERDE

 Valagro

 REGGIANI
WE SPEAK LIGHT

Restoration Works

ESSELUNGA

 Banca Popolare di Spoleto

In Collaboration with

Alitalia

HILTON WORLDWIDE

Willis

Sponsors
Office of the President of the Council
of Ministers
Italian Embassy in the United States
Consulate General of Italy in New York
Pontifical Council for Culture
Region of Umbria
Region of Abruzzo
Perugia Chamber of Commerce

Organizers

Comune di Assisi

**Sacro Convento di
San Francesco in Assisi**

Antiqua Associazione Culturale

ITALIAN ACADEMY FOUNDATION, INC.

with contributions from

**Società Internazionale di
Studi Francescani, Assisi**

Lenders of Works
City of Assisi
Sacro Convento di San Francesco in Assisi

Honour Committee
His Em. Cardinal Pietro Parolin, Secretary
of State of His Holiness the Pope
His Em. Cardinal Timothy Dolan, Archibishop
of New York
His Em. Cardinal Attilio Nicora, Papal Legate
for the Basiliche di San Francesco
and Santa Maria degli Angeli in Assisi
The Hon. Dario Franceschini, Minister
of Cultural Heritage and Activities and
Tourism
His Exc. Sebastiano Cardi, Permanent
Representative of Italy to the United Nations,
New York
His Exc. Mons. Bernardito C. Auza,
Permanent Observer of the Holy See
to the United Nations
His Exc. Mons. Domenico Sorrentino, Bishop
of Assisi – Nocera Umbra – Gualdo Tadino
His Exc. Francis Assisi Chullikatt,
Apostolic Nuncio to Iraq and Jordan, former
Permanent Observer of the Holy See
to the United Nations
The Hon. Catiuscia Marini, President
of the Region of Umbria
The Hon. Natalia Quintavalle, Consul general
of Italy in New York
Prof. Vincenzo Scotti, President
of the Link Campus University
Gianni Letta, former Undersecretary of State,
Office of the President of the Council
of Ministers
Most Revd. Father Michael Anthony Perry,
Minister General O.F.M.
Most Revd. Father Marco Tasca, Minister
General O.F.M. Conv.
Most Revd. Father Mauro Jöhri, Minister
General O.F.M. Cap.
Most Revd. Father Nicholas E. Polichnowski,
Minister General T.O.R.

Acknowledgements
*Thank you to all those who have contributed
to the various aspects of the preparation of the
exhibition and the catalogue.*

*The restoration works have been made possible
with the contribution of Banca Popolare di
Spoleto – Gruppo Banco Desio and of Esselunga
Supermarkets Italiani S.p.A.*

It is with great pleasure that I join others in welcoming the Special Exhibition Frate Francesco. Friar Francis: Traces, Words, Images *at the United Nations in New York. The event does not only offer for our appreciation exceptional historical manuscripts, but above all it gives us an opportunity to dwell on the perennial message of peace that Saint Francis of Assisi proclaimed and lived.*

I extend my heartfelt congratulations and deep gratitude to the organizers of the Exhibition.

Archbishop Bernardito C. Auza
Apostolic Nuncio – Permanent Observer

For eight centuries the presence and the influence of Francis's life and deeds have made themselves felt in the history of Christianity and in that of the rest of humanity too.

It is not easy to summarize the significance and the complexity of such an impact.

It is not a question, in fact, just of the past of a religious order, but of a whole range of institutions, reforms and expressions of life and action constantly proliferating under the unceasing impetus of the spirit of the Poor Man of Assisi, which has always retained its relevance even in the changing conditions of history.

The exhibition Frate Francesco. Friar Francis: Traces, Words, Images *represents an admirable attempt to document the history of Francis of Assisi and the Order of Friars Minor: with all its vicissitudes and its ramifications and with the saint's inner life, his apostolic dynamism, his cultural influence and his spirituality. An effort to document the story of Francis, that did not come to an end with the discovery of his Christian identity, but became a seductive proposal that drew in other young people who chose to share his choice of lifestyle.*

In the study of the origins of Franciscanism, the difficulties do not stem from the lack of data, but from the abundance of it and, above all, from the choice of sources. The very figure of Francis and its significance to Christian renewal takes on a different meaning depending on whether one goes by the official interpretation of the "community" or the one presented by the "Spirituals." We owe to St. Bonaventure the first attempt to frame the mission of St. Francis and his order within the perspective of God's plan of salvation, through the eyes of the theologian of history.

The hope is that the exhibition may above all open a chink through which the visitor will be able to get a glimpse in its essentiality of the human and Christian experience of Francis, modeled on the Gospels, whose richness and beauty will always remain, however, a difficult legacy.

Claudio Ricci
Mayor of Assisi

On the evening of October 3, 1226, Francis of Assisi went to his death singing, we are told by his first biographer. He was laid naked on the bare earth, as he himself had desired. Thus his earthly existence came to an end, happy epilogue to a "gospel" carved with the stylus on living flesh. Two years after his death he was held up to the world of the time as an icon of humanity able to offer a clear glimpse of the bit of heaven embedded in the clay of every human being. Since then the road to his tomb has become one of the best known and busiest of the routes followed by men and women in search of God.

This gentle and defenseless man, the values he chose and practiced, his warm humanity and his exceptional capacity for dialogue are once again the subjects of this exhibition, which presents some of the most important documents for the possible reconstruction of the story of St. Francis and the movement of reform to which he gave rise "by divine disposition." The exhibition proposes a threefold itinerary, summed up as follows: traces, words and images.

The traces are the ones that can still be found in the archives, sometimes solemn and at others absolutely run-of-the-mill documents that bring the life of St. Francis back to the surface and outline the complex development of the Minorite ideal.

The words are the authentic ones of Francis simplex et idiota, as he liked to describe himself, together with those of his hagiographers who, drawing on an ample and varied corpus of memories and accounts, illuminate the propositum vitae and "hard determination" (Dante, Paradiso XI, 91) of St. Francis. Hagiographic words that also betray the tones of contention that of necessity accompanied the "growing pains" of an order that had expanded in breathtaking fashion and was moreover destined for a sort of evangelical and missionary itinerancy.

The images, making up a high and evocative anthology, are taken from some venerable manuscripts in the Assisi Library. Images that, for their marked incisiveness, almost constitute a "visible speech."

Thus the religious community of the Sacro Convento di San Francesco in Assisi would like to express its gratitude to all those who have made possible, in the prestigious setting of the United Nations Assembly, the display of this "treasure trove" of documents from the Fondo Antico of the Municipal Library of Assisi, kept in the historic Library of the Sacro Convento.

Our thanks go, first of all, to Mons. Francis Assisi Chullikatt, former Permanent Observer of the Holy See to the United Nations, who came up with the proposal for the exhibition, and his successor Mons. Bernardito Cleopas Auza, who has taken it up with pleasure and made it his own, as have the municipality of Assisi, the Antiqua Cultural Association of Avezzano

(L'Aquila), and the Italian Academy Foundation of New York, which have promoted and organized the event in various ways.

The presence of Saint Francis in one of the places that best expresses the meaning and the values of the human family, the one in which the delicate service on behalf of peace, goodwill and the harmonious development of nations while respecting their differences and the inviolable rights of every individual is conducted, is an event whose exceptionality has no need of comment.

So it is only natural here to refer to the Letter to the Rulers of the Peoples that the saint sent "to all mayors and consuls, magistrates and rulers throughout the world." Francis's message can be boiled down to the invitation "not to forget the Lord" and "turn away from His commandments," expressions that it seems possible to translate into an exhortation for them to channel their political and institutional efforts into the service of the common good, in a style of disinterestedness, humility and serene acceptance of the "other" in its legitimate reasons and in its very person, which has to precede and accompany the necessary debate in search of what is just and what is better.

Let us hope that the human and spiritual life of Saint Francis can serve as an encouragement and offer a term of comparison for the precious and demanding task to which your excellencies are called. The existential experience of the Poor Man of Assisi, rooted in evangelical "minority," draws its highest lesson from the Christus patiens daily and dramatically present in the ordinary unfolding of history, especially where the poor, the humiliated and the oppressed are driven systematically onto the margins of the prevailing "throwaway culture," repeatedly denounced by Pope Francis, the first pope who has chosen to assume this name.

From the Christus exemplar et magister present in the Word and in the Bread of the Eucharist, the Poor Man of Assisi derived the coordinates of a universal brotherhood that made him by antonomasia the "brother of all" and "conductor" of all the voices of creation.

May the traces left by Saint Francis; the words that sing again of his "admirable life" (Dante, Paradiso XI, 95); the eloquent images, that at least in part show us his face, be for each of us a source of courage and hope.

And in repeating the traditional Franciscan salute of Pax et Bonum, may I be permitted to recall that Peace is the seed and the fruit of Good accepted, made and to be made.

P. Mauro Gambetti
Custodian of the Sacro Convento di San Francesco in Assisi

"In the city of Assisi, which lies at the edge of the Spoleto valley, there was a man by the name of Francis, who from his earliest years was brought up by his parents proud of spirit, in accordance with the vanity of the world; and imitating their wretched life and habits for a long time, he became even more vain and proud."

This is how Thomas of Celano begins The Life of Blessed Francis, *which speaks to us of Francis as a "new man," a man who still fascinates us today with his life and his message.*

The exhibition Friar Francis: Traces, Words, Images *staged at the headquarters of the United Nations in New York, a place that hosts a variety of cultural and religious experiences every day and that is itself a symbol of peace, is a significant event, given the powerful appeal of Francis, extraordinary man and saint. Its purpose is to document the progress of research into Francis and the Franciscan sources that, even after 800 years and a vast number of studies, is still lively, fruitful and an unexhausted source of new information and profound emotions.*

The exhibition, a very rare occasion of great scientific and cultural value, allows the visitor to approach and get to know Francis through ancient and unique manuscripts. Through its exploration of the beauty of these manuscripts and the precious papal bulls, enriched by the splendor of many illuminations, the real simplicity of Francis is revealed in the interpretation of the learned men who speak of him and in the idea that has been handed down the centuries, preserving its original purity unchanged.

Organizing an exhibition on Francis at the UN has been an emotional experience as well as a challenge for the Antiqua Cultural Association. Focusing on these works at this moment in history when the statistics are revealing inequalities so great as to put human dignity at risk, and in which poverty, marginalization, suffering and abuse no longer shock anyone, it becomes apparent that the figure of Brother Francis is an exceptional presence that bears witness not only to the interreligious dialogue called for by Pope John Paul II at Assisi but to the hope that the peoples of the world will become, like him, bearers of a different culture of living, one of peace and not violence, of equality and growth.

Our world, torn by warring factions like that of Assisi 800 years ago, needs to look again at the need for love between peoples and human beings. Whence the reconsideration of Francis as a bringer of peace between nations and opponent of violence, Francis as a symbol of indifference to power and the "'historical Francis,' not only with regard to his interpretation of Christianity, but also for some traits of his concrete humanity, from his physical appearance to his personality, from his spiritual attitudes to his emotional ones" (R. Michetti, Francesco d'Assisi e il paradosso della Minoritas*).*

Eight centuries of reflection on the work of Francis have produced an infinite number of texts, but it has not been difficult, with the aid of the Franciscans whom we thank heartily, to obtain material for this exhibition, made possible by the work of many, from the staff of the Library and Archives of the Sacro Convento di San Francesco in Assisi to Mons. Chullikat and his successor Mons. Auza, the mayor of Assisi and Stefano Acunto of the Italian Academy Foundation, who have made such great efforts to realize the ambitious objective of communicating to everyone the immense achievement that the values of peace and love have been able to create.

Flavia de Sanctis
President Antiqua Cultural Association

When the Holy Father selected Francis for his Papal name, he presented to a world in conflict the image of one of history's great healers, one of the few figures who can easily be identified and characterized universally as a sainted apostle of peace, Saint Francis of Assisi. The saint journeyed East and West to bring his message of peace, love and respect for all God's creations.
Writing in London, 1885, Margaret Oliphant, in her popular biography of the saint, underlined again and again his bridge-like presence between East and West, notably in her chapter "The Expedition to Syria." Her words:

"[…] Francis set out on his long cherished mission […]. He went as he had planned to go among the Moors […] thus accomplishing a more effectual crusade than could be undertaken by the arms of the Western powers."

Today as rarely before, while bitter contention reigns far and wide among peoples of the Occident and Orient alike—spurred to a continuous gallop of anxious rhetoric by electronic news and communications—a shared visceral understanding of our common purpose as human beings and fellow travelers on this earth has never demanded such a strong emphasis. Through the guiding hands of Francis, may peace and humility knock at the door gently, as if to awaken us to the simple, ever-present possibility of a new world inspired by peace, under the supreme guidance of Divine Love.
No less a poet than Dante points to the example and the heavenly presence of St. Francis, in the 11th Canto of the Paradiso*:*

Però chi d'esso loco fa parole,
non dica Ascesi, ché direbbe corto,
ma Orïente, se proprio dir vuole.

Non era ancor molto lontan da l'orto,
ch'el cominciò a far sentir la terra
de la sua gran virtute alcun conforto;

ché per tal donna, giovinetto, in guerra
del padre corse, a cui, come a la morte,
la porta del piacer nessun diserra;

e dinanzi a la sua spirital corte
et coram patre le si fece unito;
di dì in dì l'amò più forte.

Questa, privata del primo marito,
millecent'anni e più dispetta e scura
fino a costui si stette sanza invito;

né valse udir che la trovò sicura
con Amiclàte, al suon de la sua voce,
colui ch'a tutto 'l mondo fé paura;

né valse esser costante né feroce,
sì che, dove Maria rimase giuso,
ella con Cristo pianse in su la croce.

Ma perch'io non proceda troppo chiuso,
Francesco e Povertà per questi amanti
prendi oramai nel mio parlar diffuso.

La lor concordia e i lor lieti sembianti,
amore e maraviglia e dolce sguardo
facieno esser cagion di pensier santi […]

*The present exhibit fills out further the brilliant picture of one of the brightest,
paradigmatic icons in history, wed to poverty, humility, and love of all God's
creations.*
*The message of St. Francis surely will not be lost upon the thousands of
visitors to this exhibit nor upon the world.*
*May the spirit of Francis figure forcefully into a new equation of light and love
that will add up to peace in our time!*

Comm. Stefano Acunto
Chairman Italian Academy Foundation, Inc., New York

Contents

Introduction

Frair Carlo Bottero, Stefano Brufani, Flavia de Sanctis

Francis of Assisi, a man deeply rooted in the cultural and religious context of the medieval city-republics of the 12th and 13th centuries, is a figure in whom many would not hesitate to recognize an evident "contemporary force." To him is ascribed the ability to serve as a reliable interpreter of our present, to raise questions that go beyond the opaque screen of the fleeting and immediate, to offer solutions to complex problems of a personal and social nature. We are not thinking so much of the faithful of the Christian tradition, who almost unanimously—that is to say across confessional boundaries, beyond denominational divisions—pay to him a homage woven through with veneration and love, as of those people of every latitude and culture, believers or not, who see in him the attractive model of a full humanity. A man free from slavery to things and prejudices; able to dream and to be moved; sensitive to the precious gift of friendship; in tune with the great harmony that pervades creation in all its multifaceted beauty; able to present himself as a compassionate companion to those who bear the wounds of isolation and sickness; bold in his denunciation of the dead-ends that make human beings smaller and sadder, like the lust for possession, the futility of vainglory, the spirit of aggression and domination. Francis's style is summed up in the choice of that new designation that he chose for himself, at the critical and decisive moment of his existence, as a concrete program of life: *frater*, Friar Francis. A name that was not just a slogan, but marked for him a radical change in his way of thinking and acting. From that day where *enemy* was written, Francis learned to write *brother*; where the circumstances seemed to suggest the resolute assertion of rights and reasons as the only possible solution, Francis learned to perceive and devise approaches based on dialogue and sharing. This exhibition arises from a very simple, perhaps apparently banal consideration, the conviction that the fascination of Friar Francis, felt by so many of our contemporaries, can be better understood and appreciated if we go back to read the documents that most closely concern his person and his work. Documents that have come down to us from what is now a very remote world and of which it is not always easy for us to understand the content or appreciate the importance; documents that require the patient effort of interpretation, possible only to those who are willing to suspend for a moment their own prejudices and allow the facts and the eye witnesses to speak.

The pieces on display in the exhibition all come from the Library of the Sacro Convento di San Francesco in Assisi, and in particular from the Fondo Antico or collection of old documents of the Municipal Library of Assisi, deposited in it, which comprises the books and archive materials confiscated by the newly formed Kingdom of Italy following the suppression of the religious orders in 1866. They are the oldest papal records and manuscripts that directly concern the person of the saint from Assisi: his writings, his life, the development of the religious order he founded. A treasure trove of documents never previously shown as a whole; only rarely have individual pieces appeared in other exhibitions.

The exhibition is divided into three sections: *Traces*, *Words*, *Images*. The *Traces* are the ones left by Francis at the level of official documentation, in the papal records and some notarial deeds. Alongside these is presented the most famous and authoritative of the manuscripts in Assisi, the Codex 338, which comprises the oldest collection of the saint's writings. Among them is the Canticle of Brother Sun, the earliest example of a work of poetry in the vulgar italian tongue. In this section we see the marks left by Friar Francis, the traces of his history. In the first papal letter sent to the Order of Friars Minor *frater Franciscus* is named for the first time in an official document. In these texts we hear his

words and we follow the development of his memory and his legacy as they were perceived by those who had been closely acquainted with him.

The *Words* section contains some copies of the oldest biographies, the hagiographic *legendae* of the saint. The study of the relations between the various biographies of Friar Francis—which often portray him in ways that are at the very least alternative if not contradictory—and above all the different historical value to be given to each of them as documents that are useful to reconstructing the Francis of history in order to set him apart from the Francis of the *legendae* has given rise to a lively historiographical debate known to scholars as the "Franciscan question." This part of the exhibition sets out to provide a sort of concise introduction to these complex problems, while offering the visitor a chance to look at some very rare pieces: a fragment of the oldest biography, i.e. the *Vita beati Francisci* or "First Life" by Tommaso da Celano; one of the only three surviving copies of the *Memoriale* or "Second Life" by the same author, both of which escaped by chance the order to destroy all biographies previous to the one written by Bonaventura da Bagnoregio, the *Legenda maior*, made by the General Chapter of the Friars Minor in Paris in 1266. The section comes to a close with one of the few manuscripts in the vulgar tongue preserved in the Fondo Antico of the Sacro Convento, a copy of the *Fioretti* or *Little Flowers*, the most widely read and best known of the collections of hagiographic writings on Saint Francis, translated into many different languages and constantly being reprinted.

The *Images* section presents a selection of illuminated manuscripts in which the saint of Assisi is represented; it is a small section, as it has been deliberately restricted to illuminations in the Library of the Sacro Convento. They are sufficiently representative of some of the principal traditional iconographic models. So from words that tell the story of Friar Francis we pass on to images that are intended to celebrate his sanctity, visual documents in which the task of "vulgarizing" and disseminating the spiritual physiognomy of the saint is entrusted to the language of beauty. Alongside the illuminated manuscripts has been placed a manuscript of another kind, a *cantorinus* from the first half of the 13th century containing two very old musical sequences in honor of the saint: from the visual image to the musical image the memory of Friar Francis was developed and diffused through the main registers adopted in the context of liturgical representation and in which are expressed the Christian community's feelings of piety and veneration toward him.

So the logic underpinning the layout of the exhibition is very simple and straightforward. Within this unitary framework a great deal of freedom has been allowed to the authors of the individual contributions, who have brought their own specialist knowledge and skills to the work, resulting in an interesting and varied catalogue that offers multiple keys of interpretation and perspectives of understanding on Friar Francis and his legacy. To all the authors goes our heartfelt gratitude, not just for the authority and rigor with which they have carried out their task, but also for having shared with the members of the advisory board the sense of privilege in having been given the possibility to contribute, each in his or her own way, to an exhibition staged at such an important venue.

It is our hope that all visitors will be able to perceive in the clearest, most vivid and most fascinating way the face of Friar Francis through these *traces*, *words* and *images*.

Assisi, October 4, 2014, Feast Day of Saint Francis

Traces

Codex 338: Collection of the First Writings and Documents Related to Saint Francis and the Order of Friars Minor

Luigi Pellegrini

Sec. XIII², membr., ff. I, 91, I' (two different numberings of the pages: the oldest one, from the modern age, in ink, registers an erroneous jump in the numbering from 69 to 80; the second numbering, from the end of the 19th cent., is correct from 1 to 91; both parchment end-papers, having been reused, bear traces of faded documentary writing dating from the end of the 13th to the beginning of the 14th cent.), 310 × 225 mm. Italian Gothic writing, mostly calligraphic, due to seven copyists, each of whom appears to have worked, albeit according to a unitary logic, independently of the others for sections of text and in some cases for blocks of fascicles: A. ff. 1ra–10vb, two columns with headings in red lead and initials touched with red; B. ff. 12r–43v, single column with simple initials and headings in red led; C. ff. 44r–52r (l. 16), single column (two columns on ff. 48v–49r), with one initial done with a brush (f. 47va), the remaining initials inked in red lead and blue with filigrees in contrasting color and headings in red lead; D. ff. 52r (l. 17)–53v, single column without any paragraphemic sections in color; E. ff. 54ra–71va, two columns, with initials inked in red lead and blue with filigrees in contrasting color and headings in red lead; F. ff. 73ra–84vs (l. 15), with initials inked in red lead and blue with filigrees in contrasting color, the major initials "interlocking" (ff. 73ra, 74ra, 74va) and headings in red lead; G. ff. 84va (l. 15)–91rb, initials inked in red lead and blue with filigrees in contrasting color, major initials "interlocking" (ff. 84va, 90va) and headings in red lead. Red tetrachords on f. 11r-v, no longer marked by any musical notation; on f. 11v the lines were used for the transcription of the initial part of Nicholas III's reaffirmation of the Rule, written in a bastard handwriting (dating from the end of the 13th to the beginning of the 14th cent.); in the upper margin, written not long after: "Hic incipe legere regulam beati Francisci." Restored binding in iron-embossed leather on wooden strips (original cover, detached and conserved separately, is white leather, damaged in several spots, on wooden strips). On the residual part over the fold of f. 1: "Hic liber manuscriptus magni faciendus est inter cœetera quod contineat Vitam versiculatam | sancti Francisci Gregorio Nono dedicatam, dum Assisium venit anno 1228 seraphicum patrem canonisaturus. | Item habetur vita s. Claræ versibus exarata et alia non spernenda. Ita f. Ludovicus Lipsin | scripsit anno 1745." In the handwriting of the same Conventual Minor we can read the titles of the texts in the codex: "Cœremoniale antiquum Fratrum | Minorum" (f. 1r), "Regula Fratrum Minorum" (f. 12r), "Miracula Sancti Francisci post Mortem" (f. 44r), "Regula eadem S. Francisci" (f. 48v), "Nota. Promittuntur hic novem lectionem Breviario inserendæ | et solum tres sequentes reperiuntur" (f. 52r), "Vita S. Francisci in tribus lectionibus" (f. 52v), "Vita S. Francisci versificata Gregorio nono dicata" (f. 54r), "Antiquum Officium Sanctæ Claræ" (f. 73r), "Vita Sanctæ Claræ" (f. 74v), "Vita S. Claræ versificata" (f. 84v). On f. 72v, with an orientation opposite that of the main text, in chancery writing, perhaps transalpine (dating from the end of the 13th to the beginning of the 14th cent.): "Assingnetur fratris Bonifatio de Mutina, qui cito | expediat et bene custodiat." In many points in the manuscript, in the margins, historical notes written by the custodian Niccolò Papini Tartagni (1800–03). On f. 91v., written in about 1381 by Giovanni di Iolo, Sacro Convento librarian: "In isto libro omnes quaterni sunt .x.," which corresponds to the peculiar numbering, written in the same hand, of the individual fascicles.
(Massimiliano Bassetti)

A Witness of the First Liturgical Norms of the Friars Minor

A codex, if it is carefully analyzed, always opens an interesting page of history. In our case, manuscript 338, held at the Biblioteca del Sacro Convento in Assisi, reveals an important segment of the complex and troubled path of the first decades of the Friars Minor's experience (see Pellegrini 2002, with bibliography). Beginning with the first fascicle, the manuscript signals a turning point on a part of the Order's historical journey. The original Minorite brotherhood had by then spread through all of Europe and the Mediterranean as far as the Near East, and had transformed into an impressive religious institution. The substantial influx of educated clerics had gradually modified the Order's characteristics, ways of life, and functions. The lay brothers, still predominant, began to be considered too invasive, and it was felt that their presence and tasks had to be reproportioned. After Friar Elias was removed from the post of Minister General in 1239, at the urging of the clerical and learned members and with the support of the papacy, a rule was passed that prohibited accepting candidates who were not already sufficiently educated clerics. An Order that was by then clericalized needed precise rules for celebrating liturgies. During the period of his generalship (1240–44), Haymo of Faversham, Friar Elias's sec-

huius seculi. Scā humilitas. ꝯfundit su
pbiam. ꝫ oms homines qui funt i mundo.
simulr. ꝫ omia que i mundo sūt. Scā ca
ritas. ꝯfundit oms diabolicas ꝫ carnales
temptationes. ꝫ oms carnales timores.
Scā obedientia. ꝯfundit oms corpales ꝫ
carnales uolūtates. ꝫ habet mortificatū cō
pus suū ad obedientiā sps ꝫ ad obedientiā
frīs suu. ꝫ ē subditus ꝫ suppositꝯ oībꝫ hoībꝫ q
sūt i mundo. ꝫ nō tantū solis hoībꝫ. ſȝ etiaꝫ
oībꝫ bestiis ꝫ feris. ut possint facere de eo
quicꝙ uoluīnt. quātū fuit eis datū desu
p a dnō. Icipiūt laudes creaturaꝫ ꝙs fecit beatꝯ
frāciscus ad laude ꝫ honore dei. cū eēt ifirmꝯ apd
scīn damianū.

Ltissimu omnipotente bonsignore. tue

sole laude la gloria el honore ꝫ onne
Adte solo attissimo se
Konfano. ꝫ nullu homo
ene dignu te metuare.
benedictione.

ex Thoma a Ce
lano pag. 263.
vere felix huius
apud S. Damianū
in infirmus,
non dicit; sed
nequa sint lau
des fecisse.
sed in ultimis
diebus vitę
(V: pag: 268

Laudato ǹe mi signore cū tucte le tue crea
ture. spetial mīte messor lo frē sole. loqua
le iorno ⁊ allumīni noi p loi. Et ellu etellu
eradiante cū grande splendore. de te altiss-
imo porta significatōe. laudato si mi signore
p sora luna ele stelle. in celu lai formate
clarite ⁊ ptiose ⁊ belle. laudato si mi sigre
p frē uēto ⁊ p aere ⁊ nubilo ⁊ sereno ⁊ onne
tēpo. p loquale ale tue creature dai susten
tamēto. laudato si mi signore p sor aqua. la
quale emulto utile ⁊ humile ⁊ ptiosa ⁊ casta.
laudato si mi signore p frē focu. p loquale
enallumini la nocte. edello etello ⁊ iocūdo
⁊ robustoso ⁊ forte. laudato si mi signore p
sora nra matre tra. la quale ne sustenta
⁊ gouerna. ⁊ pduce diuisi fructi cō colorīti
flori ⁊ herba. laudato si mi signore p quelli
ke pdonano p lo tuo amore. ⁊ sostengo in
firmitate ⁊ tribulatione. beati quelli kel
sosterrano ī pace. ka da te altissimo sirano
īcoronati. laudato si mi signore p sora
nostra morte corpale. da laquale nullu
hō uiuēte po skappare. guai acquelli ke
morrano ne le peccata mortali. beati quel
li ke trouarane le tue stissime uolūtati
persecutione

ka la morte secūda nol farra male. Lau
date ꝫ bñdicete mī ſiᵹnore ꝫ rēgratiate
ꝫ ſeruiate li cū grande humilitate. ⁖

Incipiūtur laudes quas ordinauit beatiſſi
mus pat nr franciſcus. ꝫ dicebat ipas ad
oms horaſ diei ꝫ noctis. ꝫ añ offitiū beate
marie uirginis. ſic incipiens.

Sctiſſime pat nr qui es in celis ꝫ c̄. cū gla. deīnd
es. ſc̄s. ſc̄s dñs dſ oīps qui ē ꝫ dicātur laudes.
ꝫ qui erat ꝫ qui uēturuſ ē. l. ꝫ ſu. eū īſecula.
Dignuſ eſ dñe dſ nr accipe laudē. glam et
honore ꝫ bñdictōem. laudem ꝫ ſup. eū ī ſcła.
Dignuſ ē qui occiſuſ ē accipe uirtutē ꝫ diui
nitatē ꝫ ſapientiā ꝫ fortitudinē ꝫ honorez
ꝫ glam ꝫ bñdctōem. laudem ꝫ c̄. Bñdicamuſ
patē ꝫ filiū cū ſc̄o ſpū. laudem ꝫ c̄. Bñdici
te omīa opa dñī dño. laudem ꝫ c̄. Laudez
dicite deo nro omś ſui eius. ꝫ qui timetiſ
deum puſilli ꝫ magni. laudem ꝫ c̄. Et oīs
creatura que ī celo ē ꝫ ſup trā ꝫ ſubtus
trām ꝫ mare ꝫ q̄ in eo ſunt. laudem ꝫ c̄. Gła
patri ꝫ fi. ꝫ ſ. laudem ꝫ c̄. Sic erat ꝫ c̄. laude
mi. ꝫ c̄. oratio. O oīps. ſctiſſime. altiſſime et
ſume dſ. omē bonū. ſūmū bonū. totū bonū.
qui ſoluſ eſ bonuſ. ꝫ reddrā omē laudem

Fig. 1. Erasure
of the benediction
formula prescribed
by Friar Haymo.
Assisi, Fondo Antico
Comunale, Biblioteca
del Sacro Convento,
MS. 338, f. 9vb.

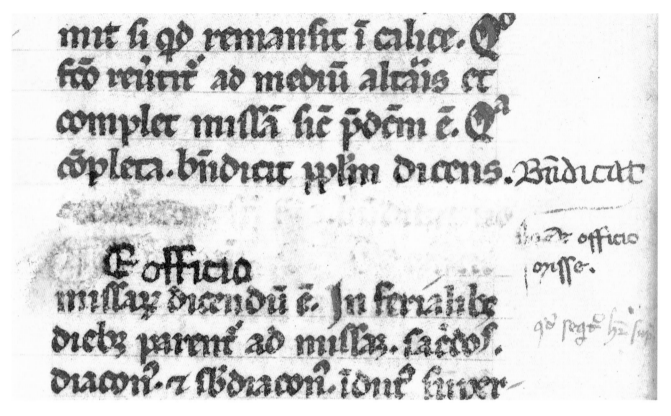

ond successor, prepared a series of *Ordinationes* for the reciting of the Divine Office (the canonical hours of prayer) and for the community's celebration of the Eucharist. Those *Ordinationes* were published in 1247 on the occasion of the General Chapter in Lyons or the next Chapter, celebrated in Genoa in 1251.

We find them transcribed in the first fascicle of our codex, where other liturgical statutes issued by the General Chapter of 1254 were later added in the same handwriting. This, then, is the date after which the content of the ten folios of this manuscript was written. A calendar on which the feast days the whole Order was to celebrate with solemn rite was also prepared on this occasion. Obviously this calendar was updated over time, as new festivities or commemorations were introduced; this also occurred whit the renewal of ritual formulas in consequence of liturgical developments. A number of marginal additions in different handwriting and cancellations of writing indicate the final point of reference for dating the transcription of the *Ordinationes* and the later statutes. On f. 9vb (fig. 1) we can clearly see that the previous writing with the benediction formula prescribed by Friar Haymo was cancelled in order to write the new one determined by the liturgical statutes of 1254 over it; the new formula is duly transcribed on f. 6rb (fig. 2) in the first handwriting; evidently the amanuensis of f. 9vb wrote the old formula from memory.

Much more indicative for dating this first fascicle are the updates to the festivities, which are in the text's side margins. These updates acknowledge the definitive settling of the statutes and liturgical calendar resulting from the decisions of the Narbonne General Chapter in 1260, the first one presided over by Friar Bonaventure of Bagnoregio. Without lingering over all the marginal additions we can look at those on ff. 3r and 4v purely by way of example, especially the one related to the "Four Doctors" (Gregory, Ambrose, Augustine, Jerome) added in the margin between the celebrations of "semidouble" rites. On f. 3rb (fig. 3) we can see the marginal note is crossed out—as are other festivities listed on the same folio—and rewritten in a different hand on f. 4rb (fig. 4). These cancellations place the additions in a period immediately following the Narbonne liturgical provisions, which called for celebrating the memory of those saints with a "semidouble" rite; the 1299 Chapter in Lyons elevated this to the more solemn "double major" rite, as added later in different handwriting. So this first fascicle was written between 1257 and 1260 and was updated according to the liturgical provisions from the Chapters until at least 1299, as proven by its constant use at the Sacro Convento for the entire 13th century.

The First Collection of Francis of Assisi's Writings
Browsing through the codex, at first glance we see a folio that has clearly been inserted in 1279: on August 21, 1279, in the context of a twenty-plus-year-old polemic—set off by the Parisian "masters" belonging to the secular clergy—on the practical observability of the norms contained in the Rule of the Friars Minor regarding poverty, Pope Nicholas III issued an official reaffirmation of the Order's fundamental regulatory text. The request for reaffirmation that came from the friars themselves was

Fig. 2. Formula of benediction established by the liturgical statutes of 1254. Assisi, Fondo Antico Comunale, Biblioteca del Sacro Convento, MS. 338, f. 6rb.

Fig. 3. Indication in the margin of the feast days of the "four Doctors," cancelled with a pen stroke. Assisi, Fondo Antico Comunale, Biblioteca del Sacro Convento, MS. 338, f. 3rb.

Fig. 4. Indication in the margin of the feast days of the "Four Doctors," updated. Assisi, Fondo Antico Comunale, Biblioteca del Sacro Convento, MS. 338, f. 4rb.

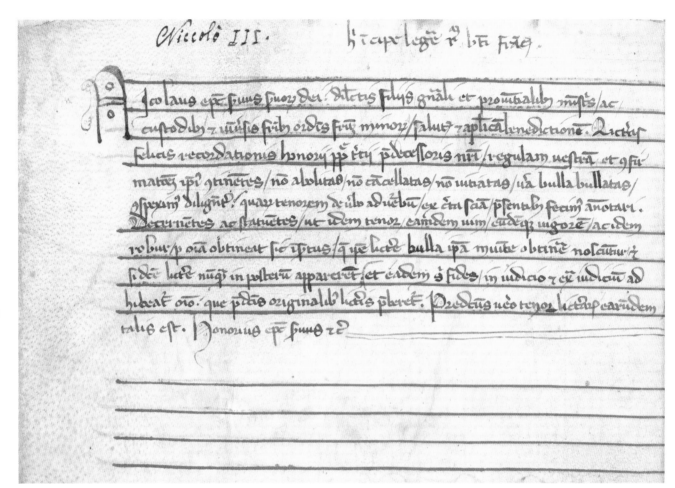

Fig. 5. "Hic incipe legere regulam beati Francisci."
Assisi, Fondo Antico Comunale, Biblioteca del Sacro Convento, MS. 338, f. 11v.

presented following the General Chapter, which was celebrated right in the Sacro Convento in Assisi in May of 1279, after a forty-year absence of the assembly from the Umbrian city. The first part of the papal letter was transcribed on a folio with a four-line staff, ready for the insertion of the musical notation for a liturgical chant but not used for that purpose (f. 11v). The insertion was done through a "heel," that is, refolding the far left edge to incorporate the folio into the first fascicle of the codex. The notable difference in the handwriting with respect to that of the three fascicles that come immediately after reveals that the folio was added at a later time than the first fascicle and the three following ones, written by a single amanuensis who filled each page with a transcription of a collection of Francis of Assisi's Writings.

The considerable size of the characters and the large headings confer a solemn tone on the collection, evidently intended to be easily and immediately legible. In fact, several signs for pauses clearly indicate that at least the first two writings were intended to be read publicly. The first is the text of the *Regula fratrum minorum*, definitively approved by Honorius III on November 29, 1223. The papal letter of approval presents the *Regula* itself, called *bullata* after Pope Honorius's *bulla confirmationis*. With the reaffirmation from Nicholas III, care was taken to transcribe the introductory part of his reaffirmation through the insertion of a folio with this indication in the upper margin: "hic incipe legere regulam beati Francisci" (here the rule of the blessed Francis must begin to be read; f. 11v, fig. 5). This is confirmed by the addition at the bottom, over the erasure (f. 15v [fig. 6]) of the *sanctio* from Nicholas III's letter, which comes after the closing *sanctio* from Pope Honorius's letter.

We have, therefore, a chronological point before which Friar Francis's Writings were reproduced. Despite the possible chronological range between the different types of writing, careful observation of the characters used by the scribe, in comparison with those from the first fascicle, reveals that the texts were written before the *Cerimoniale*, so before 1260. In 1922, Francis Crawford Burkitt published a paleographic analysis of the three fascicles with Francis's Writings, coming to the conclusion that the handwriting must be considered contemporary with the writing of the second biography of Saint Francis, written by Thomas of Celano at the end of the 1240s (Burkitt 1922), despite the different opinion of other scholars, including the author of the description in the introduction to this essay.

Moreover, what more opportune moment to insert the collection was there if not the context of the provisions of the 1244 General Chapter in Genoa, which were in-

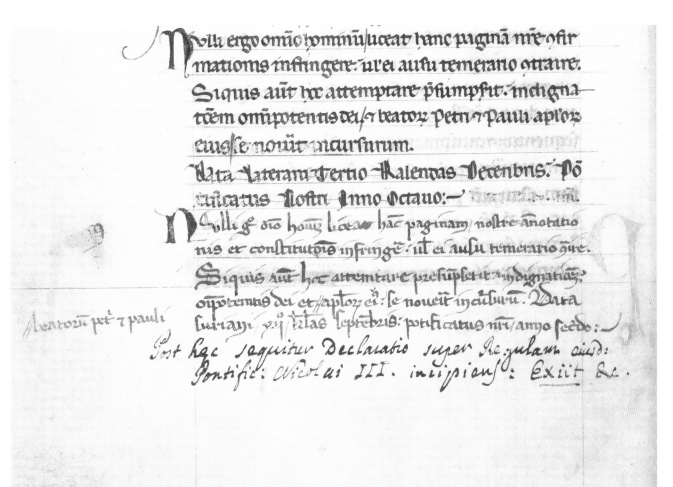

Fig. 6. Addition over the erasure of the *sanctio* from the letter of Nicolò III, which comes after the closing *sanctio* from Pope Honorius's letter. Assisi, Fondo Antico Comunale, Biblioteca del Sacro Convento, MS. 338, f. 15v.

tended to gather all possible material for composing a new hagiographic text on the Assisi saint? The members of the small circle of people Francis surrounded himself with in the very last years of his earthly life sent their memories from that period to the then Minister General: the Letter of the Three Companions (Leo, Angelo, and Rufino), dated August 1246 from Greccio, is evidence of this. The name that stands out is that of Friar Leo, whose voice seems to echo in the headings of some of the texts included in this codex. See, especially, the introductory heading to the *Laudes creaturarum*, which presents the circumstances of the poem for the first time: "quas fecit beatus Franciscus ad laudem et honorem Dei cum esset infirmum apud sanctum damianum" (the blessed Francis composed it in praise of and honor for God when he was ill at San Damiano; f. 33r, fig. 7). This extremely concise story is attributable to Friar Leo whose testimony, along with that of other of the saint's companions, would later be collected, as would the story, in the 14th-century collection of the episodes of Saint Francis's life: the so-called *Compilatio Assisiensis*. From Greccio, key date of the *Epistola trium sociorum*, we move to Assisi, the place where the Writings gathered in Codex 338 were drafted. We have the testimony of Ubertino da Casale, for as credible as he is, who writes of having seen (and read?) the following,

right there in the Sacro Convento: "Verba ipsius [Francis] solenniter conscripta de manu fratris Leonis" (the words of Francis transcribed solemnly by the hand of Friar Leo). In fact, it seems we can see the traits of the friar's handwriting in the codex, in the headings at least. The list of Friar Francis's texts collected in the manuscript is significant. It begins, obviously, with the *Regula bullata*: the collection could not do without it, rather, it had to be placed first since it was intended to be read in the refectory along with the saint's *Testamentum*; numerous codices are evidence of the two texts being indivisible from each other in that context. The introductory heading to the *Testamentum* was cancelled in 1279 in order to present the *sanctio* from Nicholas III's letter. The other texts are those that are directly or indirectly addressed to the Friars Minor. They are certainly addressed by the *Admonitiones* and the *Littera ad capitulum*, which is also preceded by a heading presenting the circumstances of its composition: "quando erat infirmus." Inserted between these two texts is the *Opusculum commonitorium et exortatorium*, commonly called the Letter to the Faithful; the texts that follow are: the so-called Letter to the Clergy, the Salutation of Virtues, the Canticle of the Creatures (with a blank space at the beginning for marking musical notations), and the liturgical offices composed by Francis, preceded by headings that

29

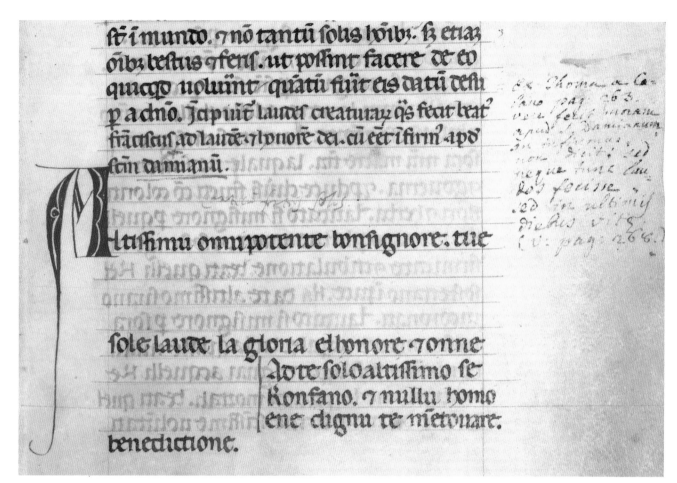

Fig. 7. Introductory heading to the *Laudes creaturarum* "quas fecit beatus Franciscus ad laudem et honorem Dei cum esset infirmum apud sanctum damianum." Assisi, Fondo Antico Comunale, Biblioteca del Sacro Convento, MS. 338, f. 33r.

indicate the times of year and moments of the day when the friars were to recite them. At the end, the rules Francis gave for those friars "who want to live religiously in a hermitage."

This last writing is separated from the others by a couple of pages left blank. Was it added later? We can see that the text was written by the same person, so why the blank space? Perhaps in anticipation of at least one other Writing being inserted; but which? We know that Friar Leo kept to himself the emotional and stirring "praises" that Francis, "after the vision of the seraphim and the impression of the stigmata on his body," addressed to "Almighty God," as Friar Leo himself wrote in a heading on the *verso* of the scrap of parchment on the *recto* of which the Assisi saint had drafted the *Laudes* in his own hand. The space left blank seems set aside just for the *Laudes* and the introductory heading. But it was too personal a text, which Leo kept jealously to himself along with the benediction that Francis had written in his own hand on the bottom half of the *verso* of that *chartula*. We're dealing with hypotheses, or rather the attempt to reconstruct Friar Leo's intentions. That blank space remains and it would be difficult to explain the reasons for it in any other way.

These first four fascicles had to have been a codical unit in themselves, at least from 1279, when the letter reaffirming the Rule was inserted.

Singular Hagiographic Texts of Saint Francis

The fascicles that follow, written in calligraphic writing by different hands, include texts of various types and origins. They all, however, are dedicated to Francis and Clare. They begin with a collection of miracles that occurred near the saint's tomb or because of his intercession. The hypothesis that the writer copied the collection from the *Tractatus de miraculis beati Francisci*, written by Thomas of Celano around 1253, collapses under careful analysis of the content and narrative style. If it were a reproduction of Celano's *Tractatus*, how can we explain the different order of the second part of the stories? But especially, how can we explain the variations that draw the text closer to Thomas of Celano's first hagiographic effort? An observation proposed in 1930 by the Conventual scholar Giuseppe Abate shows the convergence between the stories in question and those inserted in a liturgical Legend, which he called the *Neapolitan Legenda* because it was included in a codex from the Biblioteca di Napoli (Abate 1930). The hypothesis was recently confirmed by Jacques Dalarun, who maintains that in fact the collection of miracles in Codex 338 was originally part of a text he calls the *Legenda choralis umbra* (Dalarun 2007).

There is another incomplete text inserted in the codex. On the last two folios of the fascicle that includes the collection of miracles, the same hand transcribed the Rule,

while another amanuensis wrote the first three lessons of the so-called *Legenda ad usum chori*, a liturgical summary of the first biography written by Thomas of Celano. The brief introduction to the three *lectiones* of the *Legenda* is in the form of a dedication to the person who commissioned the work, Friar Benedetto (f. 52r, fig. 8); perhaps, as has been hypothesized, the Friar Benedetto who was responsible for the Minorite province in the Middle East from 1221 to 1237. If this hypothesis is correct, then the text was written sometime during the third and fourth decades of the 13th century. The "dedication," the singular partition of the text—that is found only in this codex—and the fact that the text was not included in a breviary lead us to think that this is its original form, or maybe its first draft, written by the author himself. The aim of the summary is explicitly announced: "ut in breviariis possit eam poni" (to be inserted in breviaries). So it is a text composed of nine brief readings—as the writer, or rather, author announces: "ut in novem lectionem seriem ordinarem" (arranged it in a series of nine readings)—to be recited during the liturgical office of Matins. The disappearance of the six missing readings is evidently due to the destruction Saint Francis's *Legende* underwent at the imposition of the 1266 General Chapter in Paris after the two biographies by Bonaventure were written.

The sixth through eighth fascicles include the *Legenda versificata* of Saint Francis, the work of Henry of Avranches. The characteristics features of the page layout—writing in two columns; minimal space between the lines; very narrow top, bottom, and side margins (f. 54r, fig. 9)—lead us to think that these three fascicles were originally a codical unit to themselves. Henry of Avranches composed his biographical poem in two successive drafts, the first of which is certainly datable to before 1241, since Pope Gregory IX is indicated as being still alive. There is, additionally, a positive memory from Friar Elias inserted, which is not present in the subsequent draft that is datable to several years later, after the former Minister General was removed from his post and condemned, with the consequent *damnatio memorie*. This codex, unique among those that have reached us, thus restores for us the original draft, transcribed before the diffusion of the second draft. This text also brings us to the fith or sixth decade of the 13th century.

Some Texts on Clare

The last part of the manuscript is dedicated to Saint Clare: the liturgical office; the *Legenda*, preceded by a dedication to Alexander IV; three hymns in honor of the saint; the mass orations dedicated to her; and a *Legenda versificata*. It must have originally been a codex com-

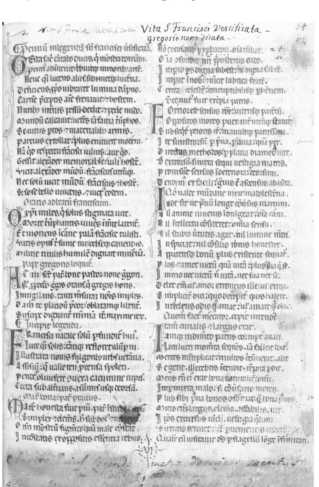

Fig. 8. Brief introduction of the three *lectiones* of the *Legenda* with dedication to Frair Benedetto, who commissioned the work.
Assisi, Fondo Antico Comunale, Biblioteca del Sacro Convento, MS. 338, f. 52r.

Fig. 9. *Legenda versificata* of Saint Francis by Enrico d'Avranches, features of the layout.
Assisi, Fondo Antico Comunale, Biblioteca del Sacro Convento, MS. 338, f. 54r.

Fig. 10. Last part of the manuscript dedicated to Saint Clare, features of the layout. Assisi, Fondo Antico Comunale, Biblioteca del Sacro Convento, MS. 338, f. 84v.

posed of two quires and a bifolium. The rougher parchment, the smaller writing that is, however, sufficiently calligraphic for easy reading and "dignified" by showy illuminated initials, the layout arranged to maximize the space on the page all reveal a writing environment ruled by the concern for avoiding "waste" of the precious writing material (f. 84v, fig. 10). We can imagine that the environment of origin, or at least of destination, was linked to the needs, or better, the choice of strict poverty. How can we not think of the Assisi monastery of the *Pauperes Domine* who, in all probability, still resided in San Damiano? We should find ourselves, therefore, in the sixth decade of the 13th century. This manuscript is therefore composed of five codical units assembled later, perhaps by the same "armarista" (librarian), Friar Giovanni di Iolo, who, in 1381, finished his precious inventory of the codices then held at the two separate libraries of the Sacro Convento: the one intended exclusively for the friars' use, the *Bibliotheca secreta*, and the one open to a wider public, the *Bibliotheca pubblica*. The dates of composition of each of these codical units ranges from the fifth to the sixth decades of the 13th century. The most conspicuous and significant part includes eleven of Friar Francis's Writings; it is obviously the most studied part which, beyond the many discussions about its dating, is by now to be set at the end of the fifth decade of the 13th century, as confirmation of the Minorite Order's commitment to conserving and passing on the saint's texts and to offering them, with the precious collaboration of Friar Leo, to the friars for public reading.

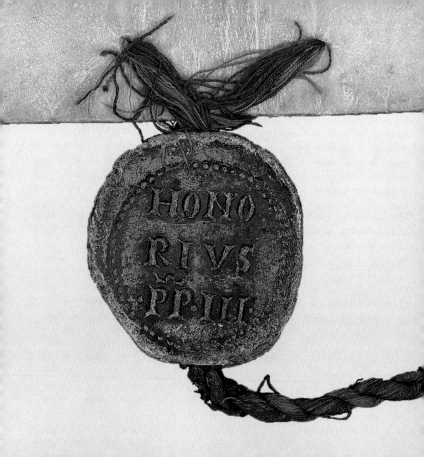

The letters of Honorius III to Brother Francis in the Archive of the Sacro Convento of Assisi

Stefano Brufani

Francis of Assisi and the Apostolic See established relations starting with the birth of the Franciscan brotherhood in 1208–09, relations that were intensified and consolidated over the years, growing in value thanks to the presence of "cultural mediators" in the Curia and among the Friars Minor (Franciscans), and eventually crystallized in legal documents giving institutional status to this *religio nova*.

This is how Francis, close to death, recorded those initial contacts in his Testament: "And after the Lord gave me some brothers, no one showed me what I had to do, but the Most High himself revealed to me that I should live according to the pattern of the Holy Gospel. And I had this written down simply and in a few words and the Lord Pope confirmed it to me" (Test 14–15: *FAED* I, 125).

Jacques de Vitry, elected bishop of Acre in the Holy Land, offers the first direct testimony of the Friars Minor and *Sorores Minores* he met when visiting the papal court, then in Perugia, after the death of Innocent III and the election of Honorius III. In a letter dated 1216 he writes: "With great profit, the brothers of this Order assemble once a year in a designated place to rejoice in the Lord and eat together; with the advice of good men they draw up and promulgate holy laws and have them confirmed by the Lord Pope. After this they disperse again for the whole year throughout Lombardy and Tuscany, Apulia and Sicily" (Jacques de Vitry, let. I: *FAED* I, 580).

Francis had simple words written to express the ideal evangelical life. These words had to go through a long legislative process, starting in the annual meetings (Chapters) of the friars in the Portiuncula, where they established their laws (*institutiones*), threading their way—in a manner of speaking—through the narrow corridors of the papal court and lastly, if successful, coming to the attention of the pope. This journey there and back was repeated many times from circa 1209 to 1223, and transformed the initial *forma vitae* written by Francis into the *Regula bullata* of the Friars Minor, which they still observe today (*Regola* 2010). The legislative process was accompanied and followed by writs with which the Apostolic See ordered the application of general rules for the religious Orders or granted exceptions to such rules, perhaps in response to a direct request by those affected.

In order to have legal validity, each one of these writs concluded with a papal letter adhering to the procedures and forms of Roman chancery, thus giving it public validity. As Werner Maleczek authoritatively stated "we should thus, if possible, close the matter of the 'oral' confirmation of the rule in 1209 and instead seek more adequate terms that characterize the reaction of the pope to the *forma vitae* presented to him" (Maleczek 2003: 184).

As far as we know, Innocent III did not address any letter to Francis. During the papacy of Honorius III (1216–27) the papal chancery issued some thirty documents regarding the history of the Friars Minor (Thomson 1971: 14–17), but only three are addressed explicitly to brother Francis: the papal letter *Cum secundum consilium* (Orvieto, 22 September 1220), the *Devotionis vestre precibus* (Lateran, 31 March 1221, replicated on 5 April from Anagni) and the *Solet annuere* (Lateran, 29 November 1223). These three letters, plus another that may be considered a complement to them (*Fratrum Minorum continent instituta*, Lateran, 18 December 1223), are the only letters from Honorius III found in the archives of the Sacro Convento of Assisi.

Since the beginning of the modern era, the most important archival papers, first and foremost the papal letters, were kept in the "secret" sacristy, the one in the Lower Church of Saint Francis, at the base of the bell tower. Here, in addition to the liturgical objects, the most precious and important objects of the Sacro Convento were kept, because the location was considered to be the most secure. Starting at the latest at the end of the 16th century, an administrative reorganization of the Sacro Convento began by initiative of father Filippo Gesualdi, Minister General of the Order. The first mention of the "newly built archive" dates to this period. It is very probable that these spaces, now used for other purposes, are those identified in this epigraph carved into an architrave: CANCELLARIA, and below, ARCHIVIUM. This is where documents were

On page 34 Honorius III, *Solet annuere* (Lateran, 29 November 1223), detail of the *bulla plumbea* with the name "Onorio papa III." Assisi, Basilica di San Francesco, Reliquary Chapel.

consulted by the learned father Francesco Maria Angeli of Assisi and organized by the fathers Lipsin and Tebaldi, archivists of the Sacro Convento in the mid 18th century (Nessi 1991: X–XXVI).

The three letters addressed primarily to brother Francis have a number of formal elements in common, the most evident of which is the silk thread (yellow and red), that make it possible to define them as *litterae gratiae*, issued to grant a concession, generally in response to a petition submitted to the papal court. The fourth letter, addressed to the prelates of the Church, was a papal ordinance, *litterae iustitiae*, ordering the recipients to honor the concession granted to the Friars Minor. Its form already distinguishes it from the others, firstly because of the hemp cord with which the seal was attached to it. These letters bear exceptional witness to the fundamental moments in the development of the intuition of Francis of Assisi into the institution of the Order of Friars Minor (Desbonnets 1986) and to the relationship between the Apostolic See and Francis that resulted in this metamorphosis, this transformation. It is quite exceptional that these documents are exhibited in this exhibition in New York, *Frate Francesco. Friar Francis: Traces, Words, Images*.

Honorius III had previously written the *Cum dilecti filii* (Rieti, 11 June 1219) and the *Pro dilectis filiis* ([Rieti], 29 May 1220), the former to all the prelates of the Church, the latter to the prelates of France, advising them to receive the friars and to reassure them that the Order of Friars Minor was one that had been approved by the Church. But the pope could not refer to a definitively approved *Regula* (Rule), which would in itself have represented a safeguard, making the papal presentation in the form of recommendatory letters superfluous. In spite of the fact that the process of formalizing the Rule had begun some years prior, the definitive version was not yet available. The papal letters addressed to Francis constitute fundamental milestones in this legislative process (Rusconi 1994: 85–92).

The Cum secundum consilium

The letter was written in Orvieto on 22 September 1220 (see entry no. 1 in this catalogue), which was where the papal court was located at the time. This is the year of the serious crisis that shook up the Friars Minor and exploded when Francis was in Egypt (1219–20) (Godet 2005; Brufani 2013). The events are vividly and amply narrated by Giordano da Giano in the *Chronica*. Returning in haste to Italy from the Orient, Francis "et ibi causis turbacionum plenius intellectis non ad turbatores, sed ad dominum papam Honorium se contulit" (Giordano da Giano 2011: 38) (after having gained a deeper understanding of the disorder, did not go before the agitators, but before lord Pope Honorius). On this occasion, Francis requested and

obtained from the pope the appointment of Ugo or Ugolino, cardinal-bishop of Ostia, as cardinal-liaison in the papal court for the Friars Minor, who could be consulted on issues regarding the brotherhood or Order. The cardinal's first provisions established his authority in the papal court and specifically in the chancery: "Cum ergo beatus Franciscus domino Hostiensi papae suo causas turbacionis suae retulisset litteras fratris Philippi in continenti revocavit et frater Johannes cum suis cum verecundia a curia est repulsus" (Giordano da Giano 2011: 39) (Blessed Francis having referred to the Lord of Ostia, his pope, the causes of his unease, he immediately revoked the letter to brother Filippo, and brother Giovanni and his group were shamefully expelled from the papal court). We are not able to date the visit by Francis to the papal court with any precision, but it is likely to have taken place in the late spring or summer of 1220. It is very probable, however, that Francis was in the papal court in the month of September, around the time of the publication of *Cum secundum consilium*. The type of document—a letter granting a concession (*litterae gratiae*)—normally presupposes the presentation of a request (petition) by the parties concerned or by their representative. This papal act may be the response to a request that was agreed in some manner between the cardinal-bishop and Francis, the first step on a shared road, but nevertheless one that was arduous and challenging, because two very different mentalities had to work together (Zerbi 1982).

The ideal motives are expressed in the preamble (*arenga*) to the letter, making reference to Biblical texts and the practice of the religious life and employing the rhetorical art of the papal chancery. This introduction is an *unicum* among the documents issued by the chancery in the 13th century; it is a formal element that already gives us an idea of particular attention being dedicated to an exceptional situation. Confirmation in this regard is provided by the later replications in the time of Gregory IX and Innocent IV (*BF* I, 6, 27, 231, 235, 285 352, 411). This introduction is used again in the following years for the replication of the letter to the Order of the Friars Minor (*Initienverzeichnis* 1978: 39). The expository part—where in general the immediate precedents for the provision, or at least the petition (*petitio*), are mentioned—is omitted and thus the document does not provide any information about who the petitioners might eventually have been. This detail has been interpreted as the expression of an "imperative command" (Rusconi 1994: 91).

The document institutes a mandatory year of probation before a brother can be professed in the Order, to experience the regular observances and to prove the goodness of his intentions ("Therefore, by authority of these present letters, we forbid you to admit to profession in your Order anyone who has not first completed a year of probation" [*FAED* I, 561]). After their profession the fri-

ars were no longer free to leave the Order and the other orders were forbidden from taking in any who did abandon it. The use of the habit of the Friars Minor was prohibited to anyone outside the Order. The friars were forbidden from "corrupting the purity of (…) poverty" (*FAED* I, 561). The religious superiors were allowed to inflict ecclesiastic censure on those who did not abide by these rules.

The introduction of the year of probation, the novitiate, is the most important part of the provision, but it has more the character of an ordinance than the granting of permission, even though it is accompanied by a number of applicative concessions. The final provisions in the letter reaffirm the dual nature of this act as both prohibition and concession ("No one, therefore, is in any way permitted to tamper with this decree of our prohibition and concession or rashly dare to oppose it" [*FAED* I, 561]). The chancery appears to have adopted a formula envisaged as being exceptional in the drafting of this type of letter, which simultaneously provided both *mandata* and *gratiae*. The impression is that an order dressed up as a concession—sugar-coated, so to speak—was delivered to Francis and the custodians of the Friars Minor, a bitter medicine felt to be indispensable in giving structure to the original small group of penitents that had unexpectedly multiplied in number, and testified throughout Europe to an evangelical life of poverty in communion with the Apostolic See. In its form and content, the papal letter expresses the dual nature of order and concession, the result of an initiative (I wouldn't call it a plea) that was in some manner agreed. And I would have very few doubts about seeing the hands of Cardinal Ugolino and Francis behind this agreement.

Given the expectations that the Apostolic See appeared to harbour for Francis and the Friars Minor and the collaborative relationship sealed with the appointment of the cardinal from Ostia, the papal chancery did not issue an executive letter, an ordinance, expressing in the formula and form a brusque and peremptory order, announced at first glance by a lead seal hanging on a humble hemp cord. It made a gesture of formal regard, charged with meaning, because the legal form expresses the substance. The silk thread of the letter, documented up to 1915 (Alessandri and Pennacchi 1915: 594, no. 1), is now lost.

With this provision, the Apostolic See sought to align the recruitment practices of the Friars Minor with those of the other religious orders. The fluidity and liberty of membership in the brotherhood was replaced by the ecclesiastical discipline typical of the regular religious orders. For this reason the historians have rightly interpreted in this document a fundamental step in the shift from the intuition to the institution of the Order of Friars Minor, but they had varying interpretations of the relation between the *Cum secundum consilium* and the "resignation" of Francis from the office of Minister General of the Order during the Chapter of San Michele (29 September) at the Portiuncula (Brufani 2013: 9–24). The relinquishment of office is recorded in the hagiographic tradition of the companions of Francis, starting with the *Compilatio Assisiensis* 11 and 39 (*FAED* II, 125, 142).

Scholars who saw a cause-effect relationship between the letter and the resignation placed an emphasis on the absence of Francis's name among the addressees of the papal letter, documented in the edition of the *Bullarium Franciscanum* by Giovanni Giacinto Sbaraglia, based on an exemplar of the letter in the Roman convent of the Ara-

Fig. 1. Honorius III, *Cum secundum consilium* (Orvieto, 22 September 1220), *verso* of the parchment with archival notations. ASC, *Bollario*, I/1.

coeli which is no longer available. The omission of the name of Francis has been interpreted as a clear sign that not only did he not solicit that document, but was so opposed to it that he distanced himself from this new period in the life of the Order.

The *Cum secundum consilium* is explicitly cited in the Rule not bearing the papal seal: "When the year and term of postulancy has ended, he may be received into obedience. After this it will be unlawful for him to join another Order or to 'wander outside obedience' […]" (ER II,10: *FAED* I, 65). It is very probable that during the Chapter in the spring of 1221, Francis and the Friars Minor acknowledged the papal ordinance requiring a training period, but did not mention the possibility of employing the practice of ecclesiastical censure against friars "wandering outside obedience" (ER II,10: *FAED* I, 65). The obligatory part regarding the novitiate (*mandatum*) was accepted, but they glossed over the optional parts (concessions) regarding the practice of the canonical discipline in the brotherhood/order and with regard to the other religious orders. The path of the *Cum secundum consilium* represents a clear example of the dialectical relationship that was established between Francis and the Apostolic See in the legislative activity that characterized the 1220s.

The letter was not recorded in the Vatican registries and, as a consequence, the original in Assisi does not bear the typical large "R" on the hair side of the parchment, a mark showing that a papal document had been registered (fig. 1). It is possible that the provision was conceived as a first action in the legislative process of the Friars Minor and the registration was put off until the pope had confirmed the Rule.

The Devotionis vestre precibus
The second letter from Honorius III, dated 31 March from Anagni, was addressed "to Francis and the other friars in the Minor Order"(see entry no. 2 in this catalogue). Here, without any doubt, this is in all respects a concession, *litterae gratiae*, because both the content and type of the chancery formula and the physical nature of the letter manifest the granting of a concession. The text is very terse, there is no introduction providing the spiritual motivations for the legal act (*arenga*), and the expository part (narration) is reduced to the mere restatement of the request (petition). The incipit of the document makes reference to the request that was presented. The pope states that he is acting in response to a request ("in favorable response to your devout prayers"), although the reference is so generic that it may simply be a chancery formula. The pope grants the Friars Minor permission to celebrate the divine offices (*divina officia*) in their churches in times of interdiction, i.e. when liturgical celebrations were prohibited in a city or region because of some grave wrongdoing. The plural of divine offices must be understood to refer to all the various liturgical moments, both the recital of the Divine Office in the strict sense with the celebration of the various liturgical hours that marked out the day and was a duty of all clerics, and the celebration of Mass. Certain conditions had to be observed in such cases ("excluding the excommunicated and interdicted, behind closed doors, and in low voices").
The availability of churches of their own for the friars was not a given, and in the document this is given as a hypothesis: "in the churches that you may hold." The action of the pope evidences the fact that the living conditions of the friars were still uncertain. Indeed, in the early 1220s they still had not established the conditions that would become customary in those years, with the places granted to or built for the Friars Minor having adjacent living quarters—which later took the form and name of convents—and churches. The presence of a church with a permanent altar and open to public worship was a possibility that wasn't so common in the first establishments of the Friars Minor. The confirmation of this situation came two years later. Honorius III sent another letter of concession to the Friars Minor (Lateran, 3 December 1224, *Quia populares tumultus*), this time not mentioning the name of Francis. In the text, the pope recalls the fact that the friars "ea-

gerly seek separate places so that you can give yourself more freely to the sacred quiet of prayer" (*FAED* I, 562). To favour this condition, the friars had advanced the request for a spiritual concession that the pope promptly granted them: the possibility to celebrate Mass on portable altars ("[…] by authority of these present letters, we concede to you this privilege: that in your places and oratories you may celebrate solemn Masses with a portable altar, as well as the other divine offices, without prejudice to the rights of parochial churches" [*FAED* I, 562]). Thanks to this concession, in places where it was not possible to use a church with a permanent, consecrated altar, the friars could still celebrate the divine offices. This letter was located in the archive of the Sacro Convento at least since the beginning of the 18th century (Angeli 1704: II, 2), but it is no longer there. A document of the same tenor was issued by Gregory IX in the first months of his papacy and is the first letter by the pope, formerly cardinal protector of the Order, addressed to the Friars Minor. It is archived in Assisi (Lateran, 4 May 1227, *Quia populares tumultus* [*BF* I, 27]).
With the concession of 1222 in the *Devotionis vestre precibus* the Apostolic See had confirmed in practice what it had acknowledged starting with the letters to the prelates in 1219–20: the Friars Minor were a religious community that was to be numbered among the approved religious orders and thus could enjoy the same spiritual benefits as the others.
However, the regular life of the Friars Minor had not yet been determined in a definitive form, because there was a continuing sequence of new editions of the Rule at every Pentecost Chapter.

The Solet annuere
This papal letter is similar in form to the other two addressed to Francis, but it has been considered to all effects to be a relic since the early modern era. The reason for such veneration and attention is easily seen: with this letter from the Lateran, dated 29 November 1223, Pope Honorius III gave final confirmation of the Rule of the Friars Minor, inserting the full text of the Rule *ad verbum* in the formal frame of a chancery dictate typical of a concession, *litterae gratiae* (figs. 2, 3 and 4). The identification between the insert and the papal letter of confirmation is nearly total in the Medieval manuscript tradition: the Rule is never transmitted without the text of the papal confirmation bull (Esser and Oliger 1972: 100–01). In the editions, the title of *Regula bullata* was adopted to distinguish it from the previous one that had not received confirmation via papal bull.
After a punctilious and keen diplomatic analysis, Attilio Bartoli Langeli affirmed that "the *Solet annuere* of 29 November 1223 reveals two contrasting characteristics. On the one hand, the total simplicity of the formulary, which is adhering to the strictest and most standardized

Fig. 2. Honorius III, *Solet annuere* (Lateran, 29 November 1223). Assisi, Basilica di San Francesco, Reliquary Chapel.

Fig. 3. Honorius III, *Solet annuere* (Lateran, 29 November 1223), detail with registry annotation "R" (for "registered"). Assisi, Basilica di San Francesco, Reliquary Chapel.

Fig. 4. Honorius III, *Solet annuere* (Lateran, 29 novembre 1223), detail of the registry annotation. Assisi, Basilica di San Francesco, Reliquary Chapel.

Fig. 5. *Inventari (1597-1725)*: "Relics. […] The *Regula Prima*, written by father Saint Francis and confirmed by Pope Honorius the third" (1597). ASC, *Registri*, 24, f. 47r.

Reliquie.

Del Velo ~~di Santa~~ della Beata Agnese sorella di
Santa Chiara, et anco delli suoi Capelli.

Il Capo del Beato Rufino Compagno di san Fran.co
et della sua Tonica, et Cilicio.

Delli Ossi del Beato Egidio, et del Beato
Corrado Compagni di san Francesco.

Quatro Tauole, et molte Cassette piene di Reliquie
di Diversi Santi, et Sante.

La Prima Regola, qual fece il P.re san Fran.co
confirmata da Papa Honorio Terzo.

La Bibia, et il Messale, et il libro delli Euangelij
et delle Epistole, di san Ludouico Vescouo.

chancery practices. On the other, a noteworthy series of facts that were at least unusual [...]. All indications of troubled origins, of a procedure in many respects extraordinary, of a path that was anything but straight" (Bartoli Langeli 2012: 89–90).

For that matter it could not have been otherwise, because the characteristics of the document reflect the troubled genesis, the extraordinary procedure and the winding path from the *forma vitae* to the *Regula bullata*, which in turn reflected the transformation of the brotherhood into the Order of Friars Minor (Godet 2010; Merlo 2010).

The exhibition contains a reproduction on parchment, complete with lead seal and yellow and red silk cord, that was created for an upcoming publishing project of the Scrinium publishing house in Venice–Mestre.

The letter is not listed in the 14th and 15th century inventories of the sacristy, whereas among the relics is mentioned the *chartula* of Assisi, written by friar Francis himself, who expresses praise to the Highest God (*Laudes Dei altissimi*) on the flesh side of the parchment, while the hair side bears a blessing to friar Leo (*Benedictio fratri Leoni data*) (Alessandri and Pennacchi 1914: 78, 91, 295, 313).

In the modern age, perhaps following a reorganization of the archive, the *Solet annuere* was placed among the relics presented for veneration to the faithful. Initially, the original had been kept in a reliquary-box; the first mention of it is in an inventory of 1597: "Four tablets and many boxes full of relics of different saints, men and women. [...] The *Regula Prima*, written by father Saint Francis and confirmed by Pope Honorius the third" (ASC, *Registri*, 24, f. 47r; fig. 5). The box is described in greater detail in 1600: "A square box made of paperboard covered with red velvet with Jesus in pearls and containing the papal seal of Pope Honorius for the Rule written by father Saint Francis" (ASC, *Registri*, 38, f. 8v [6v]). Later, following the munificent donation by the nephew of Urban VIII (1623–44), cardinal Francesco Barberini, the letter was placed in a reliquary-monstrance. In an inventory of 1639 the new placement of the *Regula* to allow its display is recorded for the first time: "Silver tabernacle. [...] A tabernacle or ornament with a wooden bottom where our original Rule is kept, from the most eminent cardinal Barberino" (ASC, *Registri*, 44, f. 73r; fig. 6). In a 17th-century wall notice calling for worship of the rich collection of relics in the church of Saint Francis in Assisi (fig. 7), the image of the reliquary containing the papal letter/*Regula* is in the centre of the first row of relics and is marked with the number 7 (fig. 8). It is much more important and prominently placed than the *chartula* of Assisi, which is given the number 63 (fig. 9). The caption is as follows: "Quadrum grande ex argento, in quo conservatur Originale Regulae FF. Minorum Divina inspiratione a S. Patre formatae, et a B. Leone Confessario eiusdem et

Socio conscriptae, et a Papa Honorio III confirmatae, quod ipsius Regulae Originale cum plumbo pontificio, ipse S. Pater magna reverentia et devotione ad pectus gestaverat" (Kleinschmidt 1928: 263–66) (A silver frame in which is kept the original Rule of the Friars Minor formed by the Holy Father and written by blessed Leo, his confessor and associate, and confirmed by Pope Honorius III; the same Holy Father used to bring to his chest the original of the same Rule with lead papal seal, with reverence and devotion).

The chronicler father Pietro Ridolfi da Tossignano records the letter in the convent of Saint Francis in Assisi, perhaps a few years before it was transformed into a relic and

preserved as such (Ridolfi da Tossignano 1586: I).

In the first edition of the *Opuscula* of Francis of Assisi, Lukas Wadding records having been in Assisi in 1619. As regards the Assisi *chartula* he writes: "Qui omnes observant, benedictionem hanc ipsius sancti viri manuscriptam reverenter at fideliter adhuc custodiri; quam ego anno 1619 in Conventu Assisiensi, ipsi sancto Patri Sacro, in sacrario inter ceteras vidi Reliquias" (Wadding 1623: 492) (All can see this blessing written by the hand of the holy man kept with reverence and faith; I saw it in the Sacro Convento, in the church with the other relics).

In another document (Wadding 1623: 169), the scholar states that he saw the letter of confirmation with the papal

RABILIS DEUS IN SANCTIS SVIS

Fig. 7. Broadsheet with the venerated relics of the church of San Francesco in Assisi (17th century print).
Assisi, Basilica di San Francesco, Museo del Tesoro.

Fig. 8. Broadsheet with the venerated relics of the church of San Francesco in Assisi: detail of reliquary no. 7 with the sealed Rule (17th century print).
Assisi, Basilica di San Francesco, Museo del Tesoro.

Fig. 9. Broadsheet with the venerated relics of the church of San Francesco in Assisi: detail of reliquary no. 63 with Francis blessing Frair Leone (17th century print).
Assisi, Basilica di San Francesco, Museo del Tesoro.

seal in the convent of Saint Francis in Assisi and adds: "[…] imo quod et magis animum recreavit, in Sacrario praeter ceteras egregias, que ibidem servantur, Reliquias, vidi hanc ipsam Regulam" (nay—something which uplifts even more the soul—I saw this same Rule in the church in front of the other relics kept there). This dual reference to papal bull/Rule and to convent/church led scholars to imagine two different objects and different placements (Bartoli Langeli 2012: 57–58, 91–92). The issue is further complicated by Wadding's statement regarding the Rule he saw which—in his opinion—was "ipsius Francisci manu exaratam" (written by the hand of Francis himself).

Do we have a new and unknown document written by Francis to add to the *chartula* of Assisi and the letter to Leo kept in Spoleto? It is very probable that Wadding claims that the Rule was written in Francis's hand to strengthen its Franciscan authorship, as he was at pains to demonstrate in the first part of his introduction, also on the authority of the *Legend maior* of Bonaventura da Bagnoregio, although no authorship claims were made ("he dictated everything" [*LegM* IV, 11: *FAED* II, 558]). However, the question of a possible new document written by Francis himself cannot be neglected.

In the first volume of his monumental *Bullarium Franciscanum* of 1759, Giovanni Giacinto Sbaraglia published the papal letter. After the brief regest he lists the evidence, handwritten and printed, but it is not clear which of them he consulted for his publication. It is certain that he visited the archive of the Sacro Convento in Assisi, but he must have seen the papal letter among the other relics in the church of Saint Francis, in the reliquary-monstrance, in spite of the fact that in the tablet of the tradition he writes "ex […] Archivo S. Francisci Assisiens. & c., & inde apud Auctorem Collis Paradisi lib. 2. P. 3." (*BF* I, 15) (from the archive of Saint Francis in Assisi and thence to the author of *Collis Paradisi*). But in listing the most extraordinary relics in the church in the first part of this work,

Francesco Maria Angeli includes the papal letter confirming the Rule (*diploma*), which is kept unfolded and protected under glass (*extensum*) in the large reliquary donated by the cardinal, and is thus easy to read in its entirety (*unde facile legi potest*). The learned religious man knew well the characteristics of the papal documents from having consulted and transcribed them in the convent archive and published them in the second book of his work. He thus affirms confidently that the document-relic is a papal letter that exhibits the characteristics of a product of a chancery and certainly not a handwritten document by Leo (Angeli 1704: I, 52).

The precious silver reliquary did not manage to survive the Napoleonic upheavals unscathed. Afterwards, the letter was placed in another reliquary and sealed. This seems to be the most likely hypothesis, because when Padri Editori of Quaracchi obtained permission from the Apostolic See in 1895 to break the seals of the reliquary in which the papal letter was kept, the letter was found folded, thus making it impossible to read the entire text (chapters VII–XII were completely invisible) (*Seraphicae legislationis* 1897: 4).

The "rediscovery" of the *Solet annuere* and its full publication based on the original, thanks to the permission granted to the Padri Editori, made a critical and trustworthy text available to historians precisely at the beginning of the "Franciscan question." It took time for scholars to realize that the text of the Rule as we have it from the papal letter and from the manuscript tradition is an insert in a papal document that demands specific attention of a diplomatic and archival nature.

In the first years and decades of the history of the Order of Friars Minor, the archive of the Sacro Convento functioned as a general archive for the Order, including not only documentation regarding the Sacro Convento and the church of Saint Francis in Assisi, but everything of general interest to the Order, and first and foremost, the papal letters.

Entry 1
Honorius III, *Cum secundum consilium*

Orvieto, September 22, 1220
ASC, *Bollario*, I/1
parchment, 295 × 325 mm, original.
The red and gold silk cord noted in 1915 has since been lost and the seal is conserved in a leather bag.
Critical editions: BF I, 6, no. 5.
Regests: Eubel 1908: 601, no. 1; Alessandri and Pennacchi 1915: 594, no. 1; Nessi 1991: 5, no. 1.
English translation: FAED I, 560–61.

Addressing brother Francis "and the other priors or custodians" of the Friars Minor, Pope Honorius III institutes a mandatory year of postulancy before a novice can be professed in the Order, forbids the professed from leaving the Order and anyone outside the Order from wearing the habit of the Minors, and reaffirms that friars must comply with the condition of poverty.

TEXT

Honorius episcopus servus servorum Dei. Dilectis filiis fratri Francisco et aliis prioribus seu custodibus minorum fratrum. Salutem et apostolicam benedictionem.

Cum secundum consilium sapientis nichil sit sine consilio faciendum ne post factum penitudo sequatur, expedit cuilibet excelsioris vie propositum aggressuro ut precedant palpebre gressus suos, vires videlicet proprias discretionis moderamine metiendo, ne, si quod absit, altiora se querens in commotionem dederit pedem suum, retro respiciat in salis infatuati statuam convertendus pro eo quod si sacrificium quod Domino fuerat oblaturus sale Sapientie non condivit; sicut enim sapiens desipit, si non fervet, sic fervens confunditur si non sapit.

Quare pene in omni religionis est ordine provide institutum ut regulares observantias suscepturi certo tempore ipsas probent et probentur in eis, ne sit locus de cetero penitudini quam non potest levitatis occasio excusare.

Auctoritate itaque vobis presentium inhibemus ne aliquem ad professionem vestri ordinis nisi per annum in probatione fuerit admittatis. Post factam vero professionem nullus fratrum ordinem vestrum relinquere audeat nec relinquentem alicui sit licitum retinere.

Inhibemus etiam ne sub habitu vite vestre liceat aliqui extra obedientiam evagari et paupertatis vestre corrumpere puritatem; quod siqui forte presumpserint liceat vobis in fratres ipsos donec resipuerint censuram ecclesiasticam exercere.

Nulli ergo omnino hominum liceat hanc paginam nostre inhibitionis et concessionis infringere vel ei ausu temerario contraire. Siquis autem hoc attemptare presumpserit indignationem Omnipotentis Dei et beatorum Petri et Pauli apostolorum eius se noverit incursurum.
Datum apud Urbemveterem, X kalendas octubris, pontificatus nostri anno quinto.

TRANSLATION

Honorius, Bishop, servant of the servants of God, to our beloved sons, friar Francis and the other priors or custodians of the Friars Minor: greetings and apostolic blessing.

The Wise One tells us that the clever do all things intelligently, lest they come to regret it later on. So it is important that anyone proposing to undertake a higher way of life look before he leaps, that is, take prudent stock of his own [inner] resources. Otherwise—which God forbid—he might aspire to things that are beyond his strength and his steps waver and turn back, only to be turned into a pillar of salt, because he did not know how to season the sacrifice which he intended to offer to the Lord—his very self—with the salt of wisdom. For just as a prudent man becomes stale should he lack enthusiasm, so the enthusiastic man will be covered with confusion if he is not prudent.

For this reason practically every religious order has wisely ordained that those who propose to undertake a life of regular observance should first test it and be tested in it for a certain length of time so that they will not later have reason to regret their decision, which cannot be excused under pretext of levity.

Therefore, by authority of these present letters, we forbid you to admit to profession in your Order anyone who has not first completed a year of probation. And once he has made profession, let no brother dare to leave your Order. It is also forbidden for anyone to receive [into another religious community] any brother who has left your Order.

We further forbid anyone to wander about clad in the habit of your Order outside obedience, corrupting the purity of your poverty. If anyone should presume to do this, it is lawful for you to bring ecclesiastical censure upon such a brother until he has come to his senses.

No one, therefore, is in any way permitted to tamper with this decree of our prohibition and concession or rashly dare to oppose it. If anyone shall have presumed to attempt this, let him know that he will incur the wrath of Almighty God and of his holy Apostles Peter and Paul.

Issued at Viterbo, the twenty-second day of September, in the fifth year of our pontificate.

This is the first document from a pope addressed to friar Francis (*fratri Francisco*), whose name is followed by *et aliis prioribus seu custodibus Minorum fratrum*. These words illustrate the uncertainty of the papal chancery, which does not yet know how to best define the addressees. The letter is addressed, first of all, to whoever exercises authority in the Order "and to the other priors or custodians of the Friars Minor" (Rusconi 1994, 91). The term *prior* was customary in the hierarchy of regular orders, the last being the Order of Preachers , but it was never used by the Friars Minor who adopted, instead, the term *minister* (meaning "servant"), and established their hierarchy made up of a general Order (minister-general), provinces (provincial ministers), custodianships (custodians), and *loci* or monasteries (guardians) (Rusconi 1982, 27–28, table 3.2).

With this letter, the process that made the Minorite movement a regular and regulated institution was given a decisive push forward. The letter, in fact, imposes several cardinal rules of regular religious life on the friars: first, the mandatory trial year, or novitiate, during which adequate instruction in the observance of religious life would be provided to aspiring friars. Alongside this, practicing itinerancy was prohibited unless ordered by one's superiors (*extra obedientiam evagari*).

These two innovations bore fruit at the end of 1223 when Pope Honorius confirmed the Rule of the Order. It was during the years from 1219 to 1223 that the Order shifted from the guidance of Francis and his first companions to government by a group of *litterati* – priests and masters of theology and law – who were more tied to the monastic and canonical tradition and were concerned with establishing the extraordinary success of the new Order on solid and proven organizational foundations (Merlo 2003, 39–41). (*Daniele Sini*)

Entry 2
Honorius III, *Devotionis vestre precibus*

Anagni, March 31, 1222
ASC, *Bollario*, I/2
parchment, 200 × 260 mm, original.
Seal with silk cord detached from the bulla and heavily oxidized
Critical editions: BF I, 9 (from another original, taken from the Vatican Registers, dated 29 March).
Regests: Eubel 1908: 602; Alessandri and Pennacchi 1915: 594, no. 2; Nessi 1991: 5, no. 2.

Pope Honorius III grants Francis and the other friars "of the Minor Order," upon their request, the right to celebrate the divine offices in the event of an interdict, as long as certain behaviors are observed.

TEXT

Honorius episcopus servos servorum Dei. Dilectis filiis Francisco et aliis fratribus minoris Ordinis. Salutem et apostolicam benedictionem.

Devotionis vestre precibus inclinati, auctoritate vobis presentium indulgemus ut in ecclesiis, si quas vos habere contigerit, cum generale terre fuerit interdictum, liceat vobis clausis ianuis, excommunicatis et interdictis exclusis, submissa voce, divina officia celebrare.

Nulli ergo omnino hominum liceat hanc paginam nostre indulgentie infringere vel ei ausu temerario contraire. Si quis autem hoc attemptare presumpserit indignationem omnipotentis Dei et beatorum Petri et Pauli apostolorum eius se noverit incursurum.
Datum Anagnie, II kalendas aprilis, pontificatus nostri anno sexto.

TRANSLATION

Honorius, Bishop, servant of the servants of God, to our beloved sons, Francis and the other friars of the Minor Order: greetings and apostolic blessing.
In favorable response to your devout prayers, with the authority of this letter we grant that you, in the churches that you may hold, in the event of an interdict against that territory, are permitted, excluding the excommunicated and interdicted, to exercise the divine offices behind closed doors, and in low voices.
No one, therefore, is in any way permitted to violate this letter of indulgence or rashly dare to oppose it. If anyone shall presume to attempt this, let him know that he will incur the wrath of Almighty God and of his holy Apostles Peter and Paul.
Issued at Anagni, the thirty-first day of March, in the sixth year of our pontificate.

Although it is formally a general "letter of indulgence" that all of the churches belonging to the Order of Minors could avail themselves of, this papal provision seems to have resulted from a local matter specific to Assisi. The interdict that the letter refers to would have been issued, in fact, by the Bishop of Assisi (Fortini 1959: II, 212 and 510). With respect to this provision, then, the Friars Minor must have asked for, and obtained by turning directly to the pontiff, permission to celebrate the divine offices—exactly the opposite of what the interdict entailed.
Beyond the situation alluded to, the pope's letter also shows that while Francis was alive there was already some ambiguity in the new order's attitudes: on the one hand,

the role as "minors," or the lowest-ranked of the Church, desired by the order's founder; on the other, strong dynamism and a certain intolerance of the limitations imposed by bishops and by the traditional structure of caring for souls.
In a few decades' time the Minors would not only obtain emancipation from the control of bishops, but would also, beginning in 1250 in Assisi, come to occupy bishops' seats in various cities (Rigon 1997: 275–76; D'Acunto 2002: 103–45) until they would reach the papal throne with Girolamo d'Ascoli, elected pope in 1288 with the name Nicholas IV.
(Daniele Sini)

H[onorius] eps seruus seruor dei. Dilectis filiis Francisco et aliis fribus ordinis minorum. Sal et aplicam ben. Deuotionis ue're precibus inclinati auctoritate uobis presentium indulgemus ut in ecclis siquas uos habere contigerit cum generale terre fuerit interdictum liceat uobis clausis ianuis excoicatis et interdictis exclusis. Non pulsatis campanis submissa uoce diuina officia celebrare. Nulli ergo omnino hominum liceat hanc paginam nre indulgentie infringere ul ei ausu temerario contraire. Siquis aut hoc attemptare presumpserit indignatione oipotentis dei et beator petri et pauli aplor eius se nouerit incursur. Dat Anagnie. y. kl. Aprilis. pontificat nri. Anno. Sexto.

Gregory IX and the Church of Saint Francis in Assisi

Pasquale Magro

The first archival evidence related to the erection of the main temple dedicated to Saint Francis of Assisi (1182–1226) is dated March 30, 1228. The notary's document records the donation by Simone di Puzarello of a plot of land in the *Collis Inferni* area to the West of the city of Assisi. The donor indicates the beneficiary and precise the purpose of the land: "Fratri Helie recipienti pro Papa Gregorio IX" for the erection of an "oratorium vel ecclesiam pro beatissimo corpore sancti Francisci" (see entry no. 3 in this catalogue). The first General Chapter after the founder's passing (1227 Pentecost) spurred the construction, and, according to Vasari (Vasari 1966: II, 51) even suggested the *T*-shaped design to signal, in the stone itself, the building's cultural and redeeming purpose. During his life, Francis "favored the sign of the Tau over all others. With it alone he signed letters he sent, and painted it on the walls of cells everywhere" (3C 2: *FAED* II, 402).

Recolentes qualiter

A month after the deed of the donation of the land, on April 29, Gregory IX issued the letter *Recolentes qualiter* (see entry no. 4 in this catalogue) justifying and urging the creation of a burial temple: "It seems to us both fitting and opportune that for the veneration of the same Father, a special church (*specialis ecclesia*) should be built in order to hold his body." The letter is addressed to the entire Christian world: "Universis Christifidelibus." The pope asks for collaboration from everyone, authorities and the populace, in wanting to appropriately and adequately commemorate Francis and his work, of which the entire Church benefitted: "We recall how the sacred plantation of the Order of the Friars Minor began and grew marvelously under blessed Francis of holy memory, through the favor of Christ spreading far and wide the flowers and perfumes of a holy way of life, so that in the desert of this world the beauty of holy religion seems to come from the aforesaid Order. Thus it seems to us both fitting and opportune that for the veneration of the same Father, a special church should be built in order to hold his body"

(*FAED* 1:564–65). The letter also clearly reveals the votive significance of the missive itself and of the cultural construction project that would stem from it. As was the practice of the time, in soliciting assistance, financial and otherwise, for creating the burial shrine, the pope did not fail to reciprocate that aid with the spiritual benefit of indulgences.

The next day, April 30, with the letter *Recolentes qualiter* II, the pope defined the legal position of the property: "The land, which through piety has been offered to us for the construction of the church and other buildings where the body of the aforesaid father should be placed, we receive by the law and as the property of the Apostolic See" (*BF* I, 46). Such legal provision is not to be understood solely as defense of the Rule of the Friars Minor and of the Testament of Francis of Assisi which do not allow the friars to own property anywhere: "Let the brothers not make anything their own, neither house, nor place, nor anything at all" (LR VI: *FAED* I, 103; cfr. Test 24: *FAED* I, 126).

It is no coincidence that the figure of the apostolic procurator was established to act on behalf of the Friars Minor with respect to donors and testators or when entering into transactions and contractual stipulations for the acquisition of land and houses. The apostolic procurator handled the friars' interests on behalf of the pontiff, who held the rights to the assets the brothers used. The office was long held by Piccardo, Francis's nephew and later, in all likelihood, a Friar Minor himself (see entry no. 6 in this catalogue).

Another letter from Gregory—the *Mirificans* from May 16, 1230, which authorizes the transfer of the saint's body from the temporary tomb in San Giorgio to the new and final one—reveals, in fact, additional reasons for devotion and personal gratitude toward the saint. Deviating from the sober diplomatic tones normally required for a missive with legal intent, Gregory, speaking confidentially to the brothers about his spiritual relationship with the saint, states that "[...] Beatum Franciscum Patrem nostrum ac vestrum, forte autem plus nostrum quam

On page 48
Gregory IX,
Recolentes qualiter
(Rieti, 29 April
1228), detail of the
bulla plumbea with
the name "Gregorius
papa VIIII."
ASC, *Bollario*, I/7.

vestrum" ([…] blessed Francis is our Father and yours, or rather, more ours than yours; *BF* I, 64).

At this point it should be noted that the three aforementioned documents reflect intentions to celebrate the saint, who had not yet been officially canonized. We learn from Thomas of Celano's *Vita beati Francisci*, written under commission from Pope Gregory at the same time of the saint's canonization, that it took place at the first tomb in San Giorgio on July 16, 1228, and was celebrated by the pope himself (1C 123–26: *FAED* I, 293–97). From the letter *Speravimus hactenus* from June 16, 1230, we also learn that it was the pope who blessed and placed the foundation stone of the new and final tomb on the day following

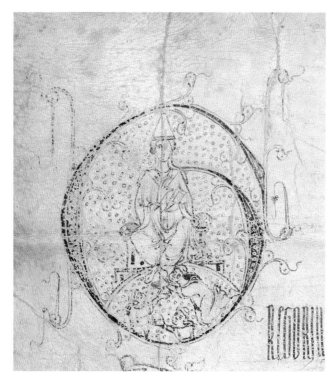

the canonization ("[…] de manibus nostris lapide ibi primario posito." *BF* I, 66). The canonization letter, *Mira circa nos*, was issued from Perugia on July 19 (*BF* I, 42). It should always be remembered that the pope's spiritual familiarity with the saint also inspired him with hymns or canticles for liturgical use such as *Proles de caelo prodiit*, *De paupertatis horreo*, and others. In the desire to glorify "his" saint, Pope Gregory personally combined the forms of geometric harmony found in the stone of Romanesque-Gothic architecture and possibly inspired by Friar Elias, with those of the Latin poetic melody of liturgy (*IOff: Fontes* 1106–7, 1113–15). Dated 1239, the largest bell in the church's tower is engraved with the names of both the pope who commissioned the sanctuary and his brilliant executor ("Papae Gregorii tempore noni […] fratris studio sed Helie." Fratini 1882, 47). We should consider the "signature" of the two protagonists as regarding not only the bell; the church was nearing completion by then, and within twelve years, Innocent IV, hosted along with the Court in the adjoining *Domus Gregoriana* (April–October

1253), would consecrate it to God in Francis's memory ("Nos ipsi ad honorem Dei, et Confessoris eiusdem duximus dedicandam." *BF* 1:662).

Is qui ecclesiam suam

Victricius of Rouen (†427) wrote that "the man of God dies, but he remains standing in the hearts of believers." Sofia Boesch Gajano interprets the significance for the people of God of a holy body as follows: "The body is the physical reality in which the spiritual journey is inscribed […]. The body of a living saint is already a holy body. And every saint continues to live in his dead body. The saint's tomb is the privileged place of the encounter between the divine and the human" (Boesch Gajano 1999: 20).

With the aforementioned letter *Mirificans* from May 16, 1230, Pope Gregory authorized the transfer of Saint Francis's body from the church of San Giorgio to the new church. But already on the eve of the event, in view of the impending arrival of the remains of the saint in the *cella memoriae* under the altar of the Lower Church, Pope Gregory, with the letter *Is qui ecclesiam suam* from April 22, 1230, addressed to the Minister and those brothers dwelling by then "in loco qui dicitur Paradisi," promoted the sanctuary to "caput et mater" of the Order (see entry 5 in this catalogue).

The letter's formal solemnity is immediately evident from the committed drafting of the text by the amanuensis of the papal chancery. In addition to the twelve well-decorated capital letters in the text, he drew an exceptional complete profile of Gregory IX sitting on a globe with three friars in the letter "G" of his name in the incipit (fig. 1). Among the papal letters kept in the Sacro Convento archive, this is the first document on parchment with a black-and-white illumination that also depicts Franciscan friars.

A month before the saint was transferred from the church of San Giorgio to his final tomb—as authorized by the *Mirificans*—Gregory addressed the letter to the community of friars who were custodians of the sanctuary.

With the *Is qui ecclesiam suam* the pontiff founder continued to better explain, and even to further consolidate, the legal, spiritual, and pastoral profile of the nascent sanctuary and of its pastoral potential. He does so keeping in mind, first of all, the property itself, belonging solely and exclusively to the Apostolic See as already established in the deed of the donation and as reaffirmed in the two *Recolentes qualiter* letters.

The pope, who collaborated with Francis in drafting and approving the Rule of the Order, insists again on keeping the property for the papacy out of respect for the will of the saint, who prohibited his brothers from dwelling in places they owned.

The pope continues then, reminding the friars of the devotion and gratitude that moved him to have the burial temple built: "[Francis] velut fidelis servus et prudens

Scogliera

Scogliera

LE TRE SOPRAPOSTE CHIESE PAPALI DI S. FRANCESCO IN ASISI

Fig. 3. Assisi, Basilica di San Francesco,
view of the complex.

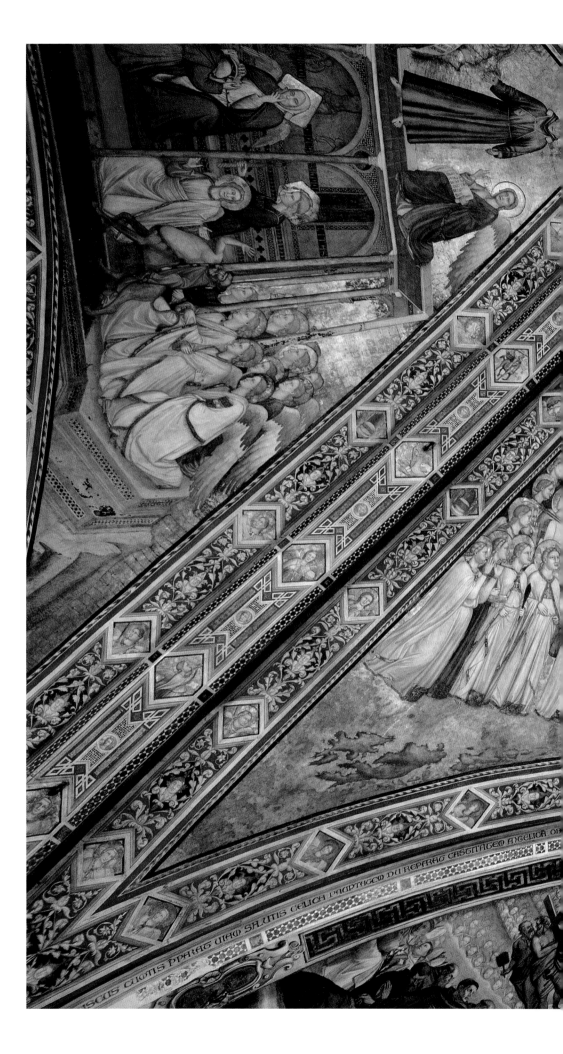

Fig. 4. Giotto, *Saint Francis in Glory*
(fresco, ca. 1315).
Assisi, Basilica di San Francesco,
Lower Church, vault of the presbytery.

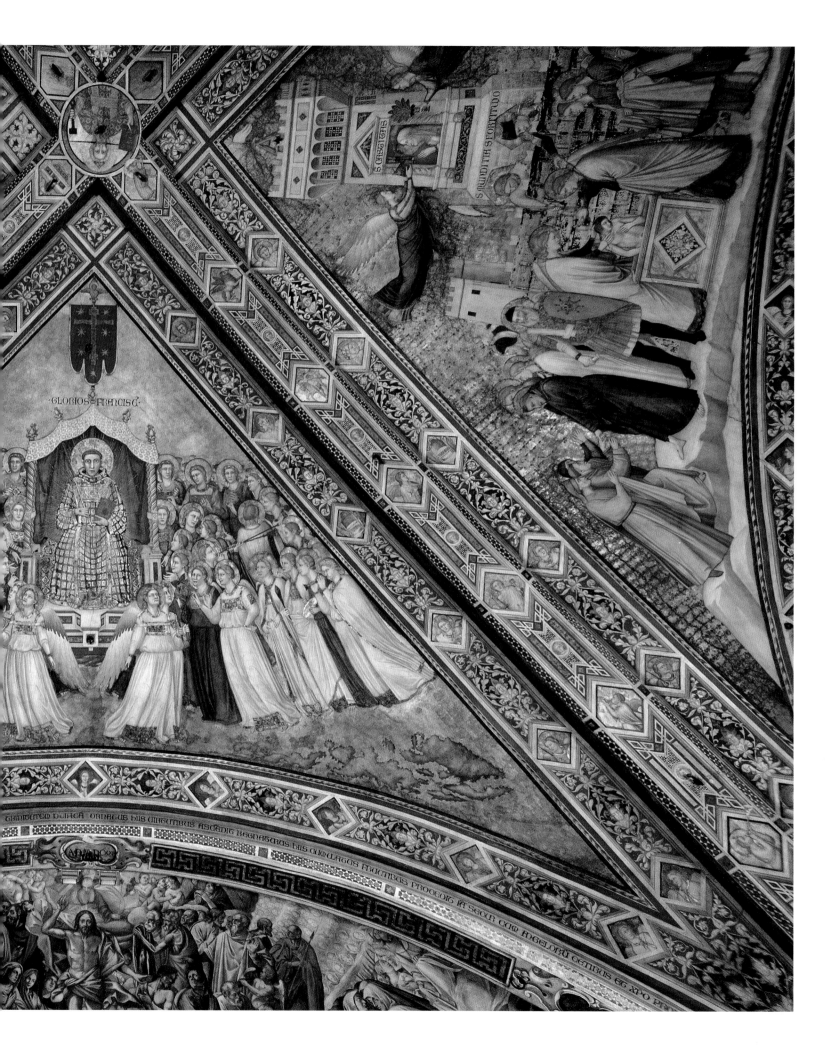

Fig. 5. Assisi, Basilica di San Francesco, Tomb of the Saint.

laudabiliter operatus in talentis et creditis fructum in Ecclesia Dei attulit copiosum. Ab ipso enim Ordinis Vestri sancta plantatio, cooperante divina gratia, processum habuit et progressum: quae palmites honestatis longe lateque producens flores protulit, et odores effudit ad resecanda nociva, et salubria inserenda" ([Francis], as a faithful and commendably wise servant, committed to the talents entrusted to him, brought abundant fruit to the Church of God. It was precisely from him, in fact, divine grace cooperating, that the holy plant of your Order began and flourished and, extending its vines of honesty far and wide, produced flowers and spread perfumes in order to prune harmful things and implant healthy ones). Seeing the life and apostolic work of the Order to which pastoral and sacramental care is entrusted as the leaven that makes the whole mass of the church rise, and desiring it to be perceived as such, the pope—with an eye on the primary Lateran throne—honors the new temple with the programmatic and compelling title of *caput et mater* of the Order itself. In establishing the hermeneutical framework for the exemption from diocesan jurisdiction communicated in this letter, we must not forget the dream-vision of the patriarch himself: "I saw a great multitude of people coming to us […]. The sound of them is still in my ears, their coming and going […]. I seemed to see highways filled with this multitude gathering in this region from nearly every nation. Frenchmen are coming. Spaniards are hurrying, Germans and Englishmen are running, and a huge crowd speaking other languages is rapidly approaching" (1C 27: *FAED* I, 206). The privileged legal and pastoral-sacramental profile that emerges from the *Is qui ecclesiam suam*, which is outlined with a view in mind of the universal Church united with the Order of the Friars Minor, already spread throughout Europe and the Near East for the past decade, reveals the continuity between the saint and the Gregorian sanctuary. The so-called "privilege" of the pastoral and liturgical *exemptio* from the diocesan bishop, as well as that of the relative territorial *immunitas* of the basilica complex, weren't meant to isolate the sacred place as an enclave, but to make it more functional for universal service. These privileges weren't meant to restrict the Order's pastoral work, but rather—with its own legal and spiritual statute, and with practical wisdom, blessed with foresight and providence—widen it to the stature and measure of the sanctuary dedicated to the saint.

A first difficult moment for the basilica's dignity arrived a few weeks later, precisely on the day of the transfer and burial of the saint's body (May 25, 1230), which was presided over by papal legates and directed by Friar Elias with local authorities. Accused of impropriety and violence in removing the coffin from the procession and the crowd in order to bury it in the shortest time possible behind closed doors, they were denounced to the pope. Giving credit to the charges (*Speravimus hactenus*, June 16, 1230; *BF* I, 66–67), the pope threatened the city and the church of Saint Francis with excommunication and interdict if he was not given the reason for the incident within fifteen days. Friar Elias and the Assisi civil authorities justified the events convincingly and so the threats in the pope's letters were not applied and the regulatory provisions for the sanctuary's exemption and freedom remained unchanged. In 1235, because of the great multitude of people attending, Pope Gregory would preside in person over the liturgical feast day for Saint Francis in the square (Thomas of Eccleston 1885: 252). The episode laid the foundation so that the space in front of the church began to be considered an extension of the sanctuary; in 1246, the City of Assisi officially defined the site's perimeter.

The universal dimension that the sanctuary acquired only thirty years later is attested to by Federico Visconti, Bishop of Pisa, who lists the sanctuary as the fourth most important site after Jerusalem, Rome, and Santiago de Compostela (Bihl 1908, 653). It was soon granted to the custodian of the sanctuary the power to "appoint suitable brothers to hear the confessions of the foreigners who, hastening to the Holy Father's feast day from distant lands, did not have priests from their own nation, and even absolve them of every sin, in those cases not reserved to the Apostolic See" (Fratini 1882: 67).

In its beauty as a canticle in stone, the church had to continue to tell the pilgrim about the radiant spirit of the saint and about his work renewing the Church in the sign of the Word crucified. In the early 1300s, at the height of the decoration works of the architectural triptych, Ubertino da Casale would recall that "due to the undoubted devotion he had to his holy father, the blessed Francis, he [Friar Giles] supported the idea of building a noteworthy church over the spot where the Saint's body lay, if only to impress upon people insensitive to the spiritual how eminently holy he was" (TL V, 3: *FAED* III, 184).

Because of the novelty of his thought and religious practice, Francis appeared to his contemporaries, to authorities, and to the populace to be "a new person of another age" (1C 82: *FAED* 1, 251), "in these last times, a new Evangelist" (1C 89: *FAED* 1, 259). Even though he loved to call himself "ignorant and stupid" (LtOrd 38: *FAED* 1, 119), he led people to reconsider the traditional axiological system of Christian and human civilization. And it was then thanks to the faithful transmission of this new experience through preaching and through the art and literature of the *dolce stil novo* that Francis's experience became "one of those events that […] overturn the normal course of history" (Vauchez 1993: 141). In the mid-1400s, in the Minorite church of Montefalco, Benozzo Gozzoli would set the central, titular figure of the saint alongside those of Giotto, Petrarch, and Dante Alighieri. "With him came a whole awakening of the world and a dawn in which all shapes and colors could be seen anew" (Chesterton 1944: 188).

The vast walls of the Gregorian basilica would be the arena where the masters of color would coin the new language of Western art, inspired by the vision Francis, the singer of the Incarnation, had of life. Bridging the space between heaven and earth, Francis exorcised the human and the earthly from the Gnostic Catharist demon, promoting them to the *habitat* of God. "The period between 1260 and 1300 witnessed a great blossoming of painting in Italy, which developed especially following the extraordinary impulse of the construction site of the Basilica of Saint Francis of Assisi" (Châtelet 1998: 501–2). In the pictorial scene that enfolds the *dramatis personae*, a three-dimensional organization of space took place, and the depiction of the human figure in its profile and gestures acquired an entirely new vitality. Assisi would be the "'Orient' of Italian painting" (Salmi 1954: 296).

We might dare to think that Gregory would today be not a little surprised by and incredulous of the vast benefit that he, with his *Recolentes qualiter* and *Is qui ecclesiam suam*, brought to Christian and human civilization.

Entry 3
Donation

Assisi, in the donor's home, March 30, 1228
ASC, *Istrumenti*, II/1
parchment, 220 × 112 mm, original.
Critical editions: Lempp 1901: 170–71, no. 1 (with preceding bibliography); Kleinschmidt 1928: 3; Bartoli Langeli 1997: 10–11.
Regests: Zaccaria 1963: 78, no. 4; Nessi 1991: 55, no. 7.

Simone di Puzarello donates, inter vivos and waiving the right to patronage to Friar Elias, who receives the gift on behalf of Pope Gregory IX, a piece of land located in the countryside of Assisi, in the area called Colle Inferno, so that a locus, oratory, or church for the most blessed body of Saint Francis be built there, for the friars' use.

TEXT

(SC) In Dei nomine, amen. Millesimo CCXXVIII, indictione prima, III kalendas aprelis, Gregorio papa VIIII et Frederico imperatore existentibus.

Dedit, tradidit, cessit, delegavit et donavit simpliciter et inrevocabiliter inter vivos Simon Puçarelli fratri Helye, recipienti pro domino Gregorio papa nono, petiam unam terre positam in vocabulo Collis Inferni, in comitatu Assisii, cui I et II via, III ecclesie Sancte Agathe, IIII filiorum Bonomi vel si qui alii sunt confines;

cum introitu et exitu suo, et cum omnibus que supra se et infra se habet in integrum, et cum omni iure et actione, usu seu requisitione sibi de ipsa re competenti; ad habendum, tenendum, possidendum, faciendum omnes utilitates et usus fratrum in ea, videlicet locum, oratorium vel ecclesiam pro beatissimo corpore sancti Francisci, vel quicquid ei de ipsa re placuerit in perpetuum.

Quam rem se suo nomine constituit possidere donec corporaliter intraverit possessionem, in quam intrandi licentiam sua auctoritate concessit.
Promictens non dedisse ius vel actionem de ea alicui, quod si apparuerit eum dedisse promisit defendere suis pignoribus et expensis.

Renunctiando iuri patronatus omnique auxilio legum ipsi competenti vel competituro.
Et promisit per se et suos heredes dicto fratri Helye, recipienti pro domino papa nono Gregorio, contra non facere vel fecisse, sed defendere dictam rem ab omni litigante persona omni tempore suis pignoribus et expensis in curia vel extra, sub pena dupli ipsius rei, habita compensatione meliorationis et extimationis; qua soluta vel non, hoc totum semper sit firmum.

Factum in domo dicti Symonis, presentibus et vocatis testibus domino Guidone iudice comunis Assisii, Petro Tedaldi, Someo Gregorii, Petro Capitanie, Tiberio Petri, Andrea Agrestoli, Iacobo Bartoli.

(SN) Ego Paulus notarius rogatus his interfui et scripsi et auctenticavi.

TRANSLATION

[SIGN OF THE CROSS] In the name of God, amen. In the year 1228, first indiction, the thirtieth day of March, Pope Gregory IX and Emperor Frederick [II] reigning.

Simone di Puzarello gives, alienates, cedes, assigns, and donates while still living, without exceptions and irrevocably, to Friar Elias, who receives it on behalf of Pope Gregory IX, a piece of land in the area called the Colle Inferno, in the Assisi countryside, along the boundaries of which are: on two sides, the road; on the third, land belonging to the church of Sant'Agata; on the fourth, the land of Bonomo's sons (or other boundaries, if there are any);

with the right of way [access and exit], and with all that is present on it or within it, in its entirety and with every right and authority, use, or concern he derives from that property; so that he has, holds, and possesses it and makes everything in said land of use to the friars, namely a *locus*, oratory, or church for the most blessed body of Saint Francis, or whatever it may please him to do with that land, in perpetuity.

He is possessor of that land in his name until he takes material possession of it, and is granted license to enter it at will.

He declares to have never ceded the right to or authority over that property to anyone; should that have ever happened, he promises to defend it [in court] at his own expense and guarantee.

He waives the right to patronage and to any assistance in law that is due or will be due to that property.

He promises, on his behalf and on behalf of his heirs, the aforesaid Friar Elias, who receives [the land] on behalf of Pope Gregory IX, to not contravene or be contravened [in what is promised], but to defend said property from every litigant, at any time, at his own expense and guarantee, in court and outside it, under the penalty of double the value of said property, complete with compensation for any improvements or appraisal. Whether such a penalty is paid or not, all this remains forever valid.

Done in the house of said Simone, [the following] present and convened as witnesses: Guido, judge of the City of Assisi; Pietro of Tedaldo; Someo of Gregorio; Pietro of Capitania; Tiberio of Pietro; Andrea of Agrestolio Iacopo of Bartolo.

[NOTARY'S MARK] I, Notary Paolo, was present upon request and I wrote and authenticated these things.

In Dei Nomine Amen. Anno millesimo ducentesimo vigesimo octa-
vo. Indictione prima. quarto Kalendas Aprilis. Gregorio Papa Nono,
& Frederico Imperatore existentibus. dedit tradidit, cessit, delegavit, & do-
navit Simpliciter & irrevocabiliter inter vivos Simon Puzarelli Fratri
Helye recipienti pro Dno Gregorio Papa nono petia una terre positam
in vocabulo Collis Inferni in comitatu Assisy, cui primo & secundo
via, tertio ecclesie Sancte Agathe. quarto filiorum Bonomi. vel si
qui alii sunt confines cum introitu & exitu suo & cum omnibus que
supra se & infra se habet in integrum & cum omni jure & actione
usu seu requisitione sibi de ipsa re competenti. ad habendum tenendum
possidendum faciendum omnes utilitates Fratrum in ea videlicet lo-
cum Oratorium vel ecclesiam pro beatissimo corpore sancti Francisci
vel quicquid ei de ipsa re placuerit in perpetuum. quam rem se suo
nomine possidere donec corporaliter intraverit possessionem in quam intran-
di licentiam sua auctoritate concessit. promittens non dedisse jus vel
actionem de ea alicui quod si apparuerit eum dedisse promisit defen-
dere suis pignoribus & expensis renunciando juri patronatus omnique
auxilio legum ipsi competenti vel competituro. et promisit per se &
suos heredes dicto Fratri Helye recipienti pro Dno Papa Nono Gregorio. contra non
facere vel fecisse, sed defendere dictam rem ab omni litigante persona omni tem-
pore suis pignoribus & expensis in curia vel extra sub pena dupli ipsius rei
habita compensatione meliorationis & extimationis. qua soluta vel non
hoc totum semper sit firmum.
Factum in domo dicti Symonis presentibus & vocatis testibus Dno Presidone Iudice
communi Soldilj. Petro Tedaldi. Somno Gregorij. Petro Capitanij. Tiberio Pe-
tri. Andrea Agrestoli. Iacobo Bartoli.
+ Ego Paulus Notarius rogatus his interfui & scripsi. & autenticavi.

This document constitutes the founding act for the presence of the Friars Minor in the place where the church and convent of Saint Francis of Assisi would later be built. Without his institutional and religious role within the community being specified, Friar Elias receives the land on behalf of Pope Gregory IX, who was born Ugolino dei Conti di Segni in Anagni and had been the Cardinal Bishop of Ostia and a protector of the Friars Minor. The land in question was probably only a parcel of the surrounding area that was already earmarked in plans for the construction of a settlement (*locus*) for the Friars Minor. There is no information about the donor of the land; all the witnesses to the contract, however, figure in various ways in the institutions of the City of Assisi, and are indicated in 1245 as conspirators for Friar Elias's return to the city after he had adopted pro-empire positions and was subsequently excommunicated by the Pope in 1239 (Fortini II, 212 and 510). As for the choice of that place with such an evocative name (*in vocabulo Collis Inferni*) for the burial site and construction of the church, tradition attributes to Francis the desire to be buried "dove sonno le forche deli malfactori" (where the gallows for evildoers is) (MS. Vat. Capponiano 207, ch. 78, quoted in Nessi 1994: 20, see also 20–24). Also worthy of note, finally, is the epithet *beatissimo* attributed to the saint's body four months before his official canonization, which occurred on July 16 of the same year. *(Daniele Sini)*

Entry 4
Gregory IX, *Recolentes qualiter*

Rieti, April 29, 1228
ASC, *Bollario*, I/7
parchment, 220 × 285 mm, original.
Hanging bulla *cum serico*.
Critical editions: BF I, 11 (refers to another text).
Regests: Eubel 1908: 602; Alessandri and Pennacchi 1915: 595,
no. 7; Nessi 1991: 5, no. 8.
Translation: FAED I, 564–65.

Pope Gregory IX grants forty days of indulgence to contributes alms for the construction of the church where the body of Father Francis will be placed.

TEXT

Gregorius episcopus servus servorum Dei. Universis Christifidelibus presentes licteras inspecturis. Salutem et apostolicam benedictionem. Recolentes qualiter sancta plantatio fratrum minorum Ordinis sub beate memorie patre Francisco incepit, et mirabiliter profecit, per gratiam Iesu Christi, flores sancte conversationis longe lateque proferens et odores, ita quod in deserto huius mundi sacre religionis honestas videatur procedere ab Ordine supradicto, dignum esse providimus et conveniens, ut pro ipsius Patris reverentia specialis Ecclesia, in qua eius corpus recondi debeat, construatur.

Cum igitur ad opus huiusmodi subventio sit fidelium opportuna, et expedire credamus saluti vestre, si exhibeatis vos in hoc devotionis filios, et manus auxilii porrigatis, universitatem vestram rogamus, monemus et exhortamur in Domino, atque in remissionem vobis iniungimus peccatorum, quatinus eidem operi de bonis a Deo vobis collatis pias elemosinas et grata caritatis subsidia erogetis; ut per subventionem vestram tam pium opus valeat consumari, et vos per hec et alia bona que, Domino inspirante, feceritis, ad eterne possitis felicitatis gaudia pervenire.

Nos enim de omnipotentis Dei misericordia, et beatorum Petri et Pauli apostolorum eius auctoritate confisi, omnibus eidem operi bene facientibus quadraginta dies de iniuncta sibi et devote suscepta penitentia misericorditer relaxamus.

Datum Reate III kalendas maii, pontificatus nostri anno secundo.

TRANSLATION

Gregory, bishop and servant of the servants of God, to all the faithful who may read these letters: greetings and apostolic blessing. We recall how the sacred plantation of the Order of the Friars Minor began and grew marvelously under blessed Francis of holy memory, through the favor of Christ spreading far and wide the flowers and perfumes of a holy way of life, so that in the desert of this world the beauty of holy religion seems to come from the aforesaid Order. Thus it seems to us both fitting and opportune that for the veneration of the same Father, a special church should be built in order to hold his body.

For such a work, the assistance of the faithful is needed, and we believe that it is beneficial for your salvation if you show yourselves to be devoted children and extend a helping hand. Therefore, we beg all of you, we admonish and exhort you in the Lord, and, for the remission of your sins, we enjoin you, that for this work you donate pious alms from the riches bestowed on you by God and subsidies imposed from the gratitude of love, so that through this and other good works which you perform through God's inspiration, you might be able to arrive at the prize of eternal happiness.

And we, invoking the mercy of almighty God and by the authority of his holy Apostles Peter and Paul, graciously grant to all the benefactors of this work the remission of forty days of penance imposed upon them.

Issued at Rieti, the twenty-ninth day of April, in the second year of our pontificate.

Gregory's letter—that is, in substance, the provision of forty days of indulgence for whoever contributes to the construction of the church of Saint Francis—uses a typical formula: "Nos enim […] misericorditer relaxamus." But the document's first clauses—*Recolentes qualiter* and *Cum igitur*—the sincere and free expression of the pontiff's personal feelings for his old friend Brother Francis, greatly depart from the norm (Merlo 2003: 39–41, 60–85). The letter is formally addressed to all of Christianity: "Universis Christifidelibus presentis liceteras inspecturis." Were that really the case, the apostolic chancery would have had to issue thousands and thousands of copies. In reality, only this copy was made, intended for those responsible for building the church. They could thus display the letter, read it aloud publicly, and publicize it to encourage the piety and charity of the faithful (Bartoli Langeli 1997: XLV–XLVII). And the exhortation for the faithful's *subventio* and charity must have been abundantly effective given the rapidity with which the work progressed in building the two basilicas, the upper and lower, which were already completed by the end of 1253 (Rusconi 1982: 24–26, 30, entry no. 3.7).

(Daniele Sini)

Gregorius eps seruus seruoz dei. Uniuersis xpi fidelibus presentes litteras inspecturis. Salt et aplicam ben. Recolentes qualiter

sca plantatio fratrum minorum ordinis sub beate memorie patre francisco incepit et mirabiliter profecit per gratiam ihu xpi. flores sue conuersationis longe

lateque pferens et odores. ita qd in deserto huius mundi sacre religionis honestas uideatur procedere ab ordine supradicto. dignum est et pdens et

conueniens ut pro ipsius patris reuerentia specialis ecclia in qua eius corpus recondi debet construatur. Cum igitur

ad opus huiusmodi subuentio sit fidelium oportuna et expedire credamus. saluti uestre si exhibeatis uos in hoc deuotio

nis filios et manus auxilii porrigatis. Uniuersitatem uestram rogamus monemus et exhortamur in domino atque in

remissionem uobis munimus peccatorum. quatinus eidem operi de bonis a deo uobis collatis pias elemosinas et

grata caritatis subsidia erogetis ut per subuentionem uestram tam pium opus ualeat consumari et uos

per hec et alia bona que domino inspirante feceritis ad eterne possitis felicitatis gaudia peruenire. Nos

enim de omnipotentis dei misericordia et beatorum petri et pauli apostolorum eius auctoritate confisi

omnibus eidem operi benefacientibus quadraginta dies de iniuncta sibi et deuote suscepta peni

tentia misericorditer relaxamus. Dat. Reate. iii. kl. maii.

Pontificatus nri Anno Secundo.

29 Aprilis
1228.

Gregorius Nonus
Uniuersis xpi fidelibus qui pias elemosinas
et grata caritatis subsidia pro consuma
tione operis et eccle in qua corpus sci
fran recondi debeat prout ipse pensio
et dignum duxit construendum quadra
ginta dies de iniuncta sibi penitentia
misericorditer relaxat.

Indulgentia X

Entry 5
Gregory IX, *Is qui ecclesiam suam*

Lateran, April 22, 1230
ASC, *Bollario*, I/11
parchment, 730 × 510 mm, original.
Seal lost.
The indiction, which is incorrect, indicates the second year rather than the third.
Critical editions: BF I: 60–62 (transcribed from another original).
Regests: Potthast 1874: 733; Alessandri and Pennacchi 1915: 595, no. 6; Nessi 1991: 6, no. 11.

Pope Gregory IX, reaffirming papal possession of the land on which the church-memorial with the blessed Francis's body is built, establishes that the church will be directly subject to him, that it is caput et mater of the Order of the Friars Minor, and that the friars will live in it, in service, in perpetuity.

TEXT

Gregorius episcopus servus servorum Dei. Dilectis filiis ministro ordinis fratrum minorum eiusque fratribus morantibus apud ecclesiam beati Francisci, in loco qui dicitur Collis Paradisi, tam presentibus quam futuris regularem vitam professis.

Is qui ecclesiam suam nova semper prole fecundat, dignatus hec moderna tempora prioribus conformare, beati confessoris Francisci spiritum in caritatis amore per inspirantem gratiam excitavit ut apostolorum vestigia imitatus in paupertate, in qua plus caritas proficit, relictis omnibus, solum secutus fuerit eterne beatitudinis largitorem et velut fidelis servus et prudens laudabiliter operatus in talentis ei creditis fructum in ecclesia Dei attulit copiosum.

Ab ipso enim ordinis vestri sancta plantatio, cooperante divina gratia, processum habuit et profectum que palmites honestatis longe lateque producens flores protulit et odores effudit ad resecanda nociva et salubria inserenda.
Cum igitur apud Asisium, in fundo nobis et ecclesie Romane oblato, in loco qui dicitur Collis Paradisi, in eiusdem confessoris honore construatur ecclesia in qua recondi debet tam preciosus thesaurus sanctum videlicet corpus ipsius, qui in tempore iracundie factus est reconciliatio ut pro peccatis populorum fieret intercessor, nos, cum dignum sit et conveniens ut eadem ecclesia prerogativa libertatis et honoris gaudeat propter eum quem in celis Dominus exaltavit pro eius reverentia ecclesiam ipsam sub beati Petri et nostra protectione suscipimus et presentis scripti privilegio communimus.

In primis siquidem statuentes ut ecclesia ipsa nulli nisi romano pontifici sit subiecta et vestri ordinis, cuius institutor et pater extitit confessor predictus, caput habeatur et mater ac in ea per fratres eiusdem ordinis perpetuo serviatur.

Prohibemus insuper ne quis audeat in eamdem ecclesiam excommunicationis vel interdicti sententiam promulgare quam si proferri contingerit tamquam contra sedis apostolice indulta prolatam decernimus non tenere.

Pro consecratione vero altarium sive pro oleo sancto vel quolibet alio ecclesiastico sacramento nullus ab eadem ecclesia sub ob[tent]u

TRANSLATION

Gregory, Bishop and servant of the servants of God, to our beloved sons, minister of the Order of the Friars Minor, and to the friars of that Order dwelling in the church of the blessed Francis in the place that is called the Hill of Paradise, both present and future, who profess the regular life.

He who continues to make his church fertile with new progeny, having considered it right to adapt these modern times to more ancient ones, through the inspiration of grace, awoke the blessed confessor Francis's spirit of love for charity so that he, having followed the apostles' footsteps into poverty, in which charity grows all the more, abandoned everything, following the only benefactor of eternal blessedness, and, as a faithful and commendably wise servant, committed to the talents entrusted to him, brought abundant fruit to God's Church.

Precisely from him, in fact, divine grace cooperating, the holy plant of your Order began and flourished and, extending its vines of honesty far and wide, produced flowers and spread perfumes «to prune harmful things and implant healthy ones».

Therefore since land near Assisi has been given to us and to the Roman Church, in the place that is called the Hill of Paradise, church in honor of the same Confessor is being built in which a very precious treasure must be hidden, which is to say his holy body, which «in the time of divine wrath became reconciliation» so that he would become an intercessor for the sins of the people, it being fitting and opportune that the same church, because of him who the Lord exalts in heaven, out of reverence for him, enjoys the prerogative of freedom and honor, we welcome it under the protection of Saint Peter and arm it with the privilege of this document.

First, we thus establish that said church not be subject to anyone other than the Roman Pontiff, and that it be considered the head and mother of your Order whose initiator and father was the aforesaid Confessor, and in it, service be rendered by the friars of the same Order in perpetuity.

We further forbid that anyone dare promulgate against the same church a sentence of excommunication or interdict, which—should it happen that one be pronounced—we decide should not be observed, it being produced contrary to the concessions of the Apostolic See.

For the consecration of altars or for holy oil or for any other church sacrament, let no one dare extort anything from the church under

consuetudinis vel alio modo quicquam audeat extorquere seu hec omnia gratis vobis episcopus diocesanus impendat. Alioquin liceat vobis quemcumque malueritis catholicum adire antistitem gratiam et communionem apostolice sedis habentem qui nostra fretus auctoritate vobis quod postulatur impendat.

Quod si sedes diocesani episcopi forte vacaverit, interim omnia ecclesiastica sacramenta a vicinis episcopis accipere libere et absque contradictione possitis; sic tamen ut ex hoc in posterum proprio episcopo nullum preiudicium generetur. Quia vero interdum eadem ecclesia non habet loci diocesani copiam si quem episcopum romane sedis ut diximus gratiam et communionem habentem et de quo plenam notitiam habeatis per vos transire contigerit, ab eo benedictiones vasorum et vestium, consecrationes altarium, ordinationes fratrum clericorum auctoritate apostolice sedis recipere valeatis.

Cum autem generale interdictum terre fuerit liceat vobis clausis ianuis, exclusis excommunicatis et interdictis, non pulsatis campanis, suppressa voce divina officia celebrare.

Paci quoque ac tranquillitati vestre paterna in posterum sollicitudine providere volentes auctoritate apostolica prohibemus ut infra clausuras locorum vestrorum nullus rapinam seu furtum facere, ignem apponere, sanguinem fundere, hominem temere capere vel interficere seu violentiam audeat exercere. Ad indicium autem huius libertatis ab apostolica sede percepte unius libre cere censum nobis et successoribus nostris annis singulis persolvetis.

Decernimus ergo ut nulli omnino hominum liceat prefatam ecclesiam temere perturbare aut eius bona auferre vel ablata retinere, minuere seu quibuslibet vexationibus fatigare, sed omnia integra conserventur eorum pro quorum gubernatione ac sustentatione concessa sunt usibus omnimodis profutura, salva sedis apostolice auctoritate.

Si qua igitur in futurum ecclesiastica secularisve persona, hanc nostre constitutionis paginam sciens, contra eam temere venire temptaverit, secundo tertiove commonita nisi reatum suum congrua satisfactione correxerit potestatis honorisque sui careat dignitate reamque se divino iudicio existere de perpetrata iniquitate cognoscat et a sacratissimo corpore ac sanguine Dei et Domini redemptoris nostri Iesu Christi aliena fiat, atque in extremo examine districte subiaceat ultioni. Cunctis autem eidem loco sua iura servantibus sit pax Domini nostri Iesu Christi quatinus et hic fructum bone actionis percipiant et apud districtum iudicem premia eterne pacis inveniant. Amen amen amen.

(R) Ego Gregorius catholice ecclesie episcopus subscripsi. (BV)

Ego Thomas titulo Sancte Sabine presbiter cardinalis subscripsi
Ego Iohannes titulo Sancte Praxedis presbiter cardinalis subscripsi
Ego Bartholomeus Sancte Prudentiane presbiter cardinalis titulo pastoris subscripsi
Ego Guifredus titulo Sancti Marci presbiter cardinalis subscripsi

the pretext of custom or in any other way, rather the diocesan bishop shall consecrate all these things for you for free. Moreover, let it be licit for you to turn to any Catholic prelate you may prefer who is in the grace of and in communion with the Apostolic See and who, trusting in our authority, may perform for you whatever is requested.

[We establish] that, should the diocesan bishop's throne by chance be vacant, you may, in that period, freely and without objection receive all church sacraments from those bishops that are close to you in such a way however that no prejudice is later created for your own bishop. Since, in fact, at times this church does not have the local bishop available, should it happen that any bishop—being, as we said, in the grace of and in communion with the Roman See and of whom you have full knowledge—come by, you may receive from him the blessing of vessels and vestments, the consecration of altars, and the ordination of friar clerics by authority of the Apostolic See. In the case, then, of general interdict on the territory, you may celebrate the divine offices behind closed doors, the excommunicated and interdicted excluded, without ringing the bells, and in low voices.

Wanting to provide with paternal solicitude for your future peace and tranquility, we forbid by apostolic authority that anyone dare commit robbery or theft, set fire, spill blood, recklessly capture or kill men, or commit violence within your walls. Furthermore, as proof of the freedom obtained from the Apostolic See, you will pay us or our successors the tribute of one pound of wax each year.

We establish, therefore, that no one is permitted to brazenly disturb the aforesaid church, steal from it or keep anything that has been stolen from it, lessen the value of or oppress any of its assets which are all to be conserved intact for all kinds of use by those to whom they have been granted for management and support, unless with the authority Apostolic See.

Should in the future, therefore, any ecclesiastical or secular person, having knowledge of this page of our provisions, rashly attempt to contradict it, having been warned a second and third time and not redressing his offense through adequate satisfaction, let him be deprived of the dignity of his power and honor and let him know he will incur divine judgment for the iniquity he has perpetrated and let him be distanced from the most holy body and blood of God and of our Lord Redeemer Jesus Christ, and may he be subjected to severe punishment in the Last Judgment. Let the peace of our Lord Jesus Christ be instead with all those who will preserve this place its rights so that they will receive the fruit of their good actions here [on earth] and eternal peace in the Last Judgment. Amen amen amen.

[MARK OF THE ROTA] Signed, Gregory, Bishop of the Catholic Church. [BENE VALETE]

Signed, Thomas, with the title of Cardinal Priest of Saint Sabina.
Signed, John, with the title of Cardinal Priest of Saint Praxedis.
Signed, Bartholomew, Cardinal Priest of Saint Prudentia with the title of pastor.
Signed, Guifredus, with the title of Cardinal Priest of Saint Mark.

Ego Sigebaldus titulo Sancti Laurentii in Lucina presbiter cardinalis subscripsi

Signed, Sigebaldus, with the title of Cardinal Priest of San Lorenzo in Lucina.

Ego Stephanus Sancte Marie Transtiberim titulo Calixti subscripsi

Signed, Stephen, [Cardinal of] Santa Maria in Trastevere with the title of Callixtus.

Ego Iohannes Sabinensi episcopus subscripsi
Ego Iacobus Tusculanus episcopus subscripsi

Signed, John, Bishop [Cardinal] of Sabina.
Signed, James, Bishop [Cardinal] of Tusculum.

Ego Octavianus Sanctorum Sergii et Bachi diaconus cardinalis subscripsi

Signed, Octavian, Cardinal Deacon of Saints Sergius and Bacchus

Ego Rainerius Sancte Marie Cosmidin diaconus cardinalis subscripsi
Ego Romanus Sancti Angeli diaconus cardinalis subscripsi
Ego Petrus Sancti Georgii ad velum aureum diaconus cardinalis subscripsi

Signed, Rainerius, Cardinal Deacon of Santa Maria in Cosmedin.
Signed, Romanus, Cardinal Deacon of Sant'Angelo.
Signed, Peter, Cardinal Deacon of San Giorgio in Velabro.

Ego Rainaldus Sancti Eustachii diaconus cardinalis subscripsi
Datum Laterani per manum Martini Sancte Romane Ecclesie vicecancellarii X kal. maii, indictione II, Incarnationis dominice anno millesimo CC° XXX°. pontificatus donni Gregorii pape VIIII anno quarto.

Signed, Rinaldo, Cardinal Deacon of Saint Eustace.
Issued at Lateran, by the hand of Martin, vice-chancellor of the Holy Roman Church, on the twenty-second day of April, second indiction, in the year 1230 of the Incarnation of our Lord, in the fourth year of the pontificate of Pope Gregory IX.

The novelty and peculiarity of this document lies in its form rather than its content. It is, in fact, not a common "letter of grace" but a "solemn privilege." Let us explain the term. In imposing the execution of his orders or in granting certain rights or favors, the pontiff usually used *litterae* written by the chancellor, which regarded a single subject each time. In composing them, the officials of the papal chancery gave each letter a precise form that made its purpose immediately recognizable. Particular forms, both in the wording of the text and in the features of the document, distinguished in this way, for example, papal mandates—called *litterae exsecutoriae*, from which the pope's seal hung by hemp cord—from the granting of particular favors or benefits to persons or churches through *litterae gratiosae*—which were sealed by the pontiff's *bulla* hung with yellow and red silk cord. Although these are formal elements, in substance they qualified the document, guaranteeing its authenticity and connoting its content (Pratesi 1982: 19).

In this case, instead, the Apostolic See uses the most solemn type of document, the privilege, which presents entirely distinct formal elements: an overall solemnity in the document; the first line composed entirely of elongated characters (*litterae elongatae*); the use of a particular formula of perpetual validation of the content (*in perpetuum*); the closing of the text of the directive with three *Amen*; the presence of distinct graphic elements such as the pontiff's signature by way of the Rota mark and the *Bene valete* monogram; the presence of the handwritten signatures of cardinals from the papal court as witnesses to and further confirmation of the document; the indication of the name of the vice-chancellor who drafted the letter (Frenz 2008: 20–23).

Breaking away, therefore, from the habit of communicating with the Minors through less solemn documents such as the *litterae*, the papacy, for the specific case of the church of Saint Francis, makes use of a privilege similar to those typically used for centuries with monasteries and monastic congregations in order to place them under its protection, affirm their property and assets, exempt them from the jurisdiction of bishops and the secular clergy, and outline the particular profile of their exemptions (see the many examples in D'Acunto 2003: 48; Cariboni 2003: 73–74 and 101–7). In the rich tradition of granting favors to the Friars Minor, among almost all the letters, mainly *litterae cum serico*, there is no trace of privileges; this letter seems to be a *unicum* and therein lies its peculiarity. In the long document there are two passages of paramount importance, which were expressly designed for the occasion in favor of the Friars Minor: first, the declaration that the land on which the church of Saint Francis is built is papal property; second, the papal provision that the church is *caput et mater* of the Order of the Friars Minor. That the land and church are papal property had fundamental impor-

tance for the ideals and character the Order assumed (see Pasquale Magro, "Gregory IX and the Church of Saint Francis in Assisi" in this catalogue); the definition *caput et mater* for the church at the head of the Order recalls a formula typically used in reference to the Roman Church (*caput et mater omnium ecclesiarum*) or to the mother abbeys in the Benedictine, Cluniac, and Cistercian monastic traditions (D'Acunto, n.d.). Such an expression in this context acquires very particular significance in response to the centrifugal tendencies determined by the rapid spread of Minors throughout Italy and Europe. The granting of such an extensive and detailed exemption to the church of Saint Francis was intertwined with the events for the burial and concealment of the saint's remains in order to prevent them from being stolen or even dismembered and sent to the numerous Minorite communities in Europe. This privileged position of the church-shrine in Assisi would then be counterpointed in hagiographic sources, in particular those that can be ascribed to the tradition of his companions, such as the *Compilatio Assisiensis*, by the exaltation of the Porziuncola as the church that is *mater et caput pauperum Minorum fratrum* (Miccoli 2008: 39).

The rest of the letter relates formal provisions that Gregory IX and his predecessors typically used in similar concessions to monasteries for men and women of the various monastic Orders: papal protection of the Minorite settlement and its exemption from the control of the diocesan Ordinary because directly subject to the pontiff (missing, instead, naturally, given their vow of poverty, is confirmation of their ownership of appurtenances, land, and assets, which the pope claims for himself). This documentary form, therefore, is not used for rhetorical purposes or prestige, but is based on concrete legal problems, which the use of known and usual forms of documentation helps to corroborate: the choice of the documentary form of the privilege, usually used in the ways and for the purposes described above, is a means of normalizing according to traditional and typical praxes the absolutely exceptional statute of the Minors' church, which could not be the property of the Friars Minor, who could not and did not want to own property, but which would forever be, at least in Gregory IX's intentions, the "head and mother" of the entire Order.

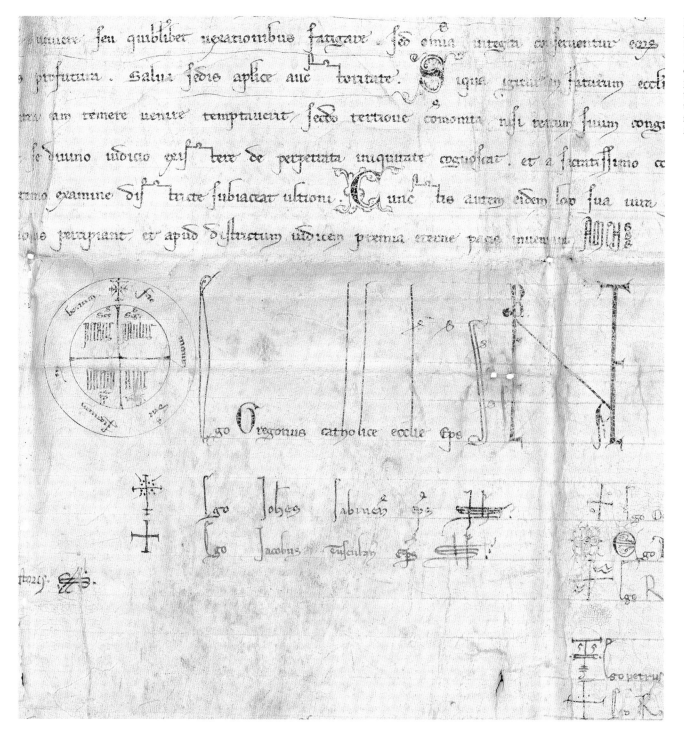

... seu quilibet uexationibus fatigare. Sed omnia integra conseruentur eius ... profutura. Salua sedis aplice auc tontate. Siqua igitur in futurum eccl... ... am temere uenire temptauerit secundo tertioue comonita nisi retum suum congr... ... se diuino iudicio que terre de perpetrata iniquitate cognoscat. et a sacratissimo co... ... timo examine dis tricte subiaceat ultioni. Cunc tis autem eidem loco sua iura que percipiant. et apud districtum iudicem premia eterne pacis inueniat. Amen Amen...

Ego Gregorius catholice ecclie eps

Ego Johes sabmen eps

Ego Jacobus tusculan eps

Fig. 1. Gregory IX,
Is qui ecclesiam suam
(Lateran, 22 April
1230), detail of the
eschatocol with the
pontiff's signature:
the Rota mark and
the *Benevalete*
monogram.
ASC, *Bollario*, I/11.

Entry 6
Division of an Estate

Assisi, November 27, 1253
ASC, *Istrumenti*, I/27
parchment, 304 × 122 mm, original.
Critical editions: Abate 1941: 269–70, no. 2; Bartoli Langeli 1997:
61–63 (here too the last will and testament of Giovannetto
[110–12] and the mention of Picardo as *nepos beati Francisci*
[216]).
Regests: Nessi 1991: 59, no. 32.

*Picardo and Giovannetto, sons and heirs of the late Angelo di Pica,
proceed to the division of their property, determining the part that
is due to Picardo and reserving the remaining part for Giovannetto.*

TEXT

(SC) In nomine Domini, amen. Anno Domini MCCLIII, indictione undecima, tempore domini Innocentii pape quarti, die IIII exeunte novembre.

Picardus et Iohannettus filii quondam et heredes Angeli Pice, ad divisionem bonorum eorum homnium mobilium et stabilium venientes, de ipsis bonis duas partes de comuni eorum concordia et voluntate fecerunt.

In qua quidem prima parte posuerunt unam domum sitam in porta Moiani, a I via et II formellum et III heredes Sfassati et IIII Ugolinus Contadini, cum omnibus massaritiis comunibus silicet scrineis et arcis et bancis; et cum dicta domo posuerunt partem agri quem habent in asio Sancti Martini Argentane ab oriente, sicut est terminata usque ad fossatum, a I cuius partis via et II dominus Paris et Sanctus Rufinus et III ospitale et IIII clesura que fuit domini Bovis;

item terram que dicitur esse duos modiolos in vocabulo Campi Semite, a I osspitale Sancti Rufini et II Egidius Actonis et III Ventura Bene et IIII Bevingnate Hugolini;

item duas strisias in Fontanelle, a I via et II Ugolinus Contadini et III heredes Andree Gidii Folgorati et IIII Iohannettus predictus;

item duos modiolos, sicut dicitur, in Campanea, a I et II via, alia latera nexit;
item unum cantonem cum predictis strisis Fontanellis, a I filii Volte et II Iohannettus et III ipsi sortientes;

item cantonem canalis, a I et II dominus Paris et III ospitale et IIII filius Iohannis Solusmente;
item omnia que habent in montanis.

Quam partem predictus Picardus in sua et pro sua portione recepit et voluit et fuit esse conteptus; et de aliis bonis fecit Iohannetto finem et quietationem et remissionem et pactum de non ulterius petendo. Et dictus Iohannettus dictam partem sibi confirmavit, et remisit sibi omne ius omnemque actionem realem et personalem, utilem et directam quod vel quam haberet vel habere posset adversus eum occasione dicte partis; promittens eidem dictam partem communiter defendere et disbrigare.

Et hec omnia supradicta promisit attendere et inviolabiliter ob-

TRANSLATION

[SIGN OF THE CROSS] In the name of God, amen. In the year of our Lord 1253, eleventh indiction, in the time of Pope Innocent IV, the twenty-seventh day of November.

Picardo and Giovannetto, sons and heirs of the late Angelo di Pica, arriving at the division of all their movable and immovable property, arrange that same property, by mutual agreement and desire, in two parts.

In the first part, they place a house located at Moiano gate—which borders the road on the first side, a small ditch on the second side, the Sfassato heirs on the third side, and Ugolino of Contadino on the fourth side—with all the common household goods, that is chests, cupboards, and tables; along with said house, they place part of a field that they possess in the eastern part of San Martino di Argentana that is runs up to the ditch—this part of the field is bordered on the first side by the road, on the second by *dominus Paris* and the lands of Saint Rufino, on the third by the hospital, and on the fourth by the enclosure that belonged to *dominus Bovis*;

also, a piece of land that is said to be two *moggi* in the area called Campo Semite, with the San Rufino hospital on the first side, Egidio of Attone on the second, Ventura of Bene on the third, and Bevignate of Ugolino on the fourth;

also, two strips [narrow fields running parallel to each other] in Fontanelle, with the road on the first side, Ugolino of Contadino on the second, Andrea of Gidio of Folgorato's heirs on the third, and the aforesaid Giovannetto on the fourth; also, two *moggi*, they said, in Campagna, the road on the first and second sides, it is not known what is on the other sides; also, an area with the aforesaid strips of land in Fontanelle, Volta's sons on the first side, Giovannetto on the second, the stipulating parties [of this document] on the third; also, the area of the canal, dominus Paris on the first and second sides, the hospital on the third, and Giovanni of Solusmente's son on the fourth; finally, everything in their possession on the mountain.

The aforesaid Picardo received this part as his and declared himself content; as regards the other property, he released it to Giovannetto, acknowledged Giovannetto's receipt of it, and agreed to not claim anything else. And the aforesaid Giovannetto confirmed that other part for himself and released him [Picardo] every right and every authority, real and personal, useful and direct, that he may have or could have over him because of said division; promising all the same to mutually defend said part.

He promised to comply with and observe all the aforesaid things in-

servare et contra non facere sub pena quinquaginta librarum, et ea soluta vel non dicta firma sint et rata, et sub obligatione suorum bonorum.

Actum ante domum filii Berardi Iohannis, presentibus Philippo notario et Ventura Pettenarii et Egidio Calçaviridis et Andrea Loreti testibus.

(SN) Ego Iacobus auctoritate inperiali notarius hiis omnibus vocatus et rogatus affui et ut supra legitur, mandato dictorum paciscentium, scripsi et auctenticavi

violably and to not contravene under penalty of fifty lire, and that, whether the penalty is paid or not, all the agreements remain in effect, pledging all his property as guarantee.

Done in front of the home of the sons of Berardo of Giovanni; present as witnesses: the notary Filippo, Ventura of Pettinario, Egidio of Calzaverde, and Andrea of Loreto.

[NOTARY'S MARK] I, Iacopo, notary by imperial authority, summoned upon request, intervened in all the things which can be read above and, by command of the aforesaid parties, I wrote and authenticated them.

This is the work of two brothers, the only male children of Angelo *Pice*, who are consensually dividing their late father's estate. He is identified not by his patronymic, as usually happens, but by his matronymic—if indeed *Pice* means "di Pica" (of Pica)—which usually happens when children are not recognized by their natural father or when the father dies very early. In any case, the name Pica, as unusual as it is, immediately calls to mind that of Francis of Assisi's mother, which is, moreover, attested (*domina Pica*) only in a late-13th-century compilation: the *Liber exemplorum fratrum minorum*, published in 1927 by Livario Oliger from MS. Vat. Ottob. 522 and then added as an interpolation in a manuscript from the *Legenda trium sociorum* tradition (Fortini 1959: II, 59). The certainty of the parentage comes, moreover, from a document of 1280, in which Picardo is called *nepos beati Francisci*. Angelo, therefore, is either Francis's brother, or one of his brothers, and Angelo's sons Picardo and Giovannetto are Francis's nephews (Nicolini 1978: 261). Below is a concise family tree. Hence scholars' interest in this document, which also offers us clues as to the location of the house that was the family's original residence (Abate 1948).

The act lists only those assets relating to Picardo's part; the unspecified *alia bona* go to Giovannetto. There is a lot of information about both brothers. Giovannetto dictated his will in 1261; it gives us a way of knowing the name of his wife, Bonagrazia, and his children, Giovannola and Francescolo, who is also called *Cecolus* or *Cicolus*, of interest the latter name evidently taken from their famous relative (Fortini 1959: II, 93–95; De Sandre Gasparini 2002: 145–46). It is likewise worthy of note that the *ecclesia Sancti Francisci* is the only religious group to which Giovannetto allocates a legacy (aside from the generic indication of *monasteria* in Assisi). Picardo, or Piccardo, is heavily documented in conventual papers as Saint Francis's *procurator* from 1256 to 1281; a role forbidden to the friars, the procurator is the bearer of the convent's legal persona and assets in relation to third parties (Bartoli Langeli 1997: XXXIII–XXXV). It is possible that Picardo became a friar himself in his later years, if we understand the mention of *frater Picardus* in a 1284 will as refering to him. His property, therefore, went to the convent, and this is the specific reason for the presence of this document, along with others concerning him as a private individual, among acts preserved at the Sacro Convento.

(Daniele Sini)

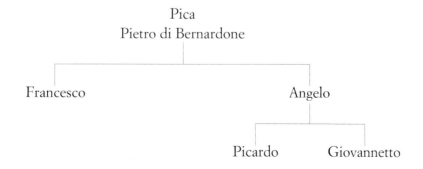

Figg. 1 e 2. Divisione dell'asse ereditario tra i nipoti di san Francesco (Assisi, 27 novembre 1253). ASC, *Istrumenti*, I/27.

oibz bestus cfens. ut posi

quicqp uoluint quatu

p a dno. Ia pnit laudez cr

fratisfaif ad laudez 7 honore d

fcin damianu.

ltissimu omnipotente

sole laudez la gloria e

facere de eo

t eas datū dñi

uray q̄s fecit beat'

ti eēt i firm' apd

nſignore. tue

nort one

altiſſimo ſe

ꝫ nullu homo

u te mietouat.

Words

Elia da Evesham, *Tractatus de vita et passione beati Thomae*

Felice Accrocca

Fondo Antico Comunale at the Biblioteca del Sacro Convento, Assisi, MS. 351

Sec. XIII *ex.*, membr., ff. 61, I' (modern numbering in pencil from 1 to 61; the final endpaper is made from a folio fragment from a codex written in big, ungainly Gothic Italian writing from the beginning of the 14th cent.; the fragment includes chapters 66–69 and 80–83 of Thomas of Celano's *Vita beati Francisci*); 249 × 180 mm. Written in one main hand (A. ff. 1ra–60rb) in careful, calligraphic transalpine Gothic arranged in two columns. Initial to the volume (f. 1ra) painted with a brush and inhabited by the scene of Thomas Beckett's martyrdom; book initials (ff. 23ra, 39ra) in Gothic "interlocking" capital letters inked alternatively in red lead and blue with filigrees that are also two-tone; the remaining initials are in Gothic capital letters inked alternatively in red lead and blue with filigrees in contrasting colors. On f. 61v, written with a lead pencil in a 14th cent. hand: "D*om*ini Radulfi ep*iscop*i Alban*ensis*." On f. 61v, written about 1381 by Giovanni Iolo, librarian of the Sacro Convento: "In isto libro om*ne*s quat*er*ni su*n*t .viii." which corresponds to the numbering, written in the same hand, of the individual fascicles. Black quarter leather binding on wooden strips with a lot of disorganized repair patches in white leather, especially on the back side. The manuscript includes Elia da Evesham's *Tractatus de vita et passione beati Thomae.*
(*Massimiliano Bassetti*)

The codex is interesting for the presence on one of the endpapers of a fragment of Thomas of Celano's *Vita beati Francisci*.

The *Vita beati Francisci* by Thomas of Celano (1C)—better known, although inappropriately, as *Vita prima*—is the oldest work in the impressive hagiographic corpus dedicated to Saint Francis in the 13th and 14th centuries. The hagiographer completed it between 1228 and 1229. It is Thomas himself who indicates, with extreme clarity, the subsections of his work. In the Prologue, in fact, he informs us that he has divided the matter in three parts. The first part, which includes some of the miracles Francis performed while alive, follows a chronological order (from the saint's birth until 1224). The second part addresses the last two years of his life. The third brings together the miracles and narrates the glorious event of his canonization (in reality, the sequence is the opposite: first the canonization, then the miracles). The different parts are unequal in length and the temporal sequence of events is not always adhered to closely. In the Prologue, the hagiographer specifies that the order to compile a *vita* of the Assisi saint was given to him by the pope directly. Such a mandate, which certainly wasn't frequent, could certainly have been motivated by the total fidelity Francis and his fol-

Post summi fauo
ris dote uestros
p̄claros pugiles.
qui auspicato pu
gillari. a tuiri ū
magir̄. usq̄ mu
cronem quo occi
buit thome depinxerūt uimita.
sū opus simile pigineam ma
num extendam ad calamū. er
ga beniuolos deptamur p̄sump
tione umprose uires amoris in
martyrem. Porro iohs sareber
ensis. ⁊ magir̄ herebertus de bo
seam. Nuls cantuariensis A
lanus abbas teokesberiensis
quatuor ueredarii de uniuice ii
gue quadriga per quatuor mu
di climata uia auuigauunt ago
ne athlete. ⁊ uernantis purpu
ra eloquii. excellentis in auran
tel matie maiestatē per se ⁊ ma
bil̄. potentia plus placendi se
struunt hystoria. At hic ⁊ acre
trouitas ⁊in ⁊mati michi uide
or obiecra. Quid g̃ ⁊summato
opt̄ ⁊umis operis. consumis o
peram. fessoq̄ milite campo nu
dato. serus p̄reliator castas du
cis exbias: Quid sumpto bra
uio g̃ gatite sopito mane. se ma
nus p̄cingit ad stadium: Quid
cigneo ūlo tibis ductilib̄ decan
tato. fragili modulari paras ave
na cum nec dedicendis auquid
otussū. nec quicquam de dictis
uneam a meat: Paucis oro sust
neat sugillator mecus. si forte ne
uū temeritatis queat eluere: pro

festio iuruatis. Historiographos su
periores relegenta occurret hic mat
tedii extensia p̄luxrtas. hinc expa
mente iuratis nouica: tuccincta bxe
uitas. Herbertus ut pote qui per sin
gl̄a dicere potuit ex sententia. qui
q̄ uidir ⁊audiuit testatur: ⁊amore
magir̄ extra metal actus ⁊pendii.
cū nichil unq̄ uitactū: narra
tione p̄telat in sinsum. Iohs pub
uce potestatis turbine in r̄a p̄cel
ta: cura p̄ profertim stilum excus
sir. Reliqui duo nec satisfecere ui
geste summā sicienta: nec fastidio
u lectoris euasere superluū op̄ ⁊co
pendinate sumptuosum. bxeuita
te ⁊iudere delicatis nec studiosos
fraudare iuratec. Ob id. ul̄ maxime
cum dicatonb̄; herê⁊o scilice. et
Gilo. diffusioris silue p̄currens op̄
ca: cum castigationib̄; Iohe uideluz
⁊aland ⁊tractionis hortus sinum
ingl̄sus: ex om̄ib̄; micanticres in
flores congestii. ⁊reptons g̃ funti
officio. aliena uēsperti codicem reo
lentia: de tocius structura fabrice
nichil michi appans: p̄et rudem
scedulam fundarrii uocum mode
cantem. Sed ⁊ ne in aliquo lib̄ ui
ta oblitextur calumpnia: aucto
res domesticos gerit in margine pa
gina peregrina. ut de⁊muni quid
singuli subi specificerit operis: erego
ne locatum nom loquatur opi
ficis. Sane. quia fine tili cathena
i uestem ū conueniunt comuncture
nec sine certta federe lapides teua
tur in murum: ansas tantū cor
cinit in nexui in seru in castratu

lowers professed to the pope and the Roman Church from the very beginning, but also and especially by the enormous importance that Gregory IX gave to the role of new mendicant Orders to reform the Church. In this introductory part, Thomas professes truth to be his master and guide, and he specifies that he tried to develop as best he could, even though it was with inapt words, what he himself had heard from Francis's lips and what he had been able to learn from proven and reliable witnesses.

The hagiographer did not have a longstanding familiarity with the saint; his personal memories could only cover a limited period of time. When he set down to work, significant help must therefore have been given to him by those that he calls "trustworthy and esteemed witnesses" (1C Prol.: *FAED* I, 180). Thomas may have had written sources at his disposal as well—the miracles that were read at the canonization were certainly written down, and he certainly knew the saint's writings as traces of them are recognizable within Thomas's work. Having fully mastered previous hagiographic models and with excellent knowledge of the Scriptures and the rules of the *cursus* (which lends a rhythmic flow to the prose), Thomas reveals notable literary talents. Without any shadow of a doubt, from this perspective, the *Vita* is a text of high quality.

In presenting an image of Francis to the brothers, Thomas could not disregard the letter of canonization from Gregory IX, *Mira circa nos*. In that committed and solemn document, Gregory IX sees in Francis the servant who has arrived at the eleventh hour to tend the Lord's vineyard that had been left uncultivated. The Assisi saint's characteristic feature was no longer the humble *sequela Christi*, deprived of any guarantee or certainty; it was, rather, his commitment to reforming the Church. The overall reading of Francis's sanctity that Thomas provides is consonant with the image the pope proposes.

Undoubtedly, Thomas describes Francis's youth in heavy terms. The resulting picture is not very charitable, especially (but not only) with respect to his parents. Nevertheless, while it is clear that the moralistic tone is exaggerated, beneath the surface of the edifying language and the use of established hagiographic models, the *Vita beati Francisci* retains tracts that are totally spontaneous and that refer to direct witnesses.

For example, in the story about the fury that took hold of Francis's father the moment he realized that his son was the object of the entire town's teasing (1C 12: *FAED* I, 191–92) we find a vivid description of an attitude that was concrete

and very understandable given the ambitions Pietro di Bernardone had nurtured and considering how he had not hesitated to loosen his purse strings in order to accommodate his son's plans for glory. The description of the rumor and mockery that spread through the city's streets and piazzas until it reached the ear of the hot-tempered merchant cannot merely be considered a topos given how vivid it is, and how capable of recreating a concrete picture of city life and of making us understand the desperation of a father whose dreams have been frustrated.

In any case, there are not only negative aspects in the portrait of the young Francis; the qualities of magnanimity and generosity that would be so emphasized by other sources, especially the *Legenda trium sociorum*, also appear. Indeed, the young merchant, "since [he] was very rich, he was not greedy but extravagant, not a hoarder of money but a squanderer of his property, a prudent dealer but a most unreliable steward. He was, nevertheless, a rather kindly person, adaptable and quite affable, even though it made him look foolish" (1C 2: *FAED* I, 183). In relation to the knight of Assisi, who was organizing an expedition in Puglia, "although [Francis] did not equal him in nobility of birth, he did outrank him in graciousness; and though poorer in wealth, he was richer in generosity" (1C 4: *FAED* I, 185). Even in his youth, Francis showed attention to the poor and did not fail to provide them with help (1C 17: *FAED* I, 195–96).

The same can be said about the rest of Thomas's work. It is true that it contains extraordinary pages that are difficult to find in other sources, such as, for example, the healing of the possessed woman in San Gemini (1C 69: *FAED* I, 241–42), the description of Francis's physical appearance (1C 83: *FAED* I, 253), and Christmas in Greccio (1C 84–87: *FAED* I, 254–57). In the *Vita*, even though an explicit comparison is never made, Francis is presented as a new Paul who bears every tribulation for God's elect. He is a soldier who, "following the life and footsteps of the Apostles" (1C 88: *FAED* I, 259), fertilizes the Lord's field with the seed of his preaching, ruling over the scene as an apostle of the last hour. Thomas attributes to Francis's vocation his intention to initiate a specific form of religious life, from the very beginning with a calling to carry out its mission in the Church and especially through preaching. We would, however, be grossly mistaken if we were to reduce Thomas's portrait to a praise of Francis's preaching and of the Order of Friars Minor's pastoral commitment. There are, in fact, multiple registers in Thomas's work that make it an "open model" capable of embracing dif-

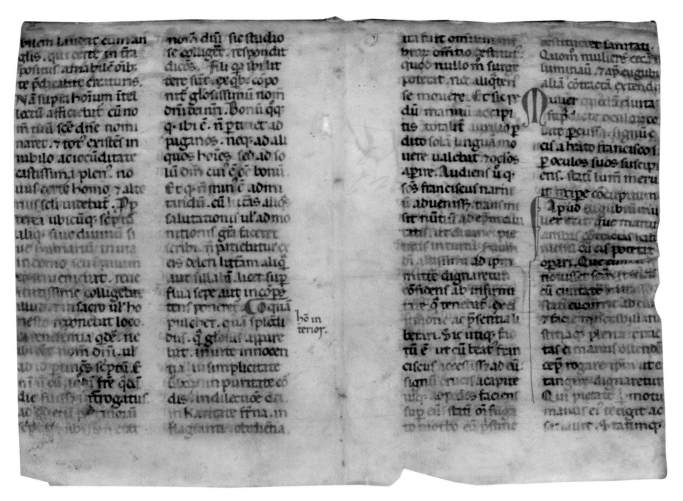

ferent experiences not to the exclusion of possible further developments with respect to its privileged model. While it is true that he talks about the Order in admiring terms, it is also true that he does not spare it from criticism. Thomas is not silent about some of Francis's doubts about the Order's future development, as is shown by the prophecy with the dual vision of sweet, less tasty and inedible fruits, and of the choice made by the fisherman who, when done fishing, throws the worst fish back. It must also be pointed out that the hagiographer considered these prophecies of Francis to have already come true (1C 26–28: *FAED* I, 205–7). All this suffices to present the possibility of different levels on which to read the text. And it is precisely that plurality of registers that contributes to making this work an extremely important document, from the point of view of both history and hagiography.

In 1266, following the decisions made by the General Chapter celebrated in Paris, Thomas's work was—as were all those works written before Bonaventure—slated for destruction. However, parchment was a precious commodity that couldn't be wasted. Sheets that were already used were scraped down and cleaned to be used again or they were employed to cover new volumes or to reinforce existing covers. This is how we find, attached to the back plate of the cover of Codex 351 of the Fondo Antico Comunale of the Biblioteca del Sacro Convento in Assisi—

which contains the life of Thomas Becket, *Vita beati Thome archiepiscopi et martiris*, written by *Elias Eveshamensis* (fig. 1, upper plate and f. 1r)—a sheet of parchment that contains some fragments of the *Vita beati Francisci* by Thomas of Celano (fig. 2). What it contains, specifically, is from paragraph 66 (the first part missing) to paragraph 69 (only the first part included)—a fragment that recounts some miracles Francis performed while alive, among which the aforementioned one of the healing of the possessed woman in San Gemini (included only in part); and from the last part of paragraph 80 to the first part of paragraph 83 in which Thomas relates a precious physical description of Francis, which the current codex only includes the very first part of, with the description of the saint's inner self: "How handsome, how splendid! How gloriously he appeared in innocence of life, in simplicity of words, in purity of heart, in love of God, in fraternal charity, in enthusiastic obedience […]" (1C 83: *FAED* I, 252).

Thomas of Celano, *Memoriale*

Felice Accrocca

Fondo Antico Comunale at the Biblioteca del Sacro Convento, Assisi, MS. 686
Sec. XIV², membr., ff. I, 51, I' (two different numberings of the pages, both modern—16th- and 18th-cent.—and in ink, the most recent one, in red, correct from page 1 to page 102, confirms the oldest, incorrect, one, which in many cases has been removed through later scraping; parchment initial endpaper that bears a frontispiece on the *recto*, written in capital letters in the 16th cent.: "Memoriale s. Francisci | in desiderio animæ, | id est | vita ejusdem s. Francisci | secunda | a fratre Thoma de Celano | præmemorati s. Patris discipulo | conscripta." Last endpaper cart.); 140 × 105 mm. Written all in one hand (A. pp. 1–101 [ff. 1r–51r]) in "bastard" Italian calligraphy arranged in long lines. Initials in simplified Gothic capitals inked alternatively in red lead and blue; space reserved for the initial to the whole work probably planned to be painted with a brush (p. 9 [f. 5r]); headings in red lead, at times not done (spaces reserved for them remain). On f. I'r, a handwritten note from the 16th cent. that summarizes some information about the Sienese inquisitor fra Matteo Ranuccini, one of whose verdicts is transcribed on p. 102 (f. 51v) in chancery writing from the 15th cent. (*incipit* "Frater Bartalomeus Dactivi de Montepolitiano, guardianus loci Sancti Processus, districtus Montis Lateronis," *explicit* "admonitos huiusmodi continuo minandos quorum duos pro primo, duos pro secundo et reliquo et quatuor pro tercio ultimo et"). Restored binding (of the 16th cent.) in white leather on cardboard strips. The manuscript is of Thomas of Celano's *Memoriale s. Francisci in desiderio animae* (Saint Francis's *Vita secunda*).
(Massimiliano Bassetti)

In 1244, the General Chapter that gathered in Genoa considered it opportune to integrate Thomas of Celano's *Vita beati Francisci*. The Minister General, Crescenzio da Iesi, then asked all the friars to write down what they actually knew about the life, signs, and miracles of the blessed Francis. The text of this circular letter has not been conserved, but we know about it from the content of the *Chronica XXIV generalium*, a text from the second half of the 14th century that is attributed to Arnald of Sarrant. The material gathered was given to Thomas of Celano so that he could return to work. The hagiographer finished a first draft of his work in 1247; the oldest draft that has reached us is in fact dedicated to Crescenzio da Iesi, who was replaced that very year by Giovanni da Parma.

Unknown for centuries, the work that Thomas titled *Memoriale* and that is also know as the *Vita secunda* was published for the first time in 1806 by Stefano Rinaldi, who printed the text included in Codex 686 of the Fondo antico comunale at the Biblioteca del Sacro Convento in Assisi, basing himself on the transcription Ubaldo Tebaldi had done some decades earlier. At the end of the 19th century, a new codex was discovered that is today held in Rome at the general archive of the Capuchin Friars Minor, and in 1906, Édouard d'Alençon created the first critical edition. The Assisi manuscript was d'Alençon's foundation for his text, which he integrated with the new elements that were brought out by the second codex. Some decades later, the Padri Editori of Quaracchi (the work is actually due to Michael Bihl) completed a new critical edition in which they maintained the choices made by the previous editor. It is only thanks to the latest critical edition—edited by Felice Accrocca and Aleksander Horowski, which takes into account a third copy (MS. C 4 of the library at Uppsala University—that we have a more facilitated view of the differences that can be ascertained between the various codices. Thomas skillfully divides his own work in two parts. The first, the only one that keeps to chronological order, is much shorter than the part that follows, also because the events narrated in Thomas's previous work are not repeated; this part is almost entirely dedicated to Francis's youth and conversion, and it includes new episodes with respect to the previous work, which are taken from the material that then flowed into the *Legenda trium sociorum*. In the second part, instead, in addition to the material that reached Crescenzio, Thomas used further accounts from witnesses. Nearly half of the events referenced in the *Memoriale*, in fact, find no parallels in any other source, except in Bonaventure who takes them, in turn, from Thomas.

While in the *Vita* Thomas presented a negative portrait of Francis's family and of Assisi society, which were held responsible for the future saint's youthful depravity, in the *Memoriale* the general presentation of the stories is very different. The greatest difference is in the description of Francis's parents. In the *Memoriale* the author seems to feel the need to redeem those he had so heavily injured previously and who certainly would not have failed to complain about it. Thomas doesn't repeat the negative portrait of them, and even the role played by Assisi society is decidedly reconsidered. The only one left who fights against Francis is his father: "now that he was set upon works of piety, his father in the flesh began to persecute him. Judging it madness to be a servant of Christ, he would lash out at him with curses wherever he went" (*Mem* 8 [Q 12]; see 2C 12: *FAED* II, 251).

A more careful reading shows that nevertheless the two works reveal substantial continuity in how the key figures are characterized. We should note, in fact, that even in the *Vita*

MEMORIALE S. FRANCISCI

IN DESIDERIO ANIMÆ,

ID EST

VITA EJUSDEM S. FRANCISCI

SECUNDA,

À FRATRE THOMA DE CELANO

PRÆMEMORATI S. PATRIS Discipulo

CONSCRIPTA.

Fig. 1. Tommaso da Celano, *Memoriale*: "Memoriale s. Francisci in desiderio animae, id est vita eiusdem s. Francisci secunda, a fratre Thoma de Celano praememorati s. Patris discipulo conscripta." Assisi, Fondo Antico Comunale, Biblioteca del Sacro Convento, MS. 686, initial endpaper.

the portrait of young Francis was not always negative (1C 2, 4, 17: *FAED* I, 183–84, 185, 195–96), while, on the other hand, in the *Memoriale* it states that Francis, as an adolescent with urban ways, did not seem like his parents' son (*Mem* 2 [Q 3]; see 2C 2: *FAED* II, 242). In his first work, Thomas definitely did not call Francis's mother a new Elizabeth, as he would later do (*ibidem*), but he tells us that she disapproved of her husband's actions (1C 13: *FAED* I, 192–93). Pietro's severity, on the other hand, is maintained unchanged in the *Memoriale*, while there even appears another son of his who is anything but loving about the choices his brother makes (*Mem* 8 [Q 12]; see 2C 12: *FAED* II, 251-52). Be that as it may, the *Memoriale* presents us with a Francis who is severe toward his parent to the point of openly telling him that he would no longer call him father (*ibidem*). While the *Vita* does not efface Francis's positive traits, it is also true that the *Memoriale* does not conceal his life as a pleasure-loving young man. And how effective the description is of those drunk and scurrilous young men who wander around Assisi late at night loudly singing songs with little edifying value (*Mem* 4 [Q 7]; see 2C 7: *FAED* II, 246-47)!

Beyond the different approaches and differently accentuated tones, the works reveal an underlying unity between them. The *Memoriale* goes back to and supplements (and even corrects) events and readings presented in the *Vita*, explaining hagiographic models that were left in the shadows, perceptible only to the discerning eye of those in the know. The saint, in fact, is compared first to the prophet John the Baptist (*Mem* 2 [Q 3]; see 2C 2–3: *FAED* II, 241–42), then to the cavalryman Martin (*Mem* 3.3 [Q 5]; see 2C 5: *FAED* II, 244–45), and finally to the apostle Paul, the true model for Francis's conversion (*Mem* 3 [Q 6]; see 2C 6: *FAED* II, 245–46).

There is further innovation in the second part of the *Memoriale*, in which, having abandoned any chronological order, Thomas composes a true *speculum perfectionis* for the saint, inaugurating within Franciscan hagiography a genre that would enjoy remarkable fortune only a few decades later. Francis is "the holiest mirror of the holiness of the Lord, the image of his perfection" and in looking at him the friars were meant to awaken their "dozing hearts" (*Mem* 19 [Q 26]; see 2C 26: *FAED* II, 263; these statements are included only in the first draft of the work, as evident from the codices in Rome and Uppsala). The Order, therefore, is dangerously drowsy, drifting away from its founder's example. Francis's virtues, listed without any strict internal connection between them, along with his teachings thus offer useful ex-

amples to those friars who desire to imitate him, while simultaneously stigmatizing deviant behavior. Thomas's objectives are clear and explicit: the example provided by Francis, he who fully lived the ideal codified by the Rule, is the only effective weapon for countering the Order's gradual decline.

The fact that a different space is assigned to the virtues also allows us to understand what the main points of discussion were between the friars. Great importance is given first of all to Francis's spirit of prophecy, to poverty, and to the saint's attitude toward the poor with Thomas referring to Francis's marriage to poverty several times (*Mem* 47, 62, 73.7 [Q 55, 70, 84]; see 2C 55, 70, 84: *FAED* II, 284–85, 294, 302).

Without a doubt, Thomas reelaborates his sources, which are taken by the *Compilatio Assisiensis* with greater adherence to the original wording. The words attributed to Francis are generally kept in their original form, although in some instances it is clear that the hagiographer rewrote them (the distinction between "ownership" and "use," see *Mem* 51 [Q 59]; see 2C 59: *FAED* II, 286–87; the exegesis of 1 Sam 2.5, *Mem* 145 [Q 164]; see 2C 164: *FAED* II, 352–53). Thomas expresses negative judgments of the Order's development more often (it must be noted that most of the most severe invectives are only found in the Assisi and Uppsala manuscripts and not in the one in Rome, which provides the definitive draft of the text), but he openly disagrees with those who, applying Francis's vision of the woman with the golden head and iron legs, saw the Order's decline as irremediable (*Mem* 72 [Q 82]; see 2C 82: *FAED* II, 301).

MS. 686, one of the three codices that contain the text of the *Memoriale* (fig. 1 and fig. 2), was not included in Giovanni di Iolo's 1381 inventory and does not bear the *quaternatura assisiensis*, but this does not necessarily mean that is must date back to a time after that year. The codex was in the Sacro Convento archive at the beginning of the 19th century, as attested by the inventory begun on June 29, 1822, titled *Repertorio di tutti i libri dell'archivio di S. Francesco in Assisi con le notizie in compendio contenute ne' medesimi le più interessanti* (Inventory of all the books of the Saint Francis in Assisi archive with summary notes containing the most interesting ones) where we read: "8. In the cupboard [...] there are many different codices, and some very valuable ones because they are rare, and perhaps unique [...]. Extremely rare now is the life of Saint Francis written by B. Thomas of Celano entitled: *Memoriale in desiderio animae*, or the *Vita secunda*" (ASC, *Registri* 1, f. 253 [244]).

Incipiunt Rubrice in sequent[i] ope[re] s[cilicet] que tituli
dissicui breuit[er] innue[n]t q[ue] in hoc ope[re] scriptu[m] e[st]. De
conuersione beati fr[a]nasca

Sub hoc titulo co[n]tinet q[uod] beatu[s] fr[a]naschus uocat[us]
fuit p[ri]mo Iolies. de hoc f[a]cit. Quod mir[um] applauit dei[n]
q[uod] q[ui] ip[su]m de se ip[s]o futura p[re]dicat. De p[ac]ie[n]cia et gaudio
q[uo]d i[n] uiaculis p[er]titul hu[i]t. I. P[ar]agrapho de milite paup[er]e
que uestiuit. De u[isi]o[n]e sue uocatio[n]is q[uam] i[n] s[om]po uidit. ij.
Qualit[er] cu[m] iuuenu[m] turbi[n]i ut eos p[as]ce[n]t. ciui[s] d[omi]n[u]s stauit
de sua sp[irit]u[a]li mutatio[n]e q[uam] t[un]c sensit. iij. Qual[ite]r paup[er]ib[us]
uestimetis i[n]duit a[n]t[e] ecclias ea p[ro]p[ter] cu[m] paup[er]ib[us] m[en]dica[n]
tur. De oblatio[n]e qua[m] ibide[m] obtulit. uij. Qual[ite]r sibi ora[n]ti
dyabolus mulier[e]m ost[en]dit. De resp[on]so q[uod] sibi d[eu]s dedit. De
t[em]plis q[uod] fecit. V. De ymagine cruc[i]fixi que sibi locu[n]
ta fuit et honore q[uem] ei i[m]pe[n]dit. Vij. De p[er]secu[ti]o[n]e p[at]r[is] et
f[rat]ris carnalis. Vuij de uerecu[n]dia qua[m] uicit et p[er] h[an]c pu
p[ri]oni uirginu[m]. Vij. De abanu[s] h[ospi]tal[i] que fui[t] x. De
exp[ro]bacio[n]e f[rat]ris bernardi. xe. De similitudi[n]e qua[m] cora[m]
Inn[oc]e[n]cio p[ro]uit. De co[n]s[il]iu[m] d[omi]ni. ip. et u[isi]o[n]e qua[m] ip[s]e p[er]
uidit. De s[an]c[t]a a[n]im[a] d[...] p[...]ia[...] Sub hoc titulo co[n]tinet amor
ca[...] co laco. Co[n]u[er]satio f[rat]ri[s] ibide[m] mora[n]tu[m] Amor beate
ih[es]u ibide[m]. I. De quada[m] u[isi]o[n]e. De co[n]u[er]satio[n]e c[um] fr[atr]ib[us].
Sub hoc titulo co[n]tinet rigor discipli[n]e ipi et f[rat]r[um]. I.
De discretio[n]e s[ua] ij. De p[ru]de[n]cia futuror[um] et q[ui] reliq[ui]
one p[ro]uisit n[o]m[in]e ecc[lesi]e et de quada[m] u[isi]o[n]e. ij. Q[ua]l[ite]r c[ur]a[m]
h[ospi]t[al]e[m] q[ui] i[n] p[...] Intrauit ad p[ro] op[us]. De sp[irit]u p[ro]ph[eti]e q[uam] b[e]n[edictus] q. h.
Sub hoc titulo q[uod] pi q[uod] b[en]t[us] f[a]m[uliu]s quada[m] q[ui] p[re]tulit ta[n]t[um] t[an]
tu[m] e[st] cog[n]ouit. et de uiuo sig[n]a[n]t[er] a[...]itur[...] Sile de alio dixit.

Bonaventure of Bagnoregio, *Legenda maior*

Felice Accrocca

Fondo Antico Comunale at the Biblioteca del Sacro Convento, Assisi, MS. 345
Sec. XIV med., membr., ff. 60 (three discordant numberings: a modern one in pencil from 1 to 60; the two older ones—15th- and 16th-cent.—register a jump of twelve numbers between the current f. 12 and f. 13, which allows us to postulate that a fascicle following the current first one fell out); 251 × 180 mm. Gothic writing by three hands (A. ff. 1ra–41vb; B. ff. 42ra–57vb; C. ff. 57vb–60rb), arranged invariably in two columns. Major initials (ff. 1ra, 42rb) in Gothic "interlocking" capital letters inked in red lead and blue; minor initials and headings in red lead ink. Modern restored binding on cardboard strips reinforced with leather on the back and corners. The codex includes Bonaventure of Bagnoregio's *Legenda maior* (ff. 1ra–41vb) and *Legenda minor Sancti Francisci* (ff. 42ra–57vb), as well as a *legenda* of Saint Clare (ff. 57vb–60rb) that is mutilated from the loss of one or two fascicles of the codex (a modest fragment from the first lost sheet remains between ff. 60 and the inside of the back cover).
(Massimiliano Bassetti)

The *Legenda maior sancti Francisci* was written by Bonaventure of Bagnoregio between 1260 and 1263. Bonaventure became the supreme leader of the Order in 1257, in the midst of a decade dominated by the tough battle that the Mendicants found themselves fighting against the lay clergy. In addition, Francis's "memory" was generating debate within the Franciscan family about the friars' fidelity to their founder's example. All this made Bonaventure's work as hagiographer even more difficult. In these circumstances he displayed his own theological talent by creating a portrait of Francis that was undoubtedly effective and capable of offering the necessary answers to the multiple problems that were plaguing the Minorite family. One source of inspiration for Bonaventure, among others, was the so-called *Tractatus de miraculis* by Thomas of Celano. Thomas wrote that the reason Francis had been marked with the stigmata consisted in the fact that "all the striving of this man of God, whether in public or in private, revolved around the cross of the Lord" (3C 2: *FAED* II, 401). He reported Francis's visions, actions, dispositions, and sentiments, and a series of other friars' visions, in this vein, all linked to Christ's cross.
Bonaventura realized that the intuition was brilliant, even if Thomas's phrasing must have given him the impression of considerable disorganization. The way in which he made use of Thomas's intuition allows us to appreciate his theological-symbolic-narrative talents. As opposed to Thomas, Bonaventure adopted an outline of six apparitions plus one, endowing the structure of his text with a more marked numeric symbolism. This was an aspect to which he devoted much attention. He also gave the material a different arrangement, omitting some events Thomas mentioned and adding others. He eliminated Francis's actions, dispositions, and feelings, leaving only the visions, which he structured in a dual triptych: first, three of the Assisi saint's visions (two of which were new with respect to the *Tractatus*); then, three visions by three different friars. Through these six apparitions, "like six steps leading to the seventh" (LMj XIII, 10: *FAED* II, 639), Francis reached the contemplation of Christ (the seventh apparition): "at the same time the sublime similitude of the Seraph and the humble likeness of the Crucified" (LMj XIII, 10: *FAED* II, 638). He was, by then, transformed into the other angel who rises from the East and bears the seal of the living God imprinted on his body (LMj XIII, 10: *FAED* II, 638). The prologue to the work admirably condenses the essential features of Francis's figure. A sign and presence of Christ in that most recent phase of history, full of prophetic spirit, he came to prepare the path to the Lord, who would soon return and call on men to repent. He was the angel of the sixth seal, he who would imprint the sign of *Tau* on the brows of faithful servants. He was another Elijah, a new John the Baptist (although Jesus himself had clearly identified the Baptist as the Elijah who was to come); the prologue thus exalted Francis's prophetic-eschatological role. He was the bridegroom's friend, he who—similar to David and the apostle Peter—marked a new stage in the history of salvation, reviving the miracles worked by the Divine Teacher (fig. 1).
Bonaventure states that he personally went to the places where the saint was born and lived, in order to perform careful investigations and be able to speak at length with those who were close to Francesco and who were still alive at the time, those who "had intimate knowledge of his holiness and were his outstanding followers" (LMj Prol. 4: *FAED* II, 528). In reality, he based his work on already written biographies above all, in particular those by Thomas of Celano, and on material that reached the Minister General, Crescenzio da Iesi. From Thomas's works he used the *Vita beati Francisci*, especially for the first four and last two chapters, and the *Memoriale*, which he largely followed in the middle chapters (chaps. V–XIII). His *Miracula* are substantially taken from Thomas's, though with a few innovations that are not without interest. He al-

Fig. 1. Bonaventure of Bagnoregio, *Legenda maior*, prologue. Assisi, Fondo Antico Comunale, Biblioteca del Sacro Convento, MS. 345, f. 1r.

so, however, made use of Julian of Speyers's *Vita sancti Francisci* and the *Legenda trium sociorum*.

In giving shape to his own work, Bonaventure was inspired by Thomas's *Memoriale*; the *Legenda maior*, in fact, substantially traces the same outline. The work, divided into fifteen chapters to which is added the book of the miracles, at first follows a chronological order—from Francis's birth to the approval of the Rule by Honorius III (LMj I–IV; fig. 2, heading for chapter I: "De conversatione sancti Francisci in habitu saeculari"; fig. 3, heading for chapter II: "De perfecta conversione eius ad Deum et de reparatione trium ecclesiarum"). That chronological order is abandoned in the middle part, where there is a discussion of the saint's individual virtues or ways or life (LMj V–XIII), and then taken up again in the last two chapters, which deal with the last phases of Francis's life, his passing, his canonization, and the translation of his body (LMj XIV–XV). According to some authors, in the middle chapters (LMj V–XIII) Bonaventure developed the itinerary of Francis's perfection on the basis of his doctrine of the three paths: in an gradual ascent, the saint would have traveled the path of purification (LMj V–VII), progressed to the path of illumination (LMj VIII–X), to finally reach fulfillment on the path of union (LMj XI–XIII). Indeed, Bonaventure states his intention to present Francis's life according to an *initium*, a *progressus*, and a *consummatio* (LMj Prol. 5: *FAED* II, 529); but it is an *iter* that, as the hagiographer explicitly says (LMj mir. X, 8: *FAED* II, 682), ends up embracing the entire work and not just its middle part.

On this progressive ascent toward mystical union, which culminates at La Verna, Francis is thus guided by Christ's cross: he ascended the mount like another Moses and Christ's love "transformed the lover into His image" (LMj XIII, 5: *FAED* II, 634). He thus became an *alter Christus*, thanks to his "perfect imitation" of Him (LMj XI, 2: *FAED* II, 613). Having divested himself of everything, he set himself, naked, in the footsteps of the "naked crucified Lord" (LMj II, 4: *FAED* II, 538).

Despite the strong tribute he pays to the production that preceded him, Bonaventure cannot be called a simple compiler as some have claimed. He appears, rather, as a true author (and a very talented one) since, as well as the new contributions, which his work indeed contains, the originality of his approach lies precisely in the overall mix he creates of pre-existing material, in his novel rereading of events that, under his pen, end up taking on different depth and meaning, and in the omissions and variations that he brings to the texts. Above everything else, the *Legenda maior* canonizes the image of an Order that was by then openly called to pastoral commitment in the Church. By converting sinners, their preaching, the "office of piety," made Christ, who had died for them, rise again (LMj VIII, 1: *FAED* II, 586–87). Providence showed Francis that he had to dedicate himself to that ministry (LMj XII, 1–2: *FAED* II, 622–24), the Church ratified that mandate (LMj XII, 12: *FAED* II, 628–29), and the saint was scrupulous about fulfilling it. He began preaching in the church of San Giorgio (LMj XV, 5: *FAED* II, 647) and he didn't spare himself until the end; he preached not just on the streets and in the squares, but in the same cathedral in Assisi where he often prayed on Sundays (LMj IV, 4: *FAED* II, 551) and in monasteries (LMj IV, 9: *FAED* II, 556).

By paying more attention to the present and future than to the past, with his biography Bonaventure thus presents the friars with a clear reference model, destined shortly thereafter—after the decisions of the 1266 General Chapter, which declared the Minister General's work to be the only one meant for circulation, condemning all the others to destruction—to become the only model.

The codex includes Bonaventure of Bagnoregio's *Legenda maior* (current ff. 1r–41v) and *Legenda minor sancti Francisci* (current ff. 42r–57v), and one of the minor *legendae* of Saint Clare of Assisi (the *Venerabilis Christi sponse*, current ff. 57v–60v, plus a fragment on 61r).

The text of the Clare legend is incomplete and that of the *Legenda maior* is actually mutilated because of the loss of a fascicle. Sheet 12r ends with LMj V, 6 ("He strongly wanted the friars to observe the silence recommended by the Gospel so that they particularly abstain at all times from every idle word"; *FAED* II, 564) while the current f. 13r begins with LMj IX, 4 ("[…] no wonder that charity of Christ made him even more a brother to those who are marked in the image of their Creator and redeemed with the blood of their Author"; *FAED* II, 599). On the current f. 39r (originally f. 51r), the heading for chapter IX of the *Miracula* (*De non servantibus festum et inhonorantibus Sanctum*) was not created though a space was left for it and the text was already indicated (*De hiis qui festa non custodierunt*). At the end of the *Legenda maior*, the copyist of the first part of the codex asks the reader to pray for him, as he entrusts all his own hope in God ("Exora Christum qui librum conspicis istum / pro me scribente tota supplico mente / me commendo Deo spes mea tota Deus").

Left leaf, column 1:

tpr omissis malis in diuisis
patmie tpibz; eide matie agniē
uicebant. Initiū aū uite ipi
ppressius. rosuāto quicd dislic
in capitlo residuut. inferius
Inotatis.

¶ Aguā e jn ouisacte ipi: inhiru
¶ Secdo d'pfca ouisce ei ṡselan
add̅m: drepatie roū ecliarū.
¶ Tcio d'institute religios: 7
aphatie regule.
¶ Quarto d'pfecta ōōis subma
nu ipi: rofirmatce regle pus ap
¶ Quito d'austitate plate
uite: 7qm catē plebat ei solatiuz.
¶ Sexto d'huilitate robia: rōgde
secdib; d̅s sibi scd admūtū.
¶ Septiō d'amore pauptatis: 7
mira siuplectcē defectuū.
¶ Octauo d'pietis affcū. 7qm
inte carcina afflia uidebāt.
¶ Decimo d'studio uitute oi.
¶ Sondeamo de itlligetia septiū
7spū yphie.
¶ Duecleco de efficacia pdicandr.
7ega sanitutuū.
¶ Benodeco de stigmatib; sacs.
¶ Quadoueno de passia ipi 7fin
situ motis.
¶ Quitocleco de canonifactce.
7tñslatce ipius.

23.

¶ ... de scilere ornitatis. ereisidio matura

Left leaf, column 2:

¶ Postremo de miraclis p̄nsiū
ei felice ostensis: aliqua sub
nectuntur. Explicat pleg;
Incipit uita bti fcisci. De
ouisice bti. f. Thatu seclari.

AR eñt ī cauitate
aisisi. fcanescus noīe:
cuius mcona inbholoõne ees:
peo qo d̅s ipm inbhdictoib;
dulceclinis. benigne pueni
ens: 7de psentis uite picaliis
clemē enpuit: 7celestis gē
dnis affluent inpleuit.
Et eñ cū inf nanos fuit: hoīu
filios. iuuenili etate nutrius
inanis: 7p alqlē leciūs no
tina lichuis mcationu depu
tatus negptiis. supno e assiste
te psicloue: nec inf lasasius in
uenes q̄uis effusus adgaud
p cunis petulātā Abiit: nec
inf cupidos mcatores quā
lictus adluc spauit īrcaua
rthesaurus. Inerat nāq̄ iu
ueni francisco cū pudiatia eā
nis qd ad paupes misatio li
balis: q̄ secū abstantia ocesens.
tata cor ipi bñigtate repleuit
ut ī euaglii ñ sūdus audito
oi pouet se pcēn tribuit. ma
rie si diuinū allegciut amos

Right leaf, column 1:

ertius 7 oferet incoi. Acebat
aut hoīa uii di fcmascus: ñ
cū bitu iil'quietu seistrentie
amucto. De psecta ouisice eius
ad dm̅. 7d'repatie tui ecliau.

Quonia aū filius alcissimi
dctõe ñ bebat alq̄; inhui
modi ñ ī: addidit adhuc ipi
clemēta cū ingr̄euisitate dil
eclie. Aū eñi die quada epssi;
ad meditamdū mag. ce ablae
miū eclar. Sc̄i damiani q̄ mi
nabat ṗuima uerustate minū
7ca instigcāte se spū cū ōōis
inīmisset: 7 psitratus aū yma
gīe cuiaxixi. ñ modica fuit
inoranco. sr̄z osolar repletus.
Cūq̄ lacrmosis oclis intencēt
monūcii cruce: uoce d'ipa ēe
dilapsa. adeū. corporeis audi
uit auib; 7 diceēte. Fciscae.
uade repa domū mā: que
ut cernis tota uitruit. Treme
factus fciscus cū ēet incee
solus stupit adeū mirante uo
cis auditū: corde q̄ pripiēs
diuini uītute eloq; meis ali
enatur excessu. Inse tamē
riisus. 7obecliens se pput tou
se rcolligit. admādatū d'ma
tiali ce repando: licet pncipa

Right leaf, column 2:

lioi inīectio ubi adcū fecer. q̄
psr suo sanguīe acristuut. sic
cū sr̄z sc̄o ocleuit. ripse ṗmod
stibus uuelauit. Sūrexit p
incē sigr cuicis se munies: 7
assūptis pānis uenalib; adu
uitate q̄ fulgmiū dicit seibat
accessit: ibiq̄ uecletis q̄ portabat
equū cū tūe insede. felix m
ctor. assūpto pro d'liquio.
Rediens q̄ assistū ece dauis
repatce mādatū accepit. reue
rent insuit. Et iuuto ille
sacclote puipelo: incientiam
cecletē exhibuit: adrepatcē
ece. 7paupex usū pcariam
obtulit: 7ut secū se mota
patetū adsr̄z. huil'r regsuit.
Acgeuit saccdos de mora ipi
si. 7ctore paretū pcariā ñ recepit.
Qua uer pcariam strepto in
quada fenestla piciens: abue
tā nelino puluiēuilipecdit.
¶ Quom aū faciente suo oi
cū saccdote pico: cū b̄ itelliceu
set pat ipi. prubat aū cuiūtc
adlacū. At ipe q̄ nouus ī eut
athleta cū auduer psciūtciu
minas. 7eor paretū aduētu.
dare lacū ite uolens īquadā
ocaulta souea se absconclat:

Bonaventure of Bagnoregio, *Legenda minor*

Felice Accrocca

Fig. 1. Bonaventure
of Bagnoregio,
Legenda minor,
prologue.
Assisi, Fondo Antico
Comunale, Biblioteca
del Sacro Convento,
MS. 347, f. 3r.

Fig. 2. Bonaventure
of Bagnoregio,
Legenda maior,
prologue.
Assisi, Fondo Antico
Comunale, Biblioteca
del Sacro Convento,
MS. 347, f. 1r.

Fondo Antico Comunale at the Biblioteca del Sacro Convento, Assisi, MS. 347
Sec. XIV *in.*, membr., ff. 26 (modern numbering in pencil from 1 to 26); 260 × 180 mm. Written in one main hand (A. ff. 3ra–25ra) in extremely skilled transalpine Gothic arranged in two columns. Ff. 1–2 constitute a single folio added after the codex was created, in which three different Gothic handwritings (two transalpine and one Italian) present introductory and explanatory texts. Major initials (ff. 3ra, 19vb, 22va) painted with a brush with gold applied for plant shoots and zoomorphic elements; remaining initials in Gothic "interlocking" capital letters inked in red lead and blue; to the left of the individual columns of writing there is a plant branch composed of modular elements, inked alternatively in red lead and blue, that runs the full vertical length of the column; headings inked in red lead. On f. 26v, written about 1381 by Giovanni di Iolo, librarian of the Sacro Convento: "In isto libro om*nes* quat*er*ni sunt .iv. vel .xxvij. folia," to which corresponds the peculiar numbering of the individual fascicles, written in the same hand. Modern (16th-cent.) binding in brown leather on wooden strips. The codex includes Bonaventure of Bagnoregio's *Legenda minor* (ff. 3ra–22rb) and chapter 15 of his *Legenda maior* (ff. 22va–25ra).
(Massimiliano Bassetti)

In addition to the *Legenda maior*, Bonaventure also composed an abbreviated life of Saint Francis, traditionally called the *Legenda minor*, to meet liturgical needs. On saints' feast days, the Office of Readings, or *Matutinum*, was based on the saint's life. During the three nights, three readings (*lectiones*) were read in turn, but in some particularly solemn circumstances the festivities were prolonged for the whole octave. The *Legenda minor*, composed of seven chapters of nine readings each, met this need.

As is understandable, Bonaventure recast the phrasing of his major work, but interesting elements are not lacking; so much so that there is reason to lament that the *Legenda minor* was systematically neglected by scholars of Franciscan hagiography for a long time. We cannot but rejoice in the interest that has recently been registered in relation to this source.

Since it was an abbreviated text, the hagiographer obviously had to perform a careful selection of the material, which is worth analytical consideration. Bonaventure, in fact, did not systematically recapitulate the many episodes narrated in the *Legenda maior*, but through careful sorting he kept some and omitted many others. In seven chapters he describes the saint's conversion (LMn I), the establishment of his new religious family and the efficacy of his preaching (LMn II), the prerogative of some of his virtues (LMn III), the care he took in prayer and his spirit of prophecy (LMn IV), the obedience creatures showed Francis and the divine condescension toward him (LMn V), the sacred stigmata (LMn VI), and his passing (LMn VII). The hagiographer borrows passages from the first fourteen chapters of the *Legenda maior*, in varying degrees: some chapters are taken in a more consistent way than others, for example chapter VI, from which only meager scraps are cited; chapter XV is omitted, as are the *Miracles*. Bonaventure does take some episodes from the last part of his major work, however, borrowing the final affirmations, which

are quoted verbatim in the last lines of the *Legenda minor*. The prologue to the *Legenda maior*, in which Bonaventure developed Francis's prophetic-apocalyptic role, is largely ignored. In the *Legenda minor*'s short prologue (even the brief work has one) the first words remain identical, with the quotation from Saint Paul the Apostle's *Epistle to Titus*, words capable to immediately bring the Francis – Christ parallel to the mind of listeners who would have been well-versed in the Holy Scripture. The Pauline excerpt that was, and is, read during the solemnity of Jesus's Nativity, immediately led one to look at the saint from Assisi as an *alter Christus* (LMn Prol. 1: *FAED* II, 684). While in the prologue to the *Legenda maior* Francis turns out to be the sign and presence of Christ in that most recent phase of history—he who, full of prophetic spirit, had come to prepare the path to the Lord who would soon return, another Elijah and a new John the Baptist—in the prologue to the *Legenda minor*, entirely centered on the metaphor of light, he appears as a luminous sign, especially of the mysteries of the cross that the Father presented again in Francis's life.

It is a prologue that is certainly less grandiloquent and solemn than that of the *Legenda maior*, but one that is no less effective, perhaps precisely because of its brevity and incisiveness, which immediately alerted readers and listeners to the centrality and importance that the mystery of the cross exercised in Francis's life (fig. 1). Themes and images from the prologue to the *Legenda maior* are nevertheless revived in the body of Bonaventure's minor work. Francis's eschatological role is reiterated several times in the *Legenda minor*. The saint essentially actualizes the name John that his mother imposed on him (LMn I, 1: *FAED* II, 684); like the Baptist, he is the Bridegroom's friend (LMn III, 9: *FAED* II, 698), Christ's friend (LMn III, 9: *FAED* II, 698; LMn VI, 2: *FAED* II, 709). He is another Elijah (LMn II, 2, *FAED* II, 689), with that prophet's spirit and power, and Elijah's two-fold spirit rests on him (LMn II, 6: *FAED*

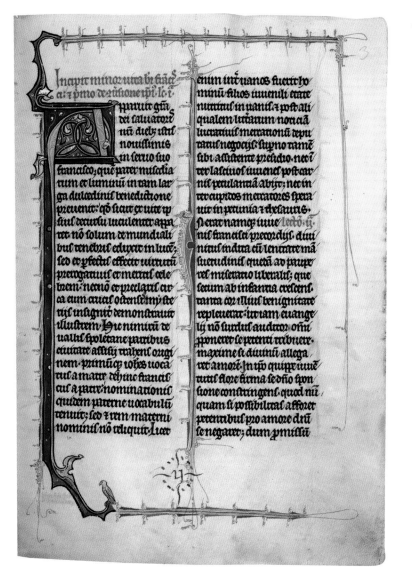

Incipit minor vita beati Francisci. Et primo de conversione ipsius...

II, 692). He is the angel that ascends from the East, from the place where the sun rises, to affix the seal of the living God to the brows of his servants (LMn VII, 1: *FAED* II, 714). He is the herald of Christ and, like the angel of the Apocalypse, bears the seal of the living God imprinted on his body (LMn VII, 9: *FAED* II, 717).

The *Legenda minor* presents a structure analogous to that of the major work. At first it follows a chronological order, with the narration of the phases of Francis's conversion and the establishment of the Order. In the middle chapters (III, IV, V) it takes on the form of a *speculum virtutum* of the saint. In the final chapters, it returns to chronological order in talking about the stigmata and of Francis's passing. Overall, then, the early and late periods of the Assisi saint's Christian experience end up being emphasized, while the time of his militancy is inevitably contracted. Actual events and episodes are reduced and instead general pictures and descriptions are given emphasis.

Among Francis's virtues (LMn III: *FAED* II, 694–98), Bonaventure recounts first of all the rigor of his discipline (III, 1), his vigilant safekeeping of his chastity (III, 2), the gift of tears (III, 3), his holy humility (III, 4), his sublime poverty (III, 5), his holy simplicity (III, 6), his sweet compassion (III, 7), his zeal for the salvation of his brothers (III, 8), and his perfect charity (III, 9).

Dedicated body and soul to oration, Francis prayed incessantly without tiring (LMn IV, 1: *FAED* II, 699). He would go to solitary places where he fought bitter battles with demons, putting them to flight, and he immersed himself in communion with God, so much so that once when he was praying with his arms extended in the shape of a cross he was seen to levitate with his body surrounded by a luminous cloud (LMn IV, 2: *FAED* II, 699). The exercise of virtue and continuous prayer meant that he received the gift of being able to penetrate the mysteries of Holy Scripture and the secrets of hearts (LMn IV, 3–9: *FAED* II, 700–3).

Since he was full of the spirit of Christ creatures obeyed his commands (LMn V, 1–9: *FAED* II, 704–8). The hagiographer, summarizing the course of the whole chapter, exclaims in admiration: "He was a truly outstanding and admirable man, for whom fire tempers its burning heat, water changes its taste, a rock provides abundant drink, inanimate things obey, wild animals become tame, and to whom irrational creatures direct their attentions eagerly. In his benevolence the Lord of all things listens to his prayer, and in his liberality he provides food, gives guidance by the brightness of light, so that every creature is subservient to

him as a man of extraordinary sanctity, and even the Creator of all condescends to him" (LMn V, 5: *FAED* II, 707–8). The text is not lacking in some new contributions with respect to the *Legenda maior*. Bonaventure takes up a definition that had already been used by Thomas of Celano and Julian of Speyers, but that was also present in liturgical officiation, and calls Francis "the least of the lesser ones" (LMn III, 4: *FAED* II, 695). In addition, while Bonaventure, in allusion to his own gratitude toward the saint, had limited himself in the *Legenda maior* to stating that as a child he had been "snatched from the jaws of death" (LMj Prol.3: *FAED* II, 528) thanks to the saint's intercession, in the minor work he explains that his mother had made a vow to Francis for him after he had fallen gravely ill and he was "restored to the vigor of a healthy life" (LMn VII, 8: *FAED* II, 717).

At times, the hagiographer's theological-symbolic reflection is less successful, while in other instances the same miracle becomes the subject of a different reading. These are all grounds that urge us to look with renewed interest at this source that has been rather neglected and that instead, considering the liturgical use that was made of it, exercised influence that was in no way inferior to that of the *Legenda maior*.

The codex includes texts drawn from Bonaventure of Bagnoregio's hagiographic work. On f. 1r–2r, the prologue to the *Legenda maior* (fig. 2; only half of the first column is used on f. 2r); on ff. 3r–22r, the text of the *Legenda minor*; and finally, on ff. 22v–25r, chapter XV, in nine lessons, of the *Legenda maior*, a text that was used in the officiation of the festivity for the translation of Francis's body (it is introduced, in fact, by the heading placed on the last two lines of f. 22r: "In festo Translationis beati Francisci").

The codex is an elegant product, written in two columns. The individual chapters of the *Legenda minor* and chapter XV of the *Legenda maior* are introduced by color initials on a field of gold, with long colored tails and scrollwork in red and blue (ff. 3r, 5v, 9r, 11v, 14v, 17r, 19v, 22v). The individual lessons of each chapter, for the *Legenda minor* and for chapter XV of the *Legenda maior*, are introduced by filigreed initials (fig. 3).

The codex was employed mainly for liturgical use, but also for readings in the refectory as is evident in the extraordinarily valuable indications present on f. 2v, where it is specified that the *Legenda minor* was extracted from the *maior* so that it would be used in portable breviaries, and also in choir books. It was to be read in chorus, but it could also be used at meals on the feast days dedicated to Saint Francis.

Ubertino da Casale, *Arbor vitae crucifixae Jesu*

Marco Bartoli

Fondo Antico Comunale at the Biblioteca del Sacro Convento, Assisi, MS. 328
Sec. XIV$^{2/4}$ e XIV *med.*, membr. (for ff. 1–221, many sheets are palimpsests), ff. 280 (one numbering done by two different hands between mid-to-late 14th cent.); 323 × 224 mm. Composite codex *ab antiquo* with two elements: I. ff. 1r–221r; II. ff. 223r–280v. The first element (14th-cent.) is transcribed by a single hand in tight, angular Gothic writing in two columns (rr. 50/49 ll.). Initial to the volume painted with a brush and inhabited by an *Arbor vitae* crucifix embraced, at its base, by Ubertino da Casale, recognizable from his Franciscan habit (f. 1ra); remaining initials of the book painted with a brush and decorated with phytomorphic motifs (ff. 39vb, 68vb, 148vb); initials of verses in Gothic capitals inked alternatively in red lead and blue with filigrees in contrasting colors. Headings and verses in red lead by the same main copyist. Reading notes written in several 14th- and 15th-cent. hands appear in the margins of the sheets. This first element includes books I–IV of Ubertino's *Arbor vitae crucifixae Jesu*. The second element (mid-14th cent.) is transcribed by a single hand in minute, round, inelegant Gothic writing in two columns (rr. 54/53 ll.). Initials, majors and minor, in Gothic capitals invariably in red lead ink, as are the headings and sporadic running titles. This element contains book V of the same *Arbor vitae*. On f. 280v, in writing consistent with the same period: "F*rater* Ioseph Anto*niu*s Marcheselli legebat 1709 die 27 7m(bre), pro quo ora, benigne lector, sive vivus sit | sive mortuus." Modern restored binding, the preparation of which led to the sheet that created ff. 202 and 205 being inverted with the one that created ff. 203 and 204 with the subsequent disruption of the text of book IV of the work.
(Massimiliano Bassetti)

The Text's Origins

In the month of March in 1304, Friar Ubertino da Casale, a friar inor originally from Piedmont but incardinated in the province of Tuscany, climbed to the hermitage at La Verna on the sacred mountain of Franciscan history, to the place where eighty years earlier (in 1224) Francis of Assisi had experienced his encounter with the crucified Seraphim; it was the experience that left Francis's body marked by the stigmata (*Ubertino da Casale* 2014). Many other friars before Ubertino had climbed to La Verna in the desire to relive Francis's spiritual experience. Among them all, the most well known was certainly Friar Bonaventure of Bagnoregio, who had climbed the holy mountain in 1259, shortly after having been elected Minister General of the Friars Minor in 1257. There Bonaventure composed what many consider the masterpiece of his spiritual theology: the *Itinerarium mentis in Deum* (Bonaventura 1993). At La Verna, Ubertino met Friar Giovannino, guardian of the monastery, who urged him to write his work and then offered himself as amanuensis. This friar has been identified by some as that Giovanni della Verna to whom the last chapters of the *Actus beati Francisci* are dedicated (*Actus* 49–53: *FAOF* 1647–71), who settled on the holy mountain in 1292 and was certainly guardian of the monastery there in 1311.

While Ubertino was at the hermitage of the stigmata, there was a "most prudent virgin" (as he himself described her) living in a town not far away: Margherita of Città di Castello. This woman was of aristocratic origins but had been abandoned by her parents because she was disabled and blind; in her prayers, she followed, joined, and sometimes anticipated Ubertino's work in writing (Brufani 2009).

Ubertino set to work on March 9, 1305, urged by the insistence of his fellow brothers. From that day on, he dedicated himself to his work with considerable commitment for seven consecutive months, during which he sensed divine support on more than one occasion, as he states in the first prologue. It would all be done before the end of September 1305, on September 28, the eve of Saint Michael's feast (Ubertino 1961).

In reality, the *Arbor vitae crucifixae Jesu* became Ubertino's life's work, as he revised the text with additions and corrections throughout the course of his entire life. At least two main drafts of the work are known (Martínez Ruiz 2000). The Assisi codex, MS. 328 of the Fondo Antico Comunale of the Biblioteca del Sacro Convento includes the first of the two drafts, the one that is likely the oldest.

The Author

In 1305 Ubertino was forty-five years old and thirty-two years into his religious life. He was born in Casale Monferrato and entered the Minorite Order between 1273 and 1274, the year Bonaventure died and also the year when the rumor spread between some of the friars in the Marches that the bishops assembled in Council in Lyons intended to force the Friars Minor to renounce their vow of poverty. Faced with the choice between obeying the Rule and obeying the pope, some of those friars chose the former and were thus stripped of their habits and locked up in hermitages. Ubertino probably did not have detailed information about all of this, given his young age at the time he entered the Order (thirteen or fourteen years old), but he certainly had direct knowledge of it during the years he was sent to study in Florence (1285–89). An encounter be-

Fig. 1. Ubertino da Casale, *Arbor vitae crucifixae Jesu*, prologue. Assisi, Fondo Antico Comunale, Biblioteca del Sacro Convento, MS. 328, f. 1r.

Fig. 2. Ubertino da Casale, *Arbor vitae crucifixae Jesu*, end of the second prologue and beginning of first versicle. Assisi, Fondo Antico Comunale, Biblioteca del Sacro Convento, MS. 328, f. 4v.

tween Ubertino and Giovanni da Parma, an old deposed Minister General who had been living at the Greccio hermitage since 1259, dates back to that Florentine period. According to the account that Ubertino himself gives in book V of the *Arbor vitae*, Giovanni talked to him about Francis of Assisi as the "angel of the sixth seal," that is, in the eschatological role that the Assisi saint (and consequently his Order) had according to the Friars Minor's reading of history based on Gioacchino da Fiore's eschatological reflections (Potestà 1982).

Another encounter marked Ubertino's life in those years: the one with the Provençal friar Minor Peter John Olivi, sent to Florence as a lector by the General Minister Matteo d'Acquasparta. Olivi, who was Ubertino's teacher in those years, applied Joachimite ideas about the division of history in three ages to the experiences of the Franciscan Order and taught Ubertino (as the pupil himself recalls in the first prologue to the *Arbor vitae*) to "me ipsum sentire semper cum Ihesu mente et corde crucifixum" (feel myself always

crucified with Jesus in mind and body; Manselli 1965). Afterward, Ubertino was sent to finish his studies in Paris (1289–98), but it seems that there his decision to live the Rule faithfully and radically experienced a crisis. It was a crisis that coincided with a very difficult moment in the life of the Church and the Order: the 1294 election of Pope Celestine V, his resignation, and the election of Boniface VIII. When some of the Italian Spiritual Friars who had been authorized by Celestine V to profess the Minorite Rule in the Order of *Pauperes heremitae Domini Celestini* (poor hermits of Celestine V) saw themselves opposed by the new pope, they openly claimed Boniface's election was illegitimate (Merlo 2003).

In 1298, Ubertino returned to Florence and for four years he carried out the post of lector at the *studium* of Santa Croce. In following years, the Piedmontese friar dedicated himself to preaching, meeting with success in various places around Central Italy. His itinerant ministry was suddenly interrupted in 1304, however, when some friars

denounced him in front of Pope Benedict XI, perhaps precisely because of his preaching against the evils of the Church (Potestà 1980, 22). Ubertino was released thanks to the intervention of some ambassadors from Perugia, who affirmed that Ubertino "had illuminated the entire city and led it to God" (Callaey 1911, 54, no. 1). The pope freed Ubertino, but imposed on him a period of silence and withdrawal, and this is the reason why, in 1304, the friar arrived at the hermitage at La Verna where he would compose the *Arbor vitae crucifixae Jesu* (Manselli 1970).

The Content of the Arbor vitae crucifixae Jesu

The *Arbor vitae* presents itself as the synthesis of all of the author's theological reflections, the presentation of Ubertino's theological project that "discovers Jesus Christ and proposes Him as the only and urgent chance to reform the status of the Order, the Church, and theology itself" (Martínez Ruiz 2000, 238). Ubertino's choice of setting Christ at the center of all his theological reflection was certainly influenced by the place where he was writing (or better, dictating) his work. The memory of Francis's encounter with the Crucifix was preserved at La Verna. When Bonaventure climbed to La Verna, as has been noted, he had also composed a wholly Christological work. And it is precisely from Bonaventure that Ubertino's work begins. More precisely, as Carlos Mateo Martínez Ruiz has shown, the *Arbor vitae*'s departure point must be identified with a list of *versiculi* (short verses), that is, with a list of titles, drawn from either Bonaventure's *Lignum vitae* or from a *Rhythmus* attributed to him, that describe an attribute or action of Christ. Those *versiculi* became the titles of the different chapters of the *Arbor vitae*. When he reached the explanation of the verse *Yhesu futura previdens*, Ubertino felt an extremely strong impulse to explain all of Jesus's "*dolor cordi*," that is, the spiritual suffering Christ experienced during the Passion. This can be considered the core of the work, which corresponds to what would end up being *liber IV* of the *Arbor vitae*. Following Martínez Ruiz's reconstruction, we can identify the following phases in the drafting of the text: (1) presentation of the first *versiculi*, those concerning the Passion; (2) presentation of Jesus's *dolor cordi*; (3) presentation of the entire course of the Passion; (4) presentation of Jesus's entire life; (5) presentation of the evils of the Church (and refutation of its errors), with a widening of Christological reflection from the creation of the world on; (6) reflection on the Apocalypse (which would go on to constitute the fifth and last book of the *Arbor vitae*). To give structure to this vast subject matter, which departs from reflection on the Passion to then widen to include all Christology and from there ecclesiology and eschatology, Ubertino uses the image of a tree (fig. 1).

The work is divided into five books preceded by two prologues. The first book (fig. 2) deals with the history of the Word, from its eternal creation to the incarnation, and it corresponds to the roots; the second book, which corresponds to the trunk, deals with Jesus's childhood; the third, with His public life, and it corresponds to the branches; the fourth (which, as noted, was the first book drafted), deals with the Passion and Christ's death, resurrection, and ascent to heaven, and is represented by the tree's foliage. The fifth book (which corresponds in the image to the fruit on the tree) presents a theological reading of the history of the Church, with very ample quotes from Peter John Olivi. It is in this last part in particular that Ubertino underscores Francis's identification with the "angel of the sixth seal" and the expectation of a future age of peace and poverty under the guidance of an angelic pope. On this point, the author is not afraid to openly identify Pope Boniface VIII and Pope Benedict XI with the mystical Antichrist, and the Roman Church with the Babylon of the Apocalypse.

As Gabriele Zaccagnini has observed, "The *Arbor vitae* is a book pervaded by an intense mysticism, but Ubertino is not just a man of prayer. He is a man of action, a fighter for the cause of the Spiritual Friars and for the reform of the Church. He wants to immerse himself in contemplation of the divine mysteries but he feels invested with the task of fighting for the truth, defending the Order and the Church from Satan's assault, and comforting the Spiritual Friars, his companions in misfortune, reminding them that the difficulties of the present are nothing more than a passing moment, painful but indispensable, in their historical mission as witnesses to Francis and to *usus pauper*, in the certainty of the final triumph of truth and of the advent of a new era" (2007, 95).

The Arbor vitae*'s Fortune*

It is difficult to follow the success and diffusion of the *Arbor vitae* with any precision (Callaey 1921). It is possible that at least at first the work circulated almost clandestinely, as demonstrated by the fact that Ubertino's opposers in Avignon, under the papacy of John XXII, cite and refute many of Ubertino's works, though not the *Arbor vitae*, albeit it included a lot of material that could have been impeached (Burr 2001). These are precisely the reasons why the presence in the Biblioteca del Sacro Convento in Assisi of a codex including the first version of the *Arbor vitae crucifixae Jesu* is particularly significant. After the author's death the work spread on a wide scale. And it became a repertory from which various authors drew various spiritual reflections. Bernardino da Siena drew elements from it for reflection on the Name and Sacred Heart of Jesus, Peter of Alcantara found some considerations on Saint Joseph, and Leonard of Port Maurice drew reflections on participation in Mass (Callaey 1921).

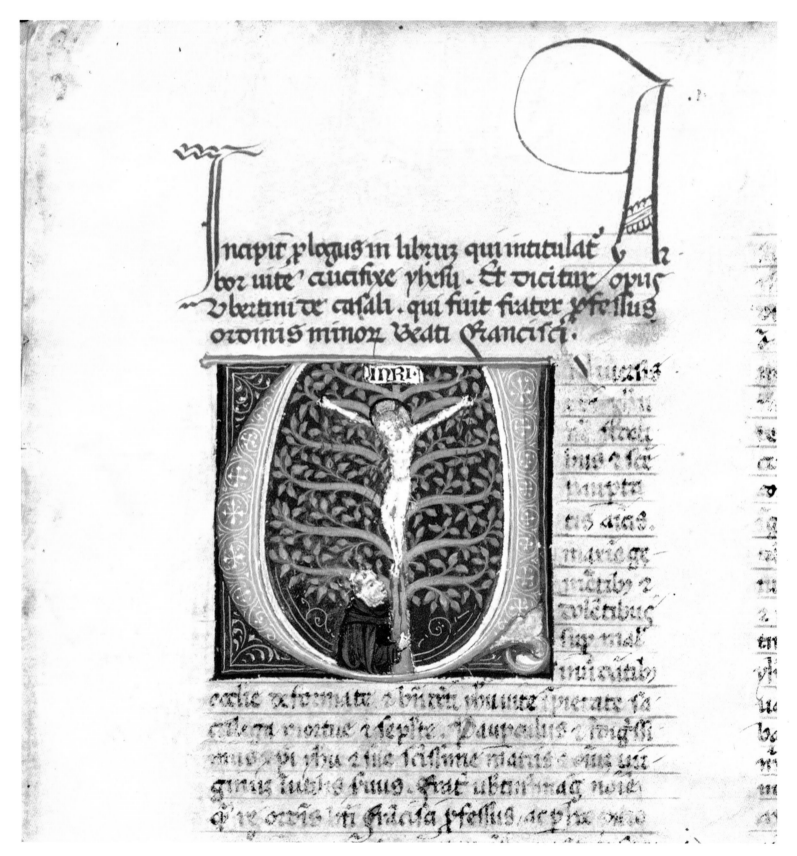

Fig. 1a. Ubertino da Casale, *Arbor vitae crucifixae*
Jesu, prologue, miniature with the *arbor vitae*.
Assisi, Fondo Antico Comunale, Biblioteca
del Sacro Convento, MS. 328, f. 1r (detail).

Chronica XXIV generalium Ordinis Minorum

Maria Teresa Dolso

Fondo Antico Comunale at the Biblioteca del Sacro Convento, Assisi, MS. 329
Sec. XIV *ex.*-XV *in.*, membr., ff. II, 190, II' (one numbering of the sheets in ink, from the 16th cent., from 1 to 189; modern writing in pencil counts the first endpaper I', membr., as "191"; endpapers I–II and II', cart., bear notes written in the 17th cent. that refer to the content of the work); 350 × 250 mm. Gothic writing by one hand, of what seems to be transalpine training, in two columns (rr. 45/44 ll.). In the margins of the manuscript there is a wealth of annotations written by at least three different hands from the 16th to 17th cent. Bordered illustration of the Rule being confirmed to Francis (f. 1ra), outlined in ink and colored in with a brush; a similar illustration remains only outlined in ink (f. 9rb); spaces are reserved at the beginning of each chapter for illustrations of this type that were never created (ff. 12va, 15ra, 18va, 21vb, 35ra, 37rb, 49va, 50rb, 54vb, 57vb, 67ra, 68vb, 73ra, 76va, 80rb, 82rb, 98va, 108rb, 111ra, 114va, 122vb, 126va, 130vb, 138rb, 141vb, 142rb, 146rb, 154vb, 162rb, 164rb, 166va, 168rb, 170rb, 174ra). Chapter initials in Gothic capitals inked alternatively in red lead and blue with filigrees in contrasting colors, in some cases extended. Minor initials in small Gothic capitals inked alternatively in red lead and blue, as are the numerous paragraph marks. Headings in red lead ink. On f. I'v, written in the 16th cent.: "Done in the year 1374" [the 3 corrected from a 2]. Modern binding in brown leather on cardboard strips with an iron border threaded with gold on the covers; two notes provide information about the restoration of the binding: the first, written on f. I'v by the restorer himself—"Io Fra Gio‹vanni› Battista Piacevole novizio napolitano libraro lo fatto in Assisi dì ultimo di marzo 1650 legato questo libro. | Vi prego che dite uno Pater et una Ave Maria per me peccatore" [I, Fra Gio‹vanni› Battista Piacevole, novice Neapolitan bookmaker did, in Assisi, the last day of March 1650, bind this book. | I beg you say a Pater and an Ave Maria for me, a sinner]—is continued on the inside back cover in a note written shortly thereafter: "Raconciò questo libro, e rilegò con le coperte | che vi stanno al presente *F*rate Gio*vanni* Batt*ista* Pia‹cevole napolitano, laico novizio libraro il dì | 1° Marzo 1650" [This book was repaired and the covers that are currently here were bound by *F*rate Giovanni Batt*ista* Pia‹cevole, Neapolitan, secular novice bookmaker, on the day March 1, 1650]. The manuscript contains the *Chronica XXIV generalium*.
(*Massimiliano Bassetti*)

The *Chronica XXIV generalium Ordinis Minorum*, composed toward the end of the 14th century, is a vast and complex work in which the chronicles and history of the Order of the Minors, marked by the succession of the first twenty-four Ministers General, are alternated with a wide collection of hagiography and exempla that begins with Francis of Assisi and his first companions and also includes Anthony of Padua, Clare, and the protomartyrs, up to the saints and martyrs from the 1300s, from Louis of Toulouse to Nicola di Montecorvino. It is a different and very comprehensive set of material, a stratified depository of remembrance and memories, of an Order—the Minors'—that had achieved extraordinary success in a few decades' time, but that had also gone through moments of crisis and was marked by strong centrifugal tendencies.

Nature and Purpose of the Work

The author's words suggest significant points of reflection for understanding the nature of the work and its purpose. The title itself, with the term *Chronica*, which was part of the manuscript tradition, presents an important clue for defining the nature of the text. With its attention to the Order's history and with an at times annalistic tendency, it shows itself decidedly as a history/chronicle, but with an equally clear hagiographic interest, evident primarily in the original operation of collecting and organizing the material available in true *Vite* of different exponents of the Order. Those *Vite* do not have an au-

tonomous manuscript tradition; they are, in fact, found only in the *Chronica*. The author's desire to create order, along with his direct intervention in the sources used and in the division of the subject matter into the twenty-four generalships, make the work something different with respect to the world of compilations, with which it does share several aspects and features. Franciscan compilations are collections of texts drafted in previous years that experienced a period of remarkable diffusion in the 14th century (Menestò 1988). Such substantial production has often been related to the difficult situation that arose in the 14th century when the Order's clash with the top ranks of Christianity "shipwrecked Franciscanism on the beach of 'compilation'" (Merlo 2009: 342). What this means is that the work of "normalization," which compilations were a far from irrelevant aspect of, "had by and large slowed the creative dynamism of Franciscanism" (Merlo 2009: 342). At the same time, however, the incessant desire to collect records of their own history—a desire that also characterizes the *Chronica*—allows us to glimpse "signs of renewed vitality and changes taking place" (Merlo 2004: 230).

In the *prologus*, the chronicler clarifies his work's objectives, saying that he "collected" everything that he was able to "find" about the Order's history and about the lives of the holy friars that was "scattered" in previous material and texts (*Chronica* 1897: 1). *Reperi* and *recollegi* are exactly the two terms he uses to describe his own commitment to research and to collecting the most varied

Fig. 1. *Chronica XXIV generalium ordinis Minorum*, illustration with the meeting of Saint Francis and his companions with Innocent III for the approval of the *propositum vitae*. Assisi, Fondo Antico Comunale, Biblioteca del Sacro Convento, MS. 329, f. 1r.

and diverse evidence; it is therefore a work of collecting, and at most of sorting, the material used. It is no longer a case of collating sources, since there is no mention of any autonomous writing activity, but just of compilation, as it seems the verb *recolligere* should here be interpreted (Guenée 1986).

With respect to the subject matter of the collection, the chronicler asserts that he turned his attention to everything of note that had happened in the Order in nearly two centuries of history: "notabilia bona et mala" (*Chronica* 1897: 1). The richness of the dossier of sources is striking. Next to narrative texts and episodic accounts there appear papal letters and privileges. The hagiographic memories of various saints and martyrs, among which Francis's first companions occupy a particular place, are not overlooked, nor is less space given to exempla. The chronicler, however, does not limit himself to merely transmitting such impressive material, rather he takes on the task of selecting sources, choosing the passages to relate, ordering them, and sometimes revising, abridging, or excerpting them, thereby creating a new work that responds to specific purposes (Dolso 2003: 257–382).

What then is the chronicler's aim? His words again provide us with the answer: *eruditio praesentiium* and *cautela futurorum*. He addresses his contemporaries with the aim of narrating and explaining the past and present to them, but he is also thinking just as much about those to come, so that past experience is used to avoid mistakes that have already happened. The careful reflection on the sources collected, the thorough reworking of the texts used, and the frequent critical analysis of the texts all demonstrate the care with which the author pursues his objective. While it is undeniable that one of the chronicler's primary aims must be the collection of previous material, he produces a work that is original in many respects and destined not to be confused with the dense tradition of 14th-century *compilationes*, but rather, to maintain its own identity. The *Chronica* indeed joins elements of compilation to a structure and design that are entirely absent in compilations. Furthermore, the absence of any specific interest in the Order's founder distances the work from the entire hagiographic tradition tied to Francis. Similarly, the absence of any geographical delimitation and the clear condemnation of any particularism within the Order distinguish the work likewise from the markedly regionalistic chronicles of the 13th century, as well as from controversial Spiritual production.

The Author

Information about the author is scarce and fragmentary; he has been identified, without decisive proof, with Arnald of Sarrant, Provincial Minister of Aquitaine (Michalczyk 1981: 23–25). The first to use his name, albeit in eloquent doubtfulness, was Luke Wadding, who relates that he was considered "by some" to be the author of the *Chronica* (*AM* VIII, 390). Grounds were then adduced from within the work to validate the hypothesis that Arnald is the author; the main reasons are the constant attention to Provincial Ministers of Aquitaine and to the ecclesiastical careers of some of them. Indeed, all the Provincial Ministers of that region are mentioned, with the only exceptions of Jean of Cognac—the first Minister proven with any certainty to have followed Cristoforo, who is traditionally considered the first of the series of Aquitanian Ministers—and Arnald of Sarrant himself, successor to the last minister mentioned, Rodolphe of Cornac. The fact that Arnald's name is omitted and that he was in office from 1366 to 1375, the years of the work's composition, can be taken as a clue to the *Chronica*'s authorship. The author also inserts the *Vita* dedicated to Cristoforo among those of Francis's first companions without any real logical justification, unless we allow that Aquitaine was precisely the author's region of origin.

Beyond these considerations, which are mostly known, upon internal examination of the work we can observe great attention given to the French area and a particular interest for, and deeper knowledge of events and people tied to that country. It is also possible at times to discern elements tied to that geographical sphere, since the chronicler uses sources produced in the French area. The author's identification nevertheless remains a substantially unresolved issue. While a work's attribution is never of secondary importance, in this case it would be of even greater value considering the fact that the Order was led by four Ministers General from Aquitaine (Geraldo Ot, Fortanier de Vassal, Guillaume Farinier, and Juan Bouchier) for nearly three decades, which were fundamental years of internal restructuring after the serious and traumatic crisis following the clash with John XXII (Dolso 2003: 189–255).

The Manuscript Tradition

The *Chronica XXIV generalium* was edited by Quintian Müller from the Collegio di San Bonaventura in Quaracchi (Florence) and published in 1897 in the third volume of *Analecta franciscana*. It is the only edition still existing today that is based on thirteen collated codices that date back to a period from the end of the 14th century to the end of the 15th century, the only exception being the Trent codex, which dates back to the 18th century (1758). Of these thirteen codices, ten are conserved in Italy and three are conserved abroad: in Vienna, in Hall in Tirol (Austria), and in Lviv (Ukraine). The primary area of conservation of Italian manuscripts is in Central Italy: Assisi, Florence, and Rome. Recently conducted research has identified four other codices, among which one is in the vernacular; they are the Latin codices in Strasbourg, Dublin, and Rome, and the vernacular codex in

Fig. 2. *Chronica XXIV generalium ordinis Minorum*, illustration in ink, not colored. Assisi, Fondo Antico Comunale, Biblioteca del Sacro Convento, MS. 329, f. 9r.

Siena, which are also datable to the end of the 14th century and the beginning of the 15th. The oldest source, which was used as the base manuscript for the critical edition, is MS. 329 in Assisi, followed by the codex conserved at the Biblioteca Angelica in Rome; both are datable to the end of the 14th century (the term *post quem* is clearly offered by the *Chronica* itself, which ends with the generalship of Leonardo da Giffoni, who led the Order from 1373 to 1378). Excluding the later codex in Trent and the two that are ascribable to a period of time that came shortly after the composition of the work, it seems clear that the 1400s were the period of the text's most intense diffusion.

Some thought should be given to the codices' origin, which is extremely difficult to trace back given the scarcity of notes and information communicated by the manuscripts themselves. We know that the codex at the Biblioteca Angelica in Rome came from the convent of Santa Maria degli Angeli in Assisi; that the codices in Hall in Tirol, Milan, and Trent had been conserved at the monasteries of Friars Minor Reformed; and that the other four manuscripts—the one in Naples, the two in Bologna, and the vernacular one in Siena—were certainly linked to the Basilica dell'Osservanza (Siena). The varied diffusion of the *Chronica* should be underscored; it relates to the nature of the text itself: the dominant themes, in fact, prove to be somehow common to and compatible with the different "souls" in the Order, unity being one of the work's leitmotifs. According to the author, unity alone could guarantee the Minorite institution's survival. The *Chronica*'s success, which was not exceptional but consistent, as attested by the seventeen surviving sources, highlights its historiographical and institutional vocation. It is essentially the first real institutional history of the Minors as it is dedicated not only and not primarily to the life of the founder, but to the experiences of the entire Order. Setting aside the *Historia septem tribulationum* by Angelo Clareno—to which wide consensus was precluded by its marked choice of field and which, furthermore, commemorated the historical events of a more restricted time span than that of the *Chronica*—the *Chronica* is, in effect, the first work to set as its objective a comprehensive history of the Minors. Angelo Clareno's *Historia*—Clareno was one of the Spiritual group's major exponents (*Angelo Clareno francescano* 2007)—is, in fact, addressed to his fellows, considering them the only ones faithful to Francis's teachings, and outlines a history of the Order's gradual and ineluctable decline, a history that is meant to give sense to their own struggles and tribulations. The *Chronica*, on the other hand, presents a positive image of the Order in its entirety. In annalistic style, the author retraces the friars' experiences from their beginning to the end of the 1300s. He takes the succession of Ministers General as the subdivision of the subject matter and he puts the *ordo*

fratrum Minorum at the center of his own account, presenting a series of details, information, known and unknown episodes, and an extremely wide selection of hagiographic material not focused on the founder (and destined to be widely used later in 15th- and 16th-century compilations, beginning with Bartolomeo da Pisa's *De conformitate* up to Nicolaus Glassberger's *Chronica*). Thus, in the course of the 1400s, in a situation in which the Order was effectively and definitively fractured—as made clear by the birth and gradual development of the Observant movement—those friars who wanted to recover their own past and remember their history, which was tortured at times but always read in a positive light, drew from the *Chronica XXIV generalium*. The *Chronica* became the attestation of different paths and orientations, in supposed continuity with the difficult present situation that was founded on that past and moreover sought its most valid legitimation in it.

All the codices, with the one exception of the manuscript conserved at the Order's general archive in Rome (Dolso 2004: 224–42), convey essentially the same version of the *Chronica*. The text of the work, which is extremely long and complicated by the frequent insertion of *Vitae* and *Passiones*, presents the same structure and narrative sequence with few, insignificant variations. These observations lead us to believe that the *Chronica* was conceived and written in a unified manner and was not, therefore, the result of later revisions and rearrangements.

Manuscript 329 of the Biblioteca del Sacro Convento in Assisi

Manuscript 329, as has been mentioned, is the base manuscript from which the critical edition was created, and for this reason it has great importance (Cenci 1981: 49–50; Dolso 2004: 196–99). The marginal notes are extremely numerous, a sign that the manuscript was consulted and read often. There are two illustrations. The first is on f. 1r (fig. 1) and represents Francis and his companions' meeting with Innocent III for the approval of the *propositum vitae*. It is a watercolor illustration in a style typical of Franciscan manuscripts from the 1300s. The second figure is on f. 9r (fig. 2), but it is uncolored. There is, additionally, space throughout the codex for other illustrations that were never created (fig. 3). The manuscript ends with a singular benediction-malediction colophon (benediction for he who wrote the manuscript and malediction for he who might steal it): "Sorte supernorum scriptor libri potiatur / Morte superborum raptor libri moriatur" (May the writer of the book obtain the fate of the supernal / May the thief of this book die the death of the arrogant; fig. 4). The medium-large format, the illuminated and filigreed initials, and the regularity of the paragraphs, as well as the catchwords at the end of each fascicle, are signs of care and precision.

Fig. 3. *Chronica XXIV generalium ordinis Minorum*, space for an illustration that was never created. Assisi, Fondo Antico Comunale, Biblioteca del Sacro Convento, MS. 329, f. 174r.

Fig. 4. *Chronica XXIV generalium ordinis Minorum*, singular benediction –malediction colophon. Assisi, Fondo Antico Comunale, Biblioteca del Sacro Convento, MS. 329, f. 191r.

SOR··.	SUPERNO··.	SCRIP··.	LI··.	POTIA··.
TE	RUM	TOR	BRI	TUR
MOR·.·	SUPERBO.··	RAP.··	LI.··	MORIA.··

The manuscript is intact, there are no missing sheets, and it is well-preserved. It includes the text of the *Chronica* and the stories of the *Passiones*, which are found in the first appendix of the critical edition.

The Work's Historical Context and Significance
The *Chronica* ends its narrative at the twenty-fourth Minister General, in office from 1373 to 1378, to whom only a few lines are dedicated. It is reasonable to assume, given the size of the text, that the author devoted himself to its composition during the 1360s to 1370s. That was on the eve of the birth of the Observant movement that would, in fact, entail the definitive rupture of the Order's unity.

The Observant experience was still at its inception, but significantly, the author does not talk about it, while he does dwell on the execrated situation with Gentile da Spoleto—traditionally considered a precursor to Paoluccio Trinci, who started the Observant movement. This, above all, is the most difficult phase of the Minors' history, after that of the agonizing crisis of the 1320s, when the Order was the target of John XXII's extremely harsh positions: the pope had denied the foundation of evangelical perfection with which the Minors had fostered their identity and their claim to incarnate a salvific and providential role within the Church and society (Tabarroni 1990). The clash with the top-ranked figure of Christianity was fol-

lowed by bitter internal dissent that brought about the removal of the Minister General Michele da Cesena and his replacement with the controversial Geraldo Ot, who was close to the pope's positions. These were decades of difficult and troubled internal reorganization, during which the search for new ideological and institutional balance was joined by the ever-present yearnings of more or less small groups of friars who wanted to live Minorite lifestyle more rigorously, in full conformity with Francis's Rule and Testament. This feverish and murky period between the 1330s and 1360s finds little space in Franciscan sources. From the historiographical perspective, it is a phase that, as it has recently been described, "while not really overlooked, is in general considered of little interest with respect to the 'extremely interesting' pre-crisis events of the beginning of the 14th century" (Merlo 2004: 230). We would not be able to understand many of the strong reasons underlying the *Chronica* author's work, or that of a number of the Franciscan compilations, without considering the ideological backlash from John XXII's decisions. Evangelical poverty, which coincided with Franciscan poverty, had been denied by the leader of Christianity and "[t]he identity of the Friars Minor that was strong and meaningful and had been elaborated in close connection with the papacy, was now denied by the papacy" (Merlo 2009: 312). From this point on, in the years immediately following, the situation progressively deteriorated and the Franciscan leadership's dissent with the pope's decisions grew increasingly sharp until it led to the rupture and consequent excommunication of Michele da Cesena, who was dismissed from his rule of the Order. Recent historiography has used heavy and meaningful terms to discuss a "fragmentation of the Minorite world," about events that would have made necessary a "rather long period to rethink Franciscanism. Such rethinking, however, could never reconcile the strong, internal, and dialectic conflicts within Franciscanism" (Merlo 2009: 315–16). Up to that point, although debate and even violent polemics had often divided the friars, the common conviction that they represented a providential and in some ways unique event in the history of the Church, just as Francis had been providential and unique, had never faltered. After the 1320s, however, the Order was not, and could no longer be, the same. It was necessary and inevitable that it should find new grounds on which to found its self-awareness and its religious specificity, which by then could no longer come from assuming evangelical poverty. It was a complex period of transition toward a new, creative, albeit contested, season for the Order—that of the Observants. This would entail the definitive split between the friars, but would also guarantee a century of extraordinary vitality.

While the Order emerged inevitably reshaped from the crisis with John XXII, it retained its institutions as its strength, the branches of its solid provincial organization, its leadership docilely brought back into strict obedience to Rome, its ever-close relationships with the aristocracy and upper levels of society, the drastic marginalization of the ferment of internal dissidence, and the emphasis on Franciscan saints and martyrs. It is no coincidence that the *Chronica* is an extraordinary "container" of hagiography and martyrology and that in light of such strongly desired normalization, as recent historiographical reflections have highlighted, the theme of martyrdom emerges so vividly in close relation to the problem of a debated and threatened identity (Heullant-Donat 2005).

The celebration of the Order's sanctity—expressed in the *Chronica* through a series of numerous and sometimes unpublished *Vite*, of multiple accounts focused on the glorious martyrdom suffered by the friars in distant lands overseas, of remembrances of friars buried in the various provinces, and through numerous exempla highlighting the virtues, miracles, and testimonials of the holy lives of many members of the Order—represents concrete compensation for the evils and tribulations the Minors suffered, and is, at the same time, an effective answer to those within and outside the Minorite institution who had questioned its role and way of being. The text thus presents the friars themselves, the primary recipients and users of the work, with what, if not models of behavior, were parameters of sanctity. It is only the theme of sanctity and martyrdom that allows the chronicler to find a reassuring and positive solution to a history that was inevitably plagued by an excess of conflicts and which left too many unanswered questions. In the radical nature of their life experiences, the martyrs in particular, even more than other saints, summarize a parable that is common to the whole Order, understood as an institution. Their sacrifice, the tribulations they endured, their decision to sacrifice themselves to bear witness to faith in the certainty of being rewarded by safely achieving their destiny of salvation and eternal glory are all mirrored in what happens to the Order where suffering makes sense in light of achieving the end goal of heavenly redemption. This is the connection I believe the chronicler means to make. It is also the attempt to find a convincing logic and explanation for evil and for the evils present in the Order by attributing to them the function of tests, of extreme suffering, such as that of the martyrs, out of the need to bear witness to faith, in expectation of otherworldly triumph.

Finding the key to understanding the Minorite family's difficult path in the parable of martyrs allowed the chronicler to establish his own ideological construction on a shared foundation. In the event of martyrdom, in the lofty, unachievable, and thus all the more admirable, sanctity of martyrs, all the friars could find a model of perfection and especially a road to reconciliation. This road, however difficult, allowed them to escape the greatest *tribulatio*, the *malum irreperabile* of division and fracture.

Fioretti di san Francesco

Stefano Brufani

Fondo Antico Comunale at the Biblioteca del Sacro Convento, Assisi, MS. 651
1485 ca. (see f. 139r: "correndo l'anno della natività | del nostro signore Yesu Christo .mcccclxxxv. a dì | ultimo di sectembre" [it being the year of the nativitiy | of our Lord Jesus Christ mcccclxxxv. on | the last day of September]) and sec. XV *ex.*, cart., ff. 185 (only one modern numbering in pencil from 1 to 185); 200 × 130 mm. Writing only by the inconstant hand of Virginio di Giacomo di Trevi (see f. 139r: "Ad laude et gloria dello omnipotente Dio | et de la sua santissima et dulcissima matre | virgene Maria et de meser san Francesco forono forniti | li soi fioricti et scripti in Trevi per Virgenio de Iacono | de la decta terra") in humanist cursive arranged in long lines (ll. 24). Chapter initials in irregular capitals, paragraph marks and headings in red lead ink. Florentine-style binding (15th-cent.) with studs in the center and at the four corners of both covers. On the inside front cover, 16th-cent. writing in italics presents an index of the volume: "Codice | che contiene | I Fioretti | 2. Poema: Il buon | padre di famiglia | 3. Poema: S. Mad|dalena | 4. Regola del 3° Ordine | 5. Santi Terziarj | 5. Frutti della S. Messa" [Codex | that contains | I Fioretti (ff. 1r-139r) | 2. Poem: The good family man (ff. 140r-147v) | 3. Poem: St. Mad|eleine (ff. 148r-164v) | 4. Rule of the 3rd Order (ff. 167r-178v) | 5. Tertiary Saints (ff. 178v-179v) | 5. Fruits of the Holy Mass (ff. 179v-183v)]. Below, written very shortly thereafter: "1485."
(*Massimiliano Bassetti*)

The most famous collection of Franciscan hagiography in the vernacular is known by the title *Fioretti di san Francesco* (*Little Flowers of Saint Francis*). The text's content is specified in the initial heading: "In this book are contained certain little flowers, miracles and devout examples of the glorious little poor man of Christ Sir Saint Francis and some of his holy companions" (*Fior* I: *FAED* III, 566). The work, that dates from the last quarter of the 14th century, is the vernacularization in the Tuscan language of fifty-three chapters of the *Actus beati Francisci et sociorum eius*, followed by the five *Considerations on the Stigmata* and often by the vernacularizations of the *Life of Friar Juniper* and of the blessed Giles of Assisi's *Sayings*.

The *Fioretti* have been seen simply as a translation of the *Actus*. Retracing the passage from the *Actus* to the *Fioretti*, Giorgio Petrocchi demonstrated with breadth and detail that the content and even the poetic tone, though certainly not the linguistic rendering, that for centuries have shaped Francis of Assisi's "popular" image, must be accredited entirely to the *Actus*, of which the *Fioretti* are the extremely fortunate vernacularization-translation (1957; 1983, 45–50). In the successful collection *Fonti Francescane* the edition of the *Fioretti* is used, and not a translation of the *Actus* (see *FF* 1826–1895), just as the corresponding collection in French from a few years earlier preferred to translate the *Fioretti* rather than their source (*Saint François d'Assise* 1968). Only recently has the initiative been taken to translate the *Actus* directly (see *FAED* III: 435–565; Dalarun 2008; *FAOF*: 1431–1757). But in introductions, what is discussed is mainly the *Actus*: the author, sources, and purposes of the text. Even in the posthumous edition by Jacques Cambell the text of the *Fioretti* accompanies the corresponding chapters of the *Actus* (*Actus* 1988). So we shifted from the overwhelming manuscript and print-publishing luck of the *Fioretti*, which obliterated the significance and value of its source, to the rediscovery of the *Actus* as a source on which to focus historical-hagiographical research. The *Fioretti* were thus reduced to a mere translation, albeit a literary one of high level, that is significant as linguistic evidence of the Tuscan language's good century. Clarifying the relationship between the *Actus* and the *Fioretti* then led, for practical reasons, to a substantial identification of the source with the vernacularization-translation; in writing about one, excerpts from the other would be cited as support, and the work's characteristics would be attributed to the author and vernacularizer as though they were coauthors of a single work so that a unity of intent is read into both works.

Perhaps the moment has arrived to reconsider the purposes of the two works separately, even with the knowledge now gained about the type of relationship that exists between them. Fra Ugolino from Monte Santa Maria, now Montegiorgio, the author of the *Actus*, wrote between 1327 and 1337 (Menestò 1995: 2057–84). The author drew from written sources and oral tradition. In the first part, the longest one, he narrates episodes of Francis's holiness and episodes from the first generation of the Friars Minor; in the second part, he narrates the experiences of daily holiness of the holy friars from later generations, who lived in the hermitages in the province of the March of Ancona. Ugolino may have had a continuer or at least a collaborator (*scriptor*). The numerous chapters that make up the *Actus* are hagiographic pieces with typically Franciscan motifs: perfect humility, absolute poverty, true joy, ascetic practices, peace with creation, visions and mystical experiences, and at the core, the theme of conformity to Christ, thanks to which Francis is defined for the first time explicitly as *quasi alter Christus* (*Actus* VI,1: *Fontes* 1995, 2098; *Atti* 6: *FAOF*, 1462).

A cohesive model of holiness to put forth for the friars and

Opera gratiosissima et utilissima a tutti li fidili xpiani
laquale sechiama lifioricti demess. san fran. assimilatiua
alla uita e allapassione de yhu xpo e tutte lesia sce uestigie
Et opera tutta fondata:—

Prima mente e da notare
et gli derare ch luglurioso
mess fro francesco i tutti
liacti d lla uita sua fo g
fotato da yhu xpo. Impo
ch come xpo nel principio
d lla sua fdicatioe elesse dudici
copagni cioe apostoli, ad expre
zare omni cosa modana, e seg
tare lui i pouertade e nelle altre
uirtude: Cusi sco. f. elesse alp̄ncipio
p fodamcto d llordine d lli dudici co
pagni pfixori d llaltissima pouerta, et
come uno d lli dudici apostoli d xpo
riprouato dadio: finalmente se ipicho
p lagola: Cusi uno delli copagni d san
f. ch ebbe nome frate fo d llacapella
apostando finalmente se ipicho seme
desmo p lagola: Et questo sie grand exemplo

Fig. 1. *Little Flowers of Saint Francis*, incipit: "Gracious and useful work for all the faithful Christians, called the Little Flowers of Saint Francis." Assisi, Fondo Antico Comunale, Biblioteca del Sacro Convento, MS. 651, f. 1r.

the simple faithful to imitate does not emerge from reading the entirety of the episodes in the *Actus*, not one that can be compared to those of the official and unofficial hagiographic works that came before, from Thomas of Celano's *Vita beati Francisci* to Bonaventure of Bagnoregio's *Legenda maior*, from the *Legenda trium sociorum* to the *Speculum perfectionis*. The lack of historical context and of the problematic nature of the story, of Francis and the first generation of Friars Minor as well as the generation that was contemporary with the author, is bridged by the magic of the narration, where miracle and the marvelous envelop every event and resolve everything in a paradisiacal atmosphere. For their narrative vivacity, realism, and efficacy, the brief narrations that follow one after the other have been likened to the literature of *novelle*, although Cesare Segre has noted a fundamental difference from that literature in the absence of evil and therefore of the good/evil dualism (1997, 351–52). The *Actus*'s atypicality in the panorama of Franciscan hagiography—despite the invention of episodes destined to make their mark on the religious imaginary of later centuries, like the narration of the episodes of the wolf in Gubbio or of perfect joy—made it less suited, less likely, as a candidate for programmatically becoming the source of the "vulgate" image of Francis of Assisi that was to be put forth as a model of holiness for the Friars Minor as well as for the legions of the devout laity. Just to give a significant example, we can remember how the quintessential hagiographic anthology written from Greccio by Francis's companions Leo, Rufino, and Angelo did not claim to be complete in itself, but was conceived as a collection of edifying episodes to be made available to a professional hagiographer so he could write a *legenda*.

And yet an anonymous author, half a century later, chose that atypical hagiographic anthology from among all possible works to engage in the work of a vernacularizer. With respect to the time we might hypothesize as that of the writing of the translation, Benvenuto Bughetti says he is convinced that the *Fioretti* can be placed between the drafting of the *Chronica XXIV generalium*—circa 1370—and that of Bartolomeo da Pisa's *De conformitate*—1385–90, approved at the Friars Minor's General Chapter in 1399 (1928: 112–13). The vulgarization was therefore drafted in a profoundly changed historical context, not during the years of the long and authoritarian papacy of John XXII, but during the very serious and many-decades-long crisis of the Great Western Schism, when papal authority was seriously weakened by the coexistence of two-to-three popes, and the crisis of the Minorites and the related Fraticelli was being resolved by settling on new forms of observance, with a renewed movement back and forth between hermitage and city.

The profound change in the historical-religious picture that occurred between the time the *Actus* was written and the time it was vernacularized into the *Fioretti* is not an indifferent element for understanding the meaning of the two works. As Petrocchi has claimed, with respect to content, "the 'Franciscanism' of the *Actus* is identical, from every perspective, to that of the *Fioretti*" (1957: 134). But the vernacularizer, as Achille Tartaro has observed, gives it "a new topicality through the ideo-sociological displacement of the translation's perspective" (1972: 478), which must be looked at as a historical moment distinct from that of the source.

The absence of history (Leonardi 1983: 5) and the bracketing off of evil (Segre 1997: 351–52), which have been noted as characteristic features of the *Actus*, could be just one side of the coin. Flipping the coin over, we reveal, through language that Paul Sabatier has called "cryptic" (1902: XIII), the song of sorrows of the friars who were persecuted for their fidelity to the Rule and strict observance of poverty; it is a song understandable only to those who were directly involved in the tragic events of the 1320s and 1330s. But the *Actus* could also be read as the story of an escape from the tragic history of the time, when there was no space for those who did not take sides, when evil was put in brackets in the narration because if he wasn't able to recreate a *hortus conclusus* where he could cultivate the hope of a better tomorrow, man risked being overwhelmed by anguish and succumbing. While it does not put forth an organic model of holiness with its fragments of paradisiacal life—from Francis of Assisi to Giovanni da Fermo or Giovanni della Verna, from Porziuncola to the hermitages of the March of Ancona—the *Actus* could be an excellent viaticum for getting through the dark night of that absurd page of history (Brufani 1998).

So the *Actus*, like Giovanni Boccaccio's *Decameron* at the time of the great black plague in the middle of the 14th century, is a book that, after it has been read, then as now, would lead you to say, like Edoardo De Filippo at the end of *Napoli milionaria! (Side Street Story*, 1950): "Ha da passà a nuttata" (You just have to get through the night).

Why a book with these characteristics—without history but born from a precise historical context, without an organic hagiographic model, without a moral because one was not needed in a paradisiacal world without sin—was chosen for a vernacularized version is not a problem of simple solution. Carlo Delcorno reminds us that the question Carlo Dionisotti formulated about vernacularizations of classical texts should be asked of vernacularizations of religious writings as well: "It is important to know not just why they were done, but for whom" (Delcorno 1998: 5). It would also be important to know who carried out such a cultural operation: working on a text born in Latin, in another cultural context, and with aims that were conditioned by a learned language, only for clerics. Study of the manuscript tradition is fundamentally important (Natale 2013) since every time a client, amanuensis, private buyer, or library chose the *Fioretti*, they confirmed the intention and pur-

poses expressed by the vernacularizer, preferring them to the parallel Latin tradition of the *Actus*. Overall consideration of these factors allows us, finally, to evaluate in the present case the greater or lesser relevance of the judgment that Giuseppe De Luca gave of fourteenth-century vernacularizations when he stated that "translation and compilation prevail over original literature and are, if you'll allow the pun, more original" (De Luca 1954: XXVI).

The work of vernacularizing the *Actus* in the Tuscan language, carried out by a Franciscan friar or by a layperson—there are not certainties about this—offers the chance of a second life to a text that was born in lonely hermitages, in environments contiguous with the Minorite Fraticelli, in a historical context with well-defined space/time coordinates. According to the outcome, at least, it is not a mere translation. Petrocchi performed a comprehensive and thorough analysis of the move from the Latin source to the new version in the vernacular, the painstaking work done, and its final value. It was a question of translating and adapting the text for a different audience, "because they want[ed] to address the people" (Petrocchi 1957: 128).

The term *vernacularization*, broader and more comprehensive than that of *translation*, does not fully render the idea of the complexity of the outcome of that work. Perhaps the least inadequate word for expressing the meaning and effects of this operation is the term *translatio*, in the etymological and variegated sense of the term, which includes the idea of translation, but also of transposition, transfer, transplant, grafting. The happy outcome of all these aspects together transformed an operation that at first glance was a simple translation for laypeople ignorant of Latin, into rewriting a work that was perhaps more original than the original, to use De Luca's words. This is the starting point to build from with some brief considerations that, if they cannot be resolved into new certainties, can at least lead to further reflection (Brufani 2010: 204–14).

The first element certainly coincides with the signature on the oldest dated codex that includes the *Fioretti* and the *Considerations*. It is the paper codex conserved in Florence at the Biblioteca Nazionale Centrale with the call number Palatino 144 (E.5.9, 84; *Manoscritti datati* 2003: 27; Petrocchi 1957a: 315). The *Fioretti* are contained on ff. 1r–103r, followed by the *Considerations*. On f. 103r, there is the following signature: "iscritto [e] cchonpiuto per me Amaretto giovedì a dì 13 di lulglio 1396 alle XVIII ore. A Dio sia onore [e] grolia. Amen" (written and completed by me, Amaretto, Thursday, the 13th day of July, 1396, at 6:00 pm. Honor and glory be to God. Amen). In the edition published by Luigi Manzoni, the name Amaretto was traced back to the Florentine family of Mannelli (*Fioretti* 1902: XXVIII) and to a cultured environment of readers, transcribers, and authors.

The manuscript tradition that developed with incredible vivacity from the end of the 14th century through all of the

Fig. 2. *Little Flowers of Saint Francis*, chapter II: conversion of Bernardo di Quintavalle. Assisi, Fondo Antico Comunale, Biblioteca del Sacro Convento, MS. 651, f. 2r.

15th century, before it was supplanted by sixteen printed editions from the 15th century and twelve from the 16th century (Manzoni 1887: XXIII, 121–30), has been briefly described in Petrocchi's survey (1957a; Fascetti 2009). In a first reading of the entries for eighty-four codices some interesting elements already stand out. In some cases, there emerge the names of copyists who cannot immediately be traced back to the Order of Friars Minor, rather, they could be laypeople who through devotion or personal pleasure provided the transcription of the *Fioretti*. The origin of some manuscripts outside the typical conventual places could lead to the hypothesis that they were used as personal or shared books of devotion.

The environments of the Friars Minor and their libraries, however, had to remain privileged places of the production of new copies and of their conservation and diffusion, not unlike a lot of other devotional literature in the vernacular, but without being able to claim exclusivity.

A significant part of the codices Petrocchi surveys are Florentine and the majority of the others are from Central-Northern Italy. The origin of the vernacularization of the *Fioretti*, the diffusion of their codices, and their use should necessarily be inserted into the context of the writers of religion or devotional literature who had their golden age in the 14th century. As authors of works in the vernacular and of vernacularizations, the members of the new religious orders had an important role. So it is in the Tuscan

context of the very lively mercantile cities that we must look for the soil in which the idea of translating, as Domenico Cavalca says, "for the secular and without grammar" (Delcorno 1998: 12–22) blossomed.

A careful study of the manuscript tradition could present more than a few surprises in relation to the identity of the vernacularizer or vernacularizers (this plurality of translation has been shown by Bughetti 1928: 325), his identification with the compiler of the *Considerations* (in the oldest manuscripts, datable to the end of the 14th century, they are copied after the *Fioretti*), and the indivisible unity of the two parts.

Finally, it is opportune that we ask the crucial question suggested by Dionisotti and reiterated by Delcorno about the reason for creating a vernacularization. The answer is found in part in the choice of an audience that was not limited to that of the Friars Minor, clerics who were able to read Latin, but was expanded, through the use of the vernacular, to include the lay friars and especially the devout laity. The vernacularizer's choice to draw from the Franciscan hagiographic tradition differed from Domenico Cavalca's, made some years earlier, to translate the *Vitae Patrum* from the Latin version. This text was already well known by the first Minorite *fraternitas*, who made it the source of edification on the most official and participatory occasion the Order had, the Chapter meetings. Faced with the Franciscan hagiographic tradition that had developed prodigiously in the 13th and 14th centuries, the vernacularizer opted for a new proposal and considered it worthy of being set alongside the centuries-old one of the *Vitae Patrum*. It was a remarkable act of Minorite self-awareness and faith in the power of the devotional diffusion of Franciscan hagiography in the vernacular. His choice was rewarded with success.

The choice of saints and exempla of exemplary life that were contemporary to Minorite history or that belonged to its immediate past responded to the need that had been felt in the Church since the beginning of the 13th century to provide narrations of modern saints because they were more effective for pastoral work and at the same time express the idea that not just Francis but all the best friars of the first Minorite generation, and even of later generations, provided edifying examples of Christian life. So alongside the ancient fathers we find the new fathers, alongside the desert, the Apennines of Central Italy, alongside Thebaid populated by anchorites, the multitude of Franciscan hermitages inhabited by small communities of simple Friars Minor.

The choice of the *Actus* as source in preference to others allowed the vernacularizer to select the episodes that interested him from a work that was not systematically organized, leaving out those that in their content or because of their narrative effect did not seem useful to his aim, without, however, being obliged to create a work of compilation or epitomization, since the source itself was not structured according to chronological succession or thematic order,

but in short, independent chapters. The nature and tone of the narratives, unassuming on the theological level and where the moral emerged with immediacy in the course of the episode, lent themselves well to being left to the reading of laypeople, even of individuals, without the need for ecclesiastical mediation.

The success of the operation is confirmed by the impressive manuscript and print tradition and, indirectly, by the meager success of other vernacularizations of hagiographic works that were far more authoritative for the official nature of the texts or their referencing of the tradition of the companions. We can think, for example, of the vernacularization of Bonaventure of Bagnoregio's *Legenda maior* or those of the *Legenda trium sociorum* (BAI 2003: 270–73). The impression we have is that the success of the *Fioretti*, which was certainly not a mirror of the modest diffusion of its source, was not determined just by the easy usability of a vernacularized text, but also by the encounter between the happy choice of source and a public thirsty for short, easily readable hagiographic narratives in which there were many miracles, elements of marvel, and visions.

In conventual libraries, the *Fioretti* found a place next to the codices and printed editions of Francis of Assisi's writings and of the hagiographic works, Bonaventure's *Legenda maior* first of all; sometimes they would also be found in the same miscellaneous manuscript (Manzoni 1887: 81–120). In relation to theological study, reading the *Fioretti* could offer the clergy the chance for *divertissement* in their training, suggest cues for "popular" preaching, and open up a spiritual *hortus deliciarum* where they could take refuge in time of spiritual and institutional crisis to draw hope that holiness was always possible. In the hands of the devout laity, the hagiographic anthology could be a valid aid to turn to between listening to one sermon and another, to nourish their Franciscan devotion, and to extract examples of virtue that were useful in daily life. Among an audience of possibly less devout readers, one could easily turn from reading a hagiographic short story to one from the *Decameron* or the post-Boccaccio short story tradition, as they did in the Mannelli household in Florence, so close was the literary tradition between these genres. On many of the *Fioretti*'s pages, and in the writings that followed them, from the *Life of Brother Juniper* to the *Life* and *Sayings* of the blessed Giles, "we really are in an area near the *piacevolezza* of the *Decameron*" (Bruni 1997: 83).

The *Fioretti*, with what Gianfranco Contini called their "extraordinary success in visualizing the Franciscan biography, comparable only to the literally figurative success of Giotto" (1970: 540), deeply characterized Francis's popular image, more than any other source in the course of the centuries. The vernacularizer essentially did not invent anything, finding it all already in the *Actus*, but thanks to his initiative, he made Franciscanism in the vernacular permanently accessible and familiar to all.

Fig. 3. *Little Flowers of Saint Francis*, chapter III, heading: "How Saint Francis went the forest to talk with Fra Bernardo and how he found him in contemplation." Assisi, Fondo Antico Comunale, Biblioteca del Sacro Convento, MS. 651, f. 4v.

Questa uisione ditte p̄ l'amor de dio cioch
lui aueua, 2 finse frate minore, 2 fone
ll'ordine di tanta sintita 2 grattia ch pā
laua co dio come fa l'uno amico co l'altro,
secudo ch sm̄ F: pio, 2 pio gio se dichiarana,
Mes bernardo similmente aue tanta gra da
dadio ch spesse uolte era rapto i dio i co
templatione: & e sto F: diciua di lui
ch lui era digno d'ongne reuerentia 2
ch lui auia fodato questo ordine, impo
ch lui era stato elp ch auea abandonato
el mondo, no restandose nulla, mado
onne cosa alli pouiri di xpo, 2 comizato
la pouerta euangnelica, offerendose nudo
alle braccia di lo crocifixo, luquale da nuy
sia benedicto i secula seculorū amī:

Como san fram ando all a selua p̄ parlare co frate bēn:
et como lotroaua i co templatione:——

O deuotissimo figo dello crocifixo
mes sm̄ F̄. p̄ la sperezza della pi
nitentia 2 q̄ tuco tinuo piagnere,
era deuentato quasi cecho, 2
poco uedea, una uolta i tra le altre, el
se partì dallo loco doue lui era, et ando

Images

Cantorinus

Two sequences for Saint Francis in Manuscript 695 in the Biblioteca del Sacro Convento of Assisi

Agostino Ziino

Fondo Antico Comunale at the Biblioteca del Sacro Convento, Assisi, MS. 695

Sec. XIII[1], membr., ff. 242 (two numberings of the papers: the former in Roman numerals of the XIII[2] cent., from I to CXCIII for the ff. 56–239; the second in pencil added during restoration of the volume, corrected from 1 to 242); 210 × 150 mm. Highly calligraphic Gothic transalpine writing by a single hand in a long line supporting the squared notation on a four-line staff. At f. 242r-v the person applying the 13th-cent. numeration prepared an index relating exclusively to the numbered section of the codex. Great number of initials painted with a brush and filled with gold; many of them (plausibly the most elaborate) have been removed (see below, annotation at f. 2v); minor initials in Gothic capitals inked in blue, or in black touched with red lead; headings in red lead ink with elaborate and contrived extensions. Squared notation on the four-line staff (occasionally with *biscantus* and *triscantus*: ff. 2r, 15r, 52v, 111r, 236r) drawn in red lead. Restored binding in half leather on wooden strips. At f. 1r, in three hands of the 14th cent.: ".xv. *libris* papar*isiensium* [*sic*]"; "Iste liber est domini Math*ei* S*ancte* Marie | in Porticu diac*oni* card*inalis*," the latter repeated literally immediately below. At f. 2v, in modern writing: "Sacrarii Sacri Conventus | sed hoc in Archivio custoditur | Ab hoc perpulchro antiphonario | et graduali jmagines | cunctæ ablatæ sunt, | proh pudor!"; immediately below, written by the custodian Niccolò Papini Tartagni (1800–03): "Questo libro contenendo de' Santi Francesi, per esempio S. Genovefa, ci pare lavoro di Francia. È del Secolo XIII, poco dopo la Canonizzazione di S. Francesco, di cui vi sono due sequenze in lode. Vi è la Festa della Concezione di M*ari*a S*antissima*: è detta pia conceptio. Il Card*inale* stato padrone di questo Cantorino della Messa fu il Card*inale* di S. M*aria* in Portico Matteo Corsini [*sic*] 1262. Non trovandoci S. Domenico né S*anta* Chiara credo questo libro scritto prima di d*etto* anno" [This book containing some French saints, for example Saint Genevieve, appears to be a French work. It is from the 13th cent., shortly after the canonization of Saint Francis, of whom there are two sequences in praise. There is the Feast of the Conception of the Most Holy Mary: called pia conceptio. The Cardinal to whom this choir book belonged was the Cardinal of Santa Maria in Portico, Matteo Corsini [*sic*] 1262. Not finding either Saint Dominic or Saint Clare, I believe the book was written prior to that year].

(*Massimiliano Bassetti*)

The French codex no. 695 in the Biblioteca del Sacro Convento of Assisi, also known as the *Cantorinus gradualis-prosarius*, is very important not only for its liturgical and musical content, for its eight polyphonic pieces and for the quality of the 60 illuminated initials contained therein (fig. 1)—many of which have however been removed—(see Assirelli 1988), but also because it transmits two sequences dedicated to Saint Francis, *Ceciderunt in preclaris* (ff. 213r–214v; fig. 2) and *In superna civitate* (ff. 214v–215v; fig. 3), perhaps among the first to have been composed in honour of the great saint of Assisi. The sequences—known in the Middle Ages also as *prosae*, whence the term *prosarius*—are sung during Mass after the Hallelujah and consist of pairs of parallel stanzas (however at times the first and last stanza can be taken alone). The stanzas within each pair usually have the same metric and rhythmic structure, end with the same rhyme (that changes with each pair) and are sung to the same music. During the Middle Ages there was a great flourishing of sequences, even if they were not part of the official canon of the Mass. But after the Council of Trent (1545–63) all but five of them were abolished. The existence of these two sequences in the *Cantorinus* of Assisi is obviously related to the rapid growth of the Friars Minor in France. Reaching Paris around 1219, in the span of a few years they succeeded in establishing very close relations not only with the Parisian intellectual, cultural and artistic spheres but also, and principally, with the royal court, the aristocracy, the universities and the highest hierarchs of the French Church. In short, Paris soon became one of the most important centres for the entire Franciscan Order.

The *Cantorinus* of Assisi is unquestionably the oldest source of the sequences *Ceciderunt in preclaris* and *In superna civitate* (the texts are presented in the Appedix), although we do not know exactly when it was written other than that it was certainly after 1228, the year that Saint Francis was canonized. The other manuscripts in which they are found certainly postdate codex 695. *Ceciderunt in preclaris* is clearly a *contrafactum* of *Laudes crucis attollamus* (now attributed to Adam de Saint-Victor): not only are they sung to the same music but they also contain the same number of stanzas (12) and the same metric scheme, including the "irregularities" in the third, sixth and seventh pair, in which the two stanzas are not parallel to one another (Shinnick 1997: 374 and 376). Given that verses 4–5 of stanza 3a in the third pair are proparoxytonic decasyllables they do not correspond to stanza 3b, which are proparoxytonic heptasyllables. In the sixth and seventh pair, the first two verses of stanza 6a are paroxytonic octosyllables while their correspondents in stanza 6b are proparoxytonic heptasyllables. But more interesting is the fact that the anonymous author of *Ceciderunt in preclaris* also adhered to another particularity of the mod-

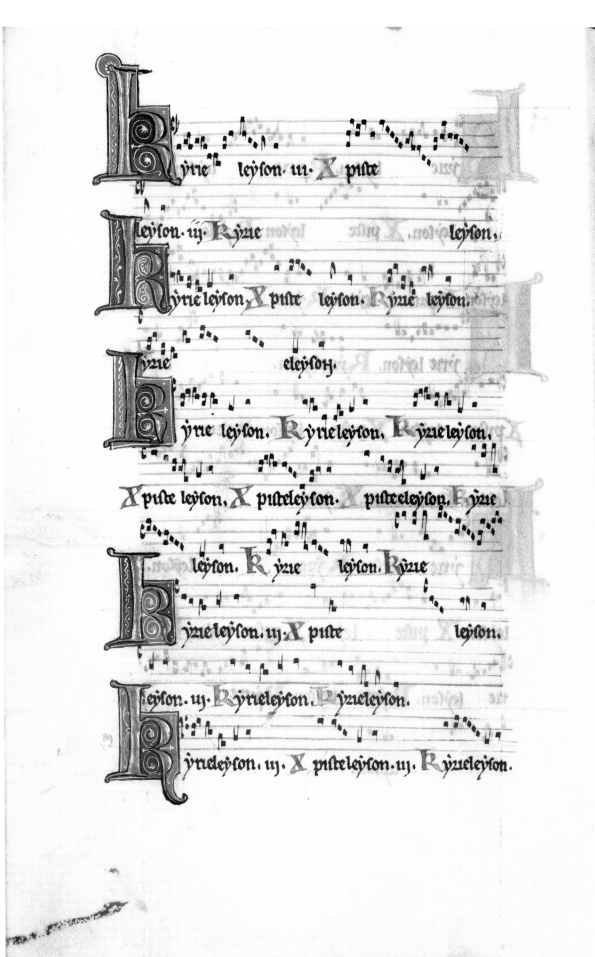

Fig. 1. *Cantorinus*, illuminated initials. Assisi, Fondo Antico Comunale, Biblioteca del Sacro Convento, MS. 695, f. 14v.

el in that stanzas 3a and 3b do not end with the same rhyme. The style and content of *Ceciderunt* are very lofty. The initial image and the entire symbology of the sequence derive, in my opinion, from the sixth verse of Psalm 15 (in the Vulgate; Psalm 16 in the Hebrew Bible), *Conserva me Domine*: "Funes ceciderunt mihi in praeclaris; insuper et haereditas mea praeclara est mihi" ("The lines are fallen unto me in pleasant *places*; yea, I have a goodly heritage" [Psalm 16:6, King James Bible]). In his *Traduzione de' Salmi e de' Cantici che si contengono nell'Officio Divino* (Translation of the Psalms and Canticles in the Divine Office) (1774), Saint Alphonsus Maria de' Liguori wrote about this verse: "Understanding here that the [agricultural] fields and each person's portion were once measured out in lines (rope lengths), we explain it as follows: I have received an excellent portion (*in praeclaris*) and thus have a goodly heritage" (Alphonsus de' Liguori 1774: 39–40). The meaning of this seems therefore quite clear: the lines have fallen unto the goodly (*preclaris*) but also ephemeral (*precaris*) Friars Minor; in short, Saint Francis, albeit "an uneducated man, a friend of true simplicity" (*1Cel* 120: *FAED* I, 290), is the best heritage left to us by the Lord. The image of the measurement of fields with lines is presented again in stanza 3a in an extraordinary play on words: "Metiaris sive metas / spicas metens, signans metas / opus est funiculo." The text of the sequence plays on the various meanings of rope (or line), also as a symbol and metaphor, in the various contexts in which it is used, including: the knotted rope worn as a belt by the friars as a sign of penitence (stanza 2a); the ropes binding one to Christ and of which sinners are deprived (stanza 2b); the belt of Francis as *Christi miles* (stanza 3b); the ropes binding the clothes (stanzas 7a/b and 12a); the lines for weaving *lectos suaves*, for towing ships into port or lifting stones with the block and tackle (stanzas 10a/b). Stanzas 5–6 are dedicated to the stigmata, which are seen, however, as a sort of *imitatio Christi*, heralded, for that matter, in stanzas 4a and 4b. Without doubt they have very profound content expressed in a lofty, complex poetic style. However, overall, they are rather generic and could refer to any other saint. The only specific elements referring to the saint of Assisi are: 1) the fact that he founded the Order of Friars Minor, as seen also in the title preceding the text; 2) that it was an order as yet with few followers (stanza 4a: "Tu pusilli pastor gregis"); and 3) that he had the stigmata of the Passion of Christ. As regards the title *Sancti Francisci In-stitutoris Ordinis Fratrum Minorum*, Shinnick observes that "at this time [circa 1230] the Friars Minor, the order of Saint Francis […] was perhaps better known than its founder in distant places such as Rheims" (Shinnick 1997: 379). And she adds: "The Saint Francis sequences in Assisi 695 reflect the recentness of Saint Francis's death and canonization and a possible need to identify the saint as the founder of an order only recently established at Rheims" (Shinnick 1997: 383–84). Furthermore, the reference to the stigmata is also, in my opinion, extremely vague and generic and accounts neither for what Thomas of Celano had written as early as circa 1229 in his *First Life* nor for the testimony of Friar Elias (of Cortona) or Friar Leo, just to name the oldest sources. Indeed, in the sequence, not only is there no mention of the apparition of the Seraph/Christ, but nothing at all is said about the agent or means by which he was given the stigmata, which seem almost completely symbolic and not real (stanza 6a: "cicatrices / quibus Christi depinxisti / vulnus sine vulnere"). Unless we imagine that the anonymous author of this sequence had prudently opted not to take a stance in this regard, perhaps aware of the doubts harboured also by Pope Gregory IX (the first three bulls "in which Gregory IX mentioned and affirmed the veracity of the stigmata for the first time" [Frugoni 1996: 124] date to 1237). This lack of elements referring exclusively to the biography of Saint Francis suggests a rather old date for this sequence, preceding not only the *Legenda maior* of Saint Bonaventure (in which the author would "rewrite" the entire story of the stigmata, even inventing the famous "dream" of Gregory IX) but also the many biographies of the saint of Assisi written after his death, starting with Thomas of Celano's *First Life* and the *Legend of Perugia* (see Frugoni 1993 and Frugoni 1996). Similar observations apply, as we will see, to *In superna civitate*. As regards the musical aspects, we observe that the version in the manuscript of Prague, National Library, I E 12, is not only completely different from the codices of Assisi and Paris, Bibliothèque nationale de France, fonds lat. 1339 (compiled however many years after the *Cantorinus* 695), but also modifies the structure of the stanzas.

In superna civitate is also included in the above-mentioned Parisian manuscript 1339. The more interesting variant of the two editions is seen in stanza 9a and regards the date of the feast dedicated to Saint Francis: in codex 695 it is 3 October while in manuscript 1339 it is one day later, the

correct date. We may compare the two texts: "In Octobri mense deno / [...] / die cadit tertia" in the *Cantorinus*; and "In Octobri vir beatus / quarta die consummatus" in codex 1339. Shinnick comments: "This discrepance of date implies that the Assisi 695 collector copied *In superna* from a Paris exemplar of some kind, since the feast of Saint Francis was celebrated on 3 October in Paris and not on 4 October in order not to conflict with the feast of Saint Aure, the first abbess of Saint-Martial of Paris" (Shinnick 1997: 382–83). The sequence begins by emphasizing the circumstance that Saint Francis is a recent saint, as is clear in the initial pair of stanzas: "In superna civitate / de Francisci novitate / felix gaudet curia. // Hunc recenter nobis misit / [...]" (Shinnick 1997: 379), which confirms the antiquity of this second text as well. Of interest, right at the beginning, is the reference to Francis's promise to remain ever faithful to the Church of Rome (stanza 1b), a particularly significant fact at a time when heresies of all types abounded, especially among the pauperistic movements (Cathars, etc.). In the second pair, the anonymous author highlights the fact that Saint Francis, being younger than his predecessor saints, understood the issues of his times much better than the other saints and even the ancient prophets did theirs. Thus Francis, like Enoch, Elias and the Apostles, is presented as a new prophet, a modern preacher. An allusion is made in stanzas 6a/6b to Francis's desire to imitate not only the crucifixion of Saint Peter but even that of Jesus Christ. A further element supporting the antiquity of this sequence is offered not only by the generic terms in which the question of the stigmata is addressed, but also by the total absence of references to miracles wrought by the saint, except for a very brief mention in the first verse of stanza 8b, in which allusion is made to his miracles with the sick: "Omne genus curans morbi." This may indicate that at the time that the *Cantorinus* was put together, Saint Francis was still not well known in France, and even less so for his miracles, as is demonstrated by the texts of the two sequences contained in codex 695. The image of Saint Francis as a thaumaturge would only spread later, especially after the *Treatise on the Miracles* by Thomas of Celano (1252–53). The two sequences found in the *Cantorinus* of Assisi are thus presumably the oldest of those composed in France in honour of Saint Francis. Several decades later, in the codex Paris, Bibliothèque nationale de France, fonds lat. 778, f. 152v, datable to 1272–76 (Husmann 1964: 113–14) we find the sequence *Laetabundus Francisco decantet clerus* attributed to the

cardinal Thomas of Capua. The sequence is also found, together with *Caput draconis*, composed by Pope Gregory IX (1227–41), in the initial fascicle (although it was added later) of codex fonds lat. 1139 in the Bibliothèque nationale di France, coming from the famous abbey of Saint-Martial in Limoges. Over the years, as the "legend" of Saint Francis spread throughout France, there was obviously an upsurge in the production of sequences in his honour. For example, the Franciscan codex Paris, Bibliothèque nationale de France, fonds lat. 1339, dating to the 14th century, contains, in addition to *Ceciderunt* and *In superna civitate*, five other sequences extolling the great saint of Assisi. It must be considered that fifty or more sequences were written in his honour during the 14th and 15th centuries. Van Dijk believes that the greater number of sequences in the manuscript Paris, Bibliothèque nationale de France, lat. 1339, is related to the initiative of Pope Innocent IV in June 1256 to promote the creation of new sequences by the Friars Minor in response to the previous limitations imposed by the General Chapter of Metz in 1254 (Van Dijk and Walker 1960: 396 et seq.). In this historical and cultural context, it is certainly interesting to note that Julian of Spira composed his *Vita S. Francisci & Officium Rhythmicum* "in littera et cantu" (words and song) and with "nobili stilo et pulchra melodia" (noble style and beautiful melody), as writes Giordano da Giano, in the same years (circa 1231–32) and cultural milieu (Paris) of the writing of codex 695.

The *Cantorinus gradualis-prosarius* 695 is composed of 32 fascicles of different sizes. Between fascicles XX and XXI, that is, between folios 151 and 152, a fascicle composed of eight folios is missing, corresponding to ff. LXXXXVII–CIV, the content of which—seven sequences—may be reconstructed by using the index. It is a composite codex that currently contains 268 pieces, almost all of them with music, clearly subdivided into four sections. The first, which goes to f. 55, mainly contains tropes to the *Ordinarium Missae* (Kyrie, Gloria, Sanctus and Agnus Dei) and other prayers and devotional formulas sung during Mass, including the various Marian Hallelujah, hymns, the *Exsultet* (Easter Proclamation), Readings, Gospels and *Laudes regiae*. Like the sequences, the tropes also enjoyed great fortune during the Middle Ages. They consist of newly created poetic texts—sung to newly composed music or to music borrowed from the liturgical piece in question—that are added at the end or inserted between the verses of certain pieces of the

Fig. 4. *Cantorinus*, part of the *Laudes regiae*
"Christus vincit, Christus regnat" with invocation
to the king of France.
Assisi, Fondo Antico Comunale, Biblioteca
del Sacro Convento, MS. 695, f. 41v.

Ordinarium Missae or the *Proprium* (e.g. Introit). As regards this initial section, we observe, first of all, that the heading on f. 38v regarding the "Versus ad sacrandum crisma," *O redemptor sume carmen*, "Secundum usum Parisiensis Ecclesie," clearly indicates that it is a codex—or a part thereof—not destined for a Parisian church in spite of the fact that it is under the influence of the liturgical tradition of Nôtre-Dame. The confirming proof is that in the immediately following f. 39v the copyist writes the same text but with different music with respect to that sung in Paris and with the rubric "Idem est alio cantu." Galliano Ciliberti places a great deal of importance on this first section, hitherto neglected by scholars, since it contains elements linking it to King Louis IX, known as the "Saint," via the equivalence Deus/Christus = Rex. Among these elements is a passage in the Prefatio *Vere quia dignum*: "pro gloriosissimo Rege nostro" (f. 34v) and a number of invocations in the *Laudes regiae*: "Domino nostro excellentissimo Regi Francorum a Deo coronato, magno et pacifico, vita et victoria" and "cuncto exercitui francorum vita et victoria" (f. 41v, fig. 4). But Ciliberti also references the Kyrie *Summe rex sempiterne*, the Sanctus *Voci vita* and the Agnus *Factus homo*, in which he sees a reflection of Louis IX (Ciliberti 2003: 179–85).

The other three sections instead appear to be true prosars. The first section, which ends at f. 111r, contains mainly sequences composed by Adam de Saint-Victor, probably belonging to the liturgy practiced in the cathedral of Rheims (see, for example, the feast of Saint Nicasius, bishop of Rheims at f. 90r). The second contains sequences from the liturgy of Nôtre-Dame (see, for example, the feast of Saint Genevieve at f. 121r and three pieces for Saint Victor, whose relics are kept at Nôtre-Dame, at ff. 139v, 145v and 161r) and closes very significantly with seven hymns (f. 162v). The final section, ending at f. 238v, also contains only sequences associated principally with the Parisian repertory of Nôtre-Dame (see, for example, that for Saint Magloire, f. 201r). Each of the three prosars begins with sequences from the Advent or Christmas liturgy and continues with those dedicated to the saints—organized more or less in keeping with the normal liturgical calendar—interspersed in some cases with those relating to the most important feasts of the Temporale and of the Virgin (but in the third prosar they are almost all located at the end). This circumstance has led scholars to think that they may be three different and independent prosars that were later brought together, i.e. that we are

dealing with a composite codex. At any rate, we may presume that it is a manuscript with contributions from different sources and of different origins, although all falling into the Paris–Rheims ambit. We also observe that the seven polyphonic pieces—although actually there are eight, including the two-voice Gospel at f. 35r—have been clearly arranged, perhaps deliberately, in very precise and thus meaningful positions: the Kyrie with the three-voice trope *Summe rex sempiterne* closes the section dedicated to the Kyrie (ff. 15v–16v), and this may be deliberate, given also the probable references to King Louis IX mentioned by Ciliberti; the Sanctus with the two-voice trope *Voci vita sit unita* clearly closes the section dedicated to the Sanctus, even if it is now found at ff. 52v–53r (preceded by two monodic chants of the Sanctus not embellished with tropes); and the two-voice troped Agnus *Factus homo sumpta de virgine*, even though it was copied onto an isolated bifolio (f. 2r), certainly ends the section of the Agnus, preceded by two monodic Agnus chants and by one with the trope *Mortis dira* on f. 53v; lastly the two-voice sequence *Gaude Dei genitrix* closes the first prosar (f. 111v), while the last three—*Sicut pratum picturatur*, *Verbum bonum et suave* and *Ave sydus lux dierum*—conclude the third prosar (ff. 238v–239v; fig. 5) prior to the index (ff. 241v–242v). The second prosar, on the other hand, ends with a cycle of seven hymns. In the case of the Sanctus and the Agnus Dei, their incorrect position within the manuscript may presumably be attributed to the copyist. After the Sanctus written out on the first half of f. 49v, for some unknown reason—perhaps simple carelessness—he interrupts the series of the Sanctus he was transcribing (two other monodic chants of the Sanctus and the two-voiced and troped *Voci vita*, currently on ff. 52v–53v, had yet to be copied) and instead transcribes a full ten Agnus Dei, both with and without tropes, from f. 50r to f. 52v. Having realized his error, after a monodic Agnus at the top of f. 52v, he interrupts the series of the Agnus and instead copies, on ff. 52v–53v, the two monodic Sanctus and the polyphonic *Voci vita* that he had neglected to transcribe earlier. From there he then picked up the series of the Agnus, placing a monodic Agnus and the Agnus trope *Mortis dira* on the second half of f. 53v. Not having sufficient space to include also the final Agnus trope, *Factus homo*, which, being both polyphonic and including a trope, was very long—indeed, starting from f. 54r he had planned to copy the series of Hallelujah—the copyist decided to write it onto the *recto* of f. 2, which was apparently still blank. He then wrote the following instruction in the left margin of the folio: "Recipe infra ante Alleluya" (resume later, before the Hallelujah), which means that this two-voiced Agnus should have been the last in the series of the Agnus, before the Hallelujah. However, not satisfied with this, to indicate that the series of the Agnus ended with the polyphonic Agnus *Factus homo*, he wrote another instruction as a precaution immediately after the Agnus *Mortis dira* at f. 53v: "Require supra in secundio folio libri" (find above, on the second folio of the book). Shinnick is of a different opinion. After having posed the question as to whether the three polyphonic tropes—the Kyrie *Summe rex sempiterne*, the Sanctus *Voci vita* and the Agnus *Factus homo*—were truly a "prototype for the polyphonic Mass cycle," she writes that the "codicological evidence also supports the hypothesis of *Factus homo* and *Voci vita* as additions to Assisi 695" (Shinnick 1997: 479). However, she does not completely discard the other hypothesis: "As to the hypothesis of the three polyphonic Mass Ordinary pieces in AS as a proto-Mass cycle […] it should not be excluded from consideration. […] The earliest complete polyphonic Mass cycles did not appear until the fourteenth century, but there is no reason that Mass Ordinary movements could not have been intentionally grouped at a much earlier time" (Shinnick 1997: 485). Galliano Ciliberti, on the other hand, speaks explicitly of a "Messe de Reims" (Rheims Mass) (Ciliberti 2003: 183–84).

Much has been written on the most significant aspects of Assisi codex 695 and this is not the place to call them back into question, especially since Shinnick has analysed all of them in systematic depth. Obviously there are still many open issues. Various possibilities have been proposed as to its date: for example "shortly after 1228" or circa 1230 if we take the miniatures as a reference point (Assirelli 1988: 194 and 200); M.G. de Manteyer proposes "post c. 1280" (Chevalier 1900: LXIX) whereas Albert Seay writes that "il nous semble suffisant de prétendre qu'*As* a du être terminé durant la deuxième quart du XIIIe siècle" (it seems sufficient to suggest that *As* had to be completed during the second quarter of the 13th century) (Seay 1957: p. 22). Gunilla Iversen proposes the "deuxième moitié du XIIIe siècle" (second half of the 13th century) or "fin du XIIIe siècle" (end of the 13th century) (Iversen 1990: 256; Iversen s.d.: sub "Ass 695"). Among the other proposals, we mention that of Father Nicolò Papini, "shortly after the canonization of Saint Francis" and in any case prior to the

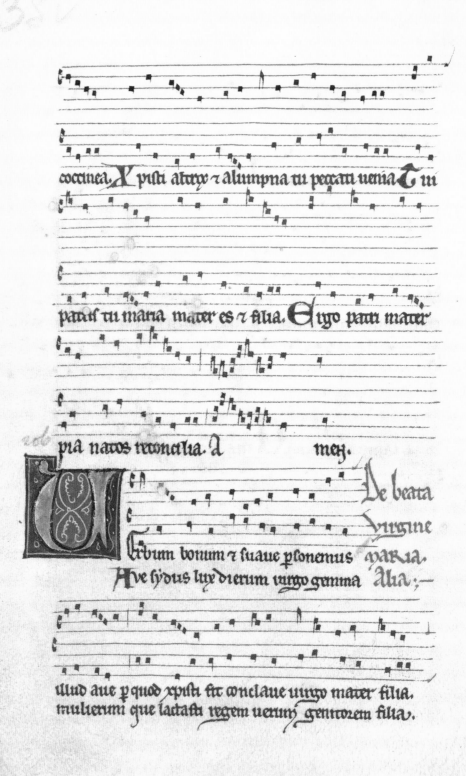

Fig. 5 – *Cantorinus*, end of the sequence *Sicut pratum picturatur*, two-voice sequence *Verbum bonum et suave* with contrafactum *Ave sydus lux dierum*. Assisi, Fondo Antico Comunale, Biblioteca del Sacro Convento, MS. 695, f. 238v.

canonization of Saint Dominic (1234) and Saint Claire (1255). Regarding the provenance and history of the *Cantorinus*, the only objective evidence are the two notes regarding ownership on f. 1r in 13th-century writing ("Iste liber est domini Mathei sancte Marie in Porticu diaconi Cardinalis [cardinal Matteo Rosso Orsini]") (this book belongs to monsignor Matteo, Cardinal Deacon of Santa Maria in Portico) and on f. 2v, written by the hand of father Ludovico Lipsin, librarian of the Sacro Convento ("Sacrarii [in place of "Bibliothecae," which was crossed out] Sacri Conventus [added below by another hand: "sed hoc in Archivio custoditur"]. Ab hoc perpulchro antiphonario et graduali imagines cunctae ablatae sunt: proh pudor!") (of the Sacristy of the Sacro Convento, but kept in the archive. All the images have been removed from this most beautiful antiphonary and gradual: shame!). It is thus certain that during the 13th century the *Cantorinus* belonged to the powerful cardinal Matteo Rosso Orsini. Born in Rome circa 1230 and dying in Perugia in 1305, Orsini studied theology in Paris around 1253—his brother Romano taught theology at the Parisian University starting in 1271, succeeding Saint Thomas, with whom he was friends. Matteo was consecrated as cardinal in 1262 by Pope Urban IV with the title of Santa Maria in Portico. In 1278 he was appointed Protector of the Order of Friars Minor by Pope Nicholas III, his uncle, and Pope Boniface VIII gave him various diplomatic assignments. We know that he gave many gifts to the Basilica and Sacro Convento of Assisi, including one of his dalmatics and numerous manuscript volumes (Assirelli 1988: 197). The problem now is knowing when and where Matteo Orsini came into possession of codex 695, whether it was in Paris or in Rome, and to whom it had belonged previously. De Manteyer hypothesized that the *Cantorinus* may have previously belonged to Geoffroy de Bar-sur-Seine, deacon of the Chapter of Nôtre Dame, named cardinal of Santa Susanna in 1280 by Pope Martin IV and dying in Rome in 1287. Shinnick, on the other hand, suggests Henri de Braine, who died in 1241, grandson of Louis VII and archbishop minor of Rheims starting in 1227 (Shinnick 1997: 532). But these are obviously mere hypotheses. Furthermore, in the case of Geoffroy de Bar-sur-Seine, the date appears too late with respect to what is suggested not only by the analysis of the miniatures by Marco Assirelli, but also, as we saw above, by the liturgical and musical content of the manuscript. But the most convincing evidence in favour of a date sometime around the fourth

decade of the 13th century, thus immediately after the canonization of Saint Francis, is presented by the sequence *In superna civitate*, which begins, as we pointed out above, alluding clearly to this recent event. Shinnick, after having presented and discussed all the various positions of the scholars as to the date of the codex and its provenance, concludes: "The manuscript appears to have been written circa 1230 or in the early 1230s in Paris as an anthology of Mass Ordinary pieces and sequences for use in Rheims. In the later years of the thirteenth century the codex came into possession of Matteo Rosso Orsini, later named Cardinal of Santa Maria in Portico and Protector of the Order of Friars Minor. Along with other lavish gifts, Orsini may have donated the book to the order, or it could have come into possession of the order after Orsini's death through the papal library which was kept at Perugia and later at Assisi" (Shinnick 1997: 75). Galliano Ciliberti believes, on the other hand, that we cannot be certain that after the death of Matteo Rosso Orsini (in Perugia) his library was absorbed by that of Boniface VIII (which was also in Perugia) and together they both went to the Sacro Convento of Assisi. Secondly, he suggests that before entering into Cardinal Orsini's possession, codex 695 may have belonged to Cardinal Ottobono Fieschi, who would then have donated it to Orsini, who, in turn, gave it to the Sacro Convento. Ciliberti's overall hypothesis is plausible for various reasons. First of all, as Ciliberti writes "if the *Cantorinus* was now an integral part of the precious possessions of the Holy See (i.e. of the library of Boniface VIII), we must ask why this codex alone (superbly miniated) and no others in the papal collection would have ended up in Assisi in the sacristy (or in the old library of the Sacro Convento)." After discussing all possible hypotheses, Ciliberti suggests that it may have been a personal bequest by Cardinal Orsini to the Order of which he was the Protector and quite closely tied to it (indeed, it has been possible to identify many other books donated by him to the Sacro Convento). As regards Ottobono Fieschi (1205–1276), there are many valid reasons to believe that he is the probable first (?) owner of the codex: 1) there was a famous cantor, Bonifacius Veronese, among his chaplains; 2) there was an Englishman among his *familiares*, Amerus, who authored a *Practica artis musicae* around 1271; 3) he was canon at Nôtre-Dame in Paris; 4) Pope Innocent IV, his uncle, named him chancellor and archdeacon of the Cathedral of Rheims, to which he bequeathed many of his possessions; and lastly 5) he was

elected Pope with the support of Cardinal Giovanni Gaetano Orsini, the future Pope Nicholas III, "always backed by his nephew Matteo Rosso," as states Raffaello Morghen (Ciliberti 2003: 196–99; Morghen 1923).

As regards its repertoire, the *Cantorinus* 695 contains nine *unica* sequences and 21 of which it is the oldest known source. There is also a very important section dedicated to polyphonic works: three tropes to the *Ordinarium Missae*—the three-voice Kyrie *Summe rex sempiterne*, the two-voice Sanctus *Voci vita sit unita*, and the two-voice Agnus *Factus homo*; a two-voice versions (only partial) of the Gospel, *Liber Generationis Ihesu Christe* (transcribed and studied for the first time by Shinnick); and four Marian sequences with two voices (*Gaude Dei genitrix*, *Sicut pratum picturatur*, *Verbum bonum et suave* and *Ave sydus lux dierum*, the last two being sung to the same music). As regards the three tropes, *Summe rex sempiterne* is an *unicum*, at least in its use of polyphony, while the other two, the Sanctus *Voci vita sit unita* and the Agnus *Factus homo*, are also found, set to different music, in the codex Wolfenbüttel, Herzog-August Bibliothek, cod. guelf. 628, of English provenance (Saint Andrew) and dating to circa 1230 (W/1) (Hiley 1981; Everist 1990). From a "hierarchical" point of view, we are immediately struck by the fact that the only three-voice piece is the Kyrie *Summe rex sempiterne*, the first piece sung of the *Ordinarium Missae*, a fact which confers greater solemnity on this triple invocation to the Lord—and perhaps also on the king of France, if we credit Ciliberti's hypothesis. Also to be noted is the fact that the text of the trope to the Agnus *Factus homo* is also found in three other manuscripts also of English origin (and the presence of five sequences in honour of Saint Thomas of Canterbury may also be a valuable element in determining the provenance of codex 695). The trope to the Sanctus *Voci unita* in the *Analecta Hymnica Medii Aevi* (*AH* 51, no. 56) was inserted between the sequences for the celebration of *Corpus Christi*, most certainly because of its meter anœd structure (four pairs of parallel stanzas: aax, aax / bby, bby / ccw, ccw / ddz, ddz) but perhaps also for its Eucharistic content, despite the fact that this celebration was not introduced into the liturgical calendar until 1264 by Pope Urban IV. Moving on to the four two-voice sequences, we must begin by saying that they are also found, again in a two-voice version, in the codex Cambrai, Bibliothèque municipale, C. 32, originating in Maubeuge in the archdiocese of Rheims and dating to the end of the 13th century, thus postdating, albeit only slightly, the *Cantorinus* of Assisi. *Sicut pratum* "could be a sequence original to Assisi 695" given that all the other sources postdate the Assisi codex (Shinnick 1997: 518–19). *Gaude Dei genitrix*, on the other hand, is a *contrafactum* of the sequence *Laudes Deo devotas*, attributed to Notker the Balbulus, and is preserved in various manuscripts, almost all of them either French or English (Shinnick 1997: 494–95). Regarding the famous sequence *Verbum bonum et suave*, much has been written about it and this is not the place to review it. Lastly, *Ave sydus lux dieum* is also a *contrafactum* of *Verbum bonum*, given that it is sung to the same music (in the Assisi codex, the texts of the two sequences were actually copied one under the other to correspond to the music). This is a very interesting text in terms of meter, in that it represents a variation on the standard framework that comes very close to the stanza structure of the vernacular Italian *lauda*. In fact, while the rhyme of the last verse in each pair of stanzas changes from one pair to the next in *Verbum bonum*, as it does in all the other sequences, in *Ave sydus*, the last verse has the same rhyme in all stanzas (*–ia*). Furthermore, the codex Siena, Archivio dell'Opera del Duomo, MS. 42 N, contains a musical version differing from that handed down to us, in which the final verse is sung, in all stanzas, with the same melodic phrase, almost a rhyme in music, exactly as in 12th- and 13th-century Italian *laude* (Ziino 1978; Ziino 1981).

Appendix

Ceciderunt in preclaris

1. Ceciderunt in preclaris
michi funes in precaris
fratribus minoribus.

2a. Preciosi vere funes,
quibus cincti sunt immunes
a mundanis sordibus.

2b. Funes isti funes Christi,
quibus cincti sunt discincti
peccatorum funibus.

3a. Metiaris sive metas,
spicas metens, signans metas
opus est funiculo.
Fune capis terram viventium,
fune messis eterne bravium
portas in manipulo.

3b. O Francisce, Christi miles,
decorasti funes viles
cingulo milicie.
Tu per hunc funiculum,
militare cingulum,
cinctum stola glorie.

4a. Tu pusilli pastor gregis,
tu vexilli summi regis
preferens insignia.

4b. Vita vitam imitaris
morte mortem emularis
exprimis vestigia.

5a. Fossus manus, pedes, latus,
prior Christus est signatus
passionis stimate.

5b. Morti cuius conformatus,
in eodem consignatus
reperiris scemate.

6a. O felices cicatrices
quibus Christi depinxisti
vulnus sine vulnere.

6b. Neque sude ferrea,
nec confessus lancea
sano lives latere.

7a. Tui funes in figura
designantur in iunctura
pannorum funiculis.

7b. Ieremias fecibus
est extractus funibus
iunctis cum panniculis.

8a. Funes verba preceptorum
panni facta sunt sanctorum
feces mundi vitia.

8b. Sociantur blanda duris,
que succurrant exituris
de culpe miseria.

9a. Fune fures suspendendi,
hostes fune vinciendi,
hostis, fur, demonia.

9b. Fures, quia nos denudant,
hostes quia sic insudant
ad mortis exicia.

10a. Funes texunt lectos suaves,
funes sistunt portu naves,
funes trahunt sursum graves
lapides in troclea.

10b. Pax eterna, lectus suavis,
Christus portus, homo navis,
moles carnis, mola gravis
sursum vite laurea.

11a. Virgis cesus et nudatus,
fune Christus est ligatus,
pannis infans reclinatus
ornavit presepia.

11b. Non sunt funes abhorrendi,
nos sunt panni contempnendi,
sed gratanter amplectendi,
commutandi gloria.

12a. Roga Christum, o Francisce,
et sic funes pannis misce,
ut qui pannis sunt induti
fune cincti te sequuti
assequantur premia.

12b. Pannum rudem saccum scissum
in splendoris mutet byssum,
Sathan missum in abyssum
fune liget, det promissum,
induat leticia. Amen

In superna civitate

1a. In superna civitate
de Francisci novitate
felix gaudet curia.

1b. Hunc recenter nobis misit
qui mansurum se promisit
semper cum ecclesia.

2a. Hic est fratrum dux minorum
nullo minor antiquorum
sed etate iunior.

2b. Qui modernos inter mores
super sanctos seniores
intellexit promptior.

3a. Legislator vetustatis
cohibebat a peccatis
seve legis ferula.

3b. Hic extreme lux etatis
primitive sanctitatis
restauravit secula.

4a. Quondam Enoch et Helyas
ad celestes rapti vias,
hostes hostis subdoli.

4b. Predicabunt adhuc vivi,
iam per istum redivivi
predicant apostoli.

5a. Explorator arcte vie,
distinctores ierarchie
superavit studio.

5b. Sine textu doctor sanus,
sine glosa christianus,
iustus sine pallio.

6a. Petrus claves, clavos iste
laterisque tui, Christe,
monstrat privilegia.

6b. Tu in Petro crucifigi,
sed hunc tibi vis configi
passione socia.

7a. Vulneratrix aliorum,
istum solum dilectorum
crucifixit caritas.

7b. Quam in carne nulla disco,
crucem carnis in Francisco
miretur humanitas.

8a. Novit intus et in cute
hunc deducens de virtute
in virtutem deitas.

8b. Omne genus curans morbi,
iam egeno dives orbi
fit egenis claritas.

9a. In Octobri, mense deno,
flos siccato carnis seno,
die cadit tertia.

9b. In octava nostre spei
legis custos trini Dei
possidens dupplitia.

10. Resurget in gloria. Amen

(See Shinnick, 1997: 375–76 and 380–81 for the English translation of the sequences.)

121

Antiphonary

Milvia Bollati

Fondo Antico Comunale at the Biblioteca del Sacro Convento, Assisi, Fondo musicale di Cappella, MS. 1
Sec. XIII ex., membr., ff. 316 (numbered *recto* and *verso* from 3 to 679; the first two and 227–28 are missing; errors in numbering are observed; pagination in ink of the 16th cent.; sheets numbered in pencil in the 20th cent.), 550 × 385 mm. Gothic *rotunda* lettering, highly calligraphic and with large module, apparently by a single hand, corresponding to the black square notation written on six four-line staffs, drawn with red lead. Numerous inhabited and historiated initials, painted with a brush, many of which have been cut out; only 3 large ones with illustrations are left; some have been roughly added back in by a modern hand; minor initials in Gothic capital letters inked alternatively in red lead and blue with filigrees in contrasting colors. Leather restored binding on strips and iron studs.
(Massimiliano Bassetti)

This Antiphonary for the liturgical period from the first Sunday of Lent to the Nativity of the Virgin comes from the sacristy of the Basilica of San Francesco in Assisi and is the only remnant of the missing series of choir books used at the Sacro Convento.

The codex is acephalous and mutilated and is without a large part of the illuminated initials, which have been reinstated with parchment on which the letter was traced again in a coarse restoration, perhaps from the nineteenth century (*Biblioteca Assisi* 1990: 113-121, cat. 76, with previous bibliography).

The only original initials that are preserved are those with the illuminations of *Francis entombed* (f. 235r; fig. 1), the *Martyrdom of a saint* (f. 258v; fig. 2), and *Christ and saints* (f. 267v; fig. 3). The first (f. 235r) illustrates the responsory for the first nocturne of the Matins for the feast of Saint Francis, *Franciscus ut in publicum cessat negotiari in agrum mox dominicum secedit meditari inventum evangelicum thesaurum vult mercari.* The second (f. 258v), *Iste sanctus pro lege Dei sui certavit usque ad mortem*, is related to the feast for the birthday of a martyr, while the third (f. 267v), *Absterget Deus omnem lacrimam ab oculis sanctorum*, is for the feast for the birthday of more than one martyr, usually illustrated with a different scene of martyrdom, while this codex presents a group of saints and Christ Blessing in the upper loop of the letter. The illuminator was a master trained in Umbria who was probably active in the city of Assisi during the last decades of the 13th century; he has been identified with the Maestro del Messale (Master of the Missal) from Deruta and Salerno, also known as the Maestro dei corali (Master of Choir Books) from Assisi (Lunghi 2004: 627–29, with previous bibliography).

Some cropped illuminations that are stylistically similar—being from this Antiphonary or, more likely, from the same choral series (a hypothesis that can only be confirmed by examination of the liturgical sequence)—have been recognized as being by the same illuminator. They in-

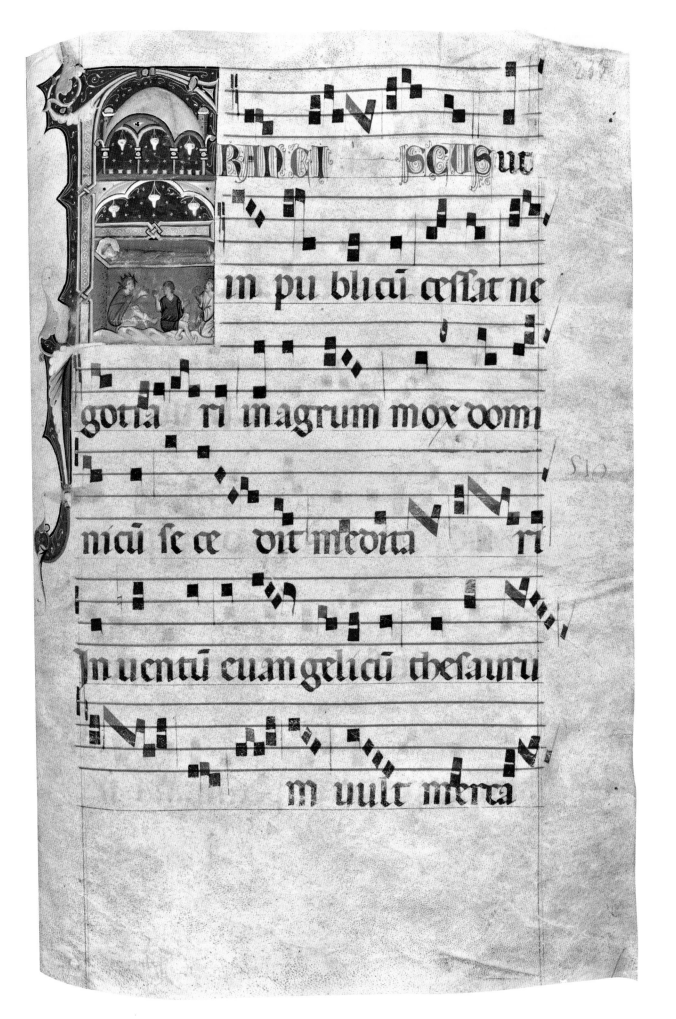

RANCI SCUS ut

in pu blicū cessat ne

gotia ri in agrum mox domi

nicū se ce dit medita ri

Invētū euāgelicū thesauru

m uult mercā

Fig. 1. *Antiphonary*, responsory for the first nocturne of the Matins for the feast of Saint Francis: *Franciscus ut in publicum cessat negotiari in agrum mox dominicum secedit meditari inventum evangelicum thesaurum vult mercari.* Assisi, Fondo Antico Comunale, Biblioteca del Sacro Convento, Fondo musicale di Cappella, MS. 1, f. 235r.

On page 122
Fig 1a. *Antiphonary*, miniature with *Francis entombed.* Assisi, Fondo Antico Comunale, Biblioteca del Sacro Convento, Fondo musicale di Cappella, MS. 1, f. 235r (detail).

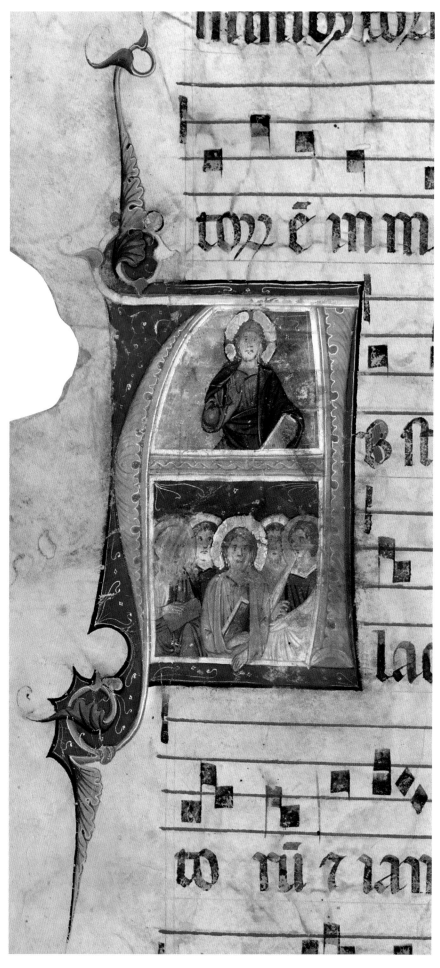

Fig. 2. *Antiphonary*, miniature with *Martyrdom of a saint*. Assisi, Fondo Antico Comunale, Biblioteca del Sacro Convento, Fondo musicale di Cappella, MS. 1, f. 258v.

Fig. 3a. *Antiphonary*, miniature with *Christ and saints*. Assisi, Fondo Antico Comunale, Biblioteca del Sacro Convento, Fondo musicale di Cappella, MS. 1, f. 267v (detail).

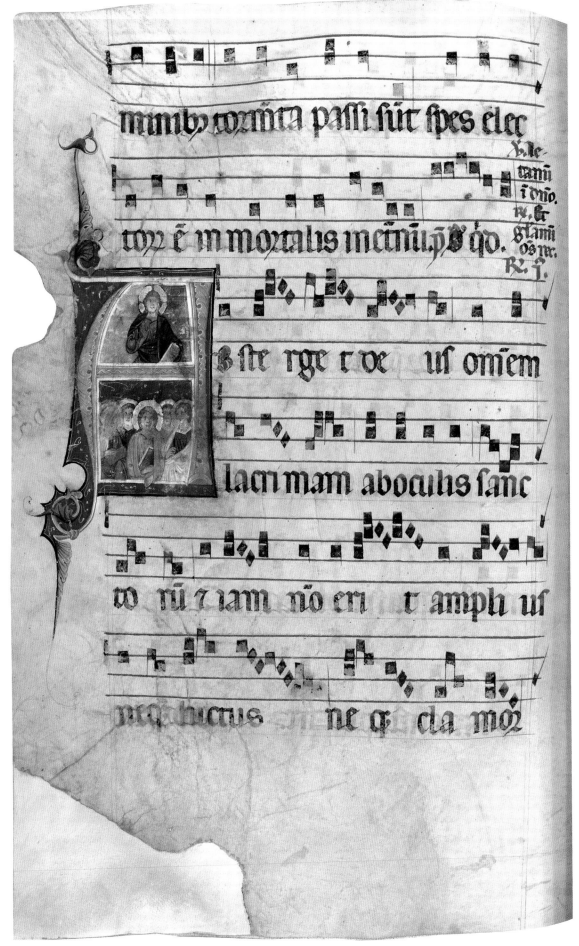

mnubo tormta paffi fut fpes elec

tor e immortalis in etnu. pu qd.

te
ranu
i dno.
iv. et
glami
os pec
R̷. J.

s ste rge t de us onem

lacrimam abocalis sanc

to rū z iam no eri t ampli us

mebicms ne q̃ cla mo

Fig. 3. *Antiphonary,*
miniature with *Christ
and saints.*
Assisi, Fondo Antico
Comunale, Biblioteca
del Sacro Convento,
Fondo musicale di
Cappella, MS. 1,
f. 267v.

Fig. 4. Maestro del Tesoro, reredos with *Francis and four of his miracles* (tempera on panel, 1260 ca.), detail with *The healing of a young girl with a twisted neck at the tomb of the Saint in the church of San Giorgio* and *The healing of the possessed woman at the tomb of the new basilica*. Assisi, Basilica di San Francesco, Museo del Tesoro

clude: four initials, conserved today at the Germanisches Nationalmuseum in Nuremberg (B 32–34), with *Christ Blessing and a saint*, *Job and the three friends*, *Saint Paul preaching*, and *Saint Francis preaching*—shown at the New York exhibition *The Treasury of Saint Francis* (Kanter and Palladino 1999: 144, cat. 40); *Saint Francis's stigmata and Preaching to the birds*, formerly in the von Nemes collection and now in a private collection in London, which is reminiscent of the Maestro di San Francesco's frescoes in the Lower Church (Lunghi 1989: 12–20); a *Saint Michael and the dragon*, formerly in a private collection in Paris; a last initial with the *Nativity*, which we do not know the current location of, indicated by Filippo Todini (1989: I, 116); and another initial, in the Frascione collection in Florence, with *Christ and a saint*, which according to Ada Labriola (*Miniature Brera* 1997: 108-109, cat. 18) is the work of a master with Umbro-Roman training who is close to but distinct from the Maestro dei corali from Assisi and was active in years shortly thereafter.

Our attention here is particularly on the initial with *Francis entombed* (f. 235r), *Franciscus ut in publicum*, an illustration of the responsory *Ad Matutinum in primo nocturno*.

The letter presents a curious and unusual architectural design. A trefoil arch with votive lamps hanging within each arch supports a cross vault on columns, from which three more lamps hang. Two tiny square towers flank it on the right and left. It is a unique, however improbable, architecture, meant to evoke the place of Francis's burial in a rendering of the tomb which was far from the real one in the Lower Church in Assisi. The only reference seems to be the presence of the votive lamps, that recall the solution adopted for the altar/tomb in the Lower Church. Francis's body lies uncovered within his tomb and three pilgrims in the foreground, their bodies visibly affected by various illnesses, approach the tomb and touch it. It is not a graveside miracle but a prayer for intercession so that the miracle of healing happens. Pilgrimages to the tombs of holy bodies were a very common devout practice in the

worked in the city of Assisi, seems nevertheless unaware of the historical reality of Francis's tomb or at least not to pay it the attention we would expect, preferring to resort to more generic iconographic solutions. In the tomb we are unable to glimpse any hint of the wooden casket, raised a bit above the ground precisely to accommodate the practices of piety just described, that had temporarily held Francis's body in the church of San Giorgio. The reredos with *Francis and four of his miracles* (fig. 4), originally from the Lower Church and now at the Basilica's Museo del Tesoro, gives us a faithful and almost photographic image of the first miracle that occurred at the tomb in San Giorgio, the healing of a little girl with a twisted neck. Another miracle on the same reredos, the healing of the possessed woman, occurs right near the tomb in the new basilica, before the altar that the unknown painter represents in great detail, making it easily recognizable.

The illuminator here seems instead to have resorted to more conventional solutions, even though they were less expressive of common piety and devotion. In liturgical manuscripts, illustrations of the initials related to the feast of Saint Francis show a great variety in both the choice of subjects and their translation into images. We can cite a few examples. In *Antiphonary* 3 (Bagnacavallo, Biblioteca Comunale Taroni, MS. 3, f. 3v; Montanari 2000: 165–66), illuminated in the third quarter of the 13th century by the Maestro di Bagnacavallo, the incipit initial related to the responsory *Franciscus ut in publicum* presents *Francis preaching to the birds* in place of the more typical image of his death and of the translation of his body to his tomb. Quite unique in the tradition of these episodes of Francis's life are the initials in two recently published *Antiphonaries* from Oristano Cathedral (P.VI and P.VII; Pace 2009: 97–140, especially 124, 134), illuminated in the last quarter of the 13th century in the Central part of Italy, probably between Emilia and Tuscany; I can only devote a few remarks to them here. The two initials illustrating the responsory *Franciscus ut in publicum* in the *Antiphonaries* P.VI (f. 102v) and P.VII (f. 46r) respectively, present: in the first one, an extremely rare image of the funeral procession with the transporting of the wooden casket on a cart pulled by two oxen and accompanied by a bishop, friars, and the populace; while the second recounts the episode in two superimposed scenes of *Francis receiving the stigmata* and the *Saint's death*, with his *animula* taken to heaven by two angels.

Middle Ages. Contact with the tomb, which was usually above ground precisely to make this proximity between the pilgrim and the holy body possible, allowed the miracle to occur through the thaumaturgic force that was communicated from the body to whoever drew near with faith in prayer. None of this was possible in Assisi, however, because Francis's body was buried and hidden beneath the altar of the Lower Church, removed from the gaze and contact of pilgrims and the devout (Cooper 2005: 1–37). In this way, other forms of piety were favored that were not necessarily tied to pilgrimage to the tomb. This is well attested by hagiographers, especially Bonaventure with his *Legenda maior*, who thanks to the remembrance of miracles granted through Francis's intercession—even far from Assisi—also contributed to the delocalization of cults that distinguished the last centuries of the Middle Ages and that, in Francis's case, confirms the greatness of his figure and the universality of his sanctity as well. The illuminator here, who presumably

Bible

Mirko Santanicchia

Fondo Antico Comunale at the Biblioteca del Sacro Convento, Assisi, MS. 17

Sec. XIII *med.*, membr., II, 306, I' (numbering of the sheets with a stamping machine of the last cent.; back endpaper made of paper); 419 × 290 mm. Rounded Gothic writing (probably of North Italian education) by a single hand in two columns (rr. 37/36 ll.). Some inhabited book initials painted with the brush with ample plant branches with geometric motifs, complicated by animal, human or grotesque protomes (ff. 1ra [dedicatory epistle of Jerome to Paulinus], 5va [Gen], 53va, 134vb [Ruth], 157rb [2Kns], 172vb [3Kns], 211rb [1Chr], 227rb [2Chr], 248va [Ezr], 254ra [Neh], 270vb [Tob], 276vb [Jdt], 284va [Ezek], 292rb [Job]); remaining decorated book initials painted with the brush and framed and decorated with plant motifs; chapter initials in Gothic capitals in pen and alternatively red lead and blue ink, with filigrees in contrasting colors; running titles and chapter numbering with small Gothic capitals and letters alternatively in red lead and blue. Modern restored binding in marbled paper on cardboard strips and spine reinforced with leather. On f. IIv, in Gothic formata of the 14th cent.: "P*ri*ma pars Biblie"; immediately underneath, in a consistent hand with the date: "Secuda pars non invenitur amplius hoc anno 1753, quo ego | […]arius hæc scribo | […]terib*us*"; higher up, in a 17th-cent. hand: "Contenta in hoc volumine: | Liber Genesis | Exodus | Leviticus | Numerorum | Deuteronomii | Josue | Libri quatuor Regum | Libri duo Paralipomenon | Liber primus Esdræ | Nehemias | Josias | Tobias | Judith | Esther | Job. Simples textus Sacræ Scripturæ sine glossa."

(Massimiliano Bassetti)

Fig. 1. *Bible* (first part), incipit of the book of Job, miniature with *Job's Speech*. Assisi, Fondo Antico Comunale, Biblioteca del Sacro Convento, MS. 17, f. 292r.

The Bible presented here is mentioned in the oldest inventory of the "Libreria segreta" of the Sacro Convento, dating from 1381, in these terms: "Prima pars unius magne biblie cum postibus bullatis. Acta ad serviendum pro lectione, dum fratres comedunt in refectorio, sive forestaria […]" (Alessandri 1906: 49; Cenci 1981) (First part of a large bible with studded boards. Intended for reading from while the friars are eating in the refectory or guest quarters).

There is no reliable information with regard to the client of the codex in question and consequently on the date of execution, information that may have been contained in the final part of the second volume, now lost. Thus the date proposed by scholars is based on considerations of a stylistic and paleographic nature, which have also been used to assess the reliability of an old tradition that links this Bible to John of Parma, general of the Order from 1247 to 1257, a tradition that is to some extent tenable (Sesti 1990: 82–89).

The presence of an image of Saint Francis with a halo fixes the *terminus post quem* for its realization as 1228, the year of his canonization. The *terminus ante quem*, if we accept the reference to John of Parma, should be set at 1257, the year in which Bonaventura da Bagnoregio became general of the Order of the Friars Minor. A span of time, as will be seen, compatible with the stylistic evidence.

The decorative scheme is composed of many filigreed initials in pen and ink and thirty-one illuminated initials, set at the beginning of each book of the Bible: specifically, there are fifteen solely decorated initials, thirteen figured ones and three historiated ones, with subjects linked to the respective contents of the text, so that, for example, the scene of *Job's Speech* illustrates the *incipit* of the book of the same name (fig. 1).

Rather than on the decoration as a whole, which has made it possible to link this codex on the stylistic plane with others produced by the same workshop, we will concentrate here mainly on the page with an image of Francis (fig. 2), which is moreover significant on the iconographic as well as iconological plane.

Fig. 2. *Bible* (first part), incipit of the book of Genesis, miniature with *Christ, Adam and Saint Francis*. Assisi, Fondo Antico Comunale, Biblioteca del Sacro Convento, MS. 17, f. 5v.

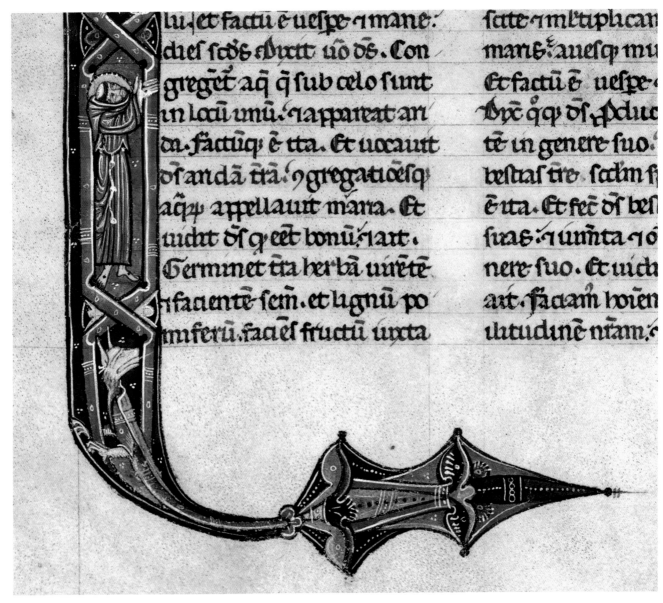

It is inserted in the *incipit* to the book of Genesis (fig. 3), to be precise in the body of the letter I, the third and last figure at the bottom, above which are set Adam and then the Creator with a cruciform halo, in an iconography that alludes to his incarnation in Christ as the "Word of God." The intention is to suggest a direct link between God the creator incarnate in Christ, Adam the first man and Francis as the person who has "adhered" perfectly to Christ, and already from the perspective of the *alter Christus*, as the stigmata show. The insertion of Francis in the *incipit* of Genesis has been connected with the zealous pauperist circles of the Minorite rule, a fact that, together with the absence of gold and the not excessive preciousness of the decorative scheme and range of colors, bears out the hypothesis of a client from the time of John of Parma, a convinced follower of Joachim of Fiore (Ciardi Dupré 1982: 331; Sesti 1990: 87). Francis is depicted with a halo, a tonsured head, dark hair, beard and moustache, the rope with three knots symbolizing the three religious vows and the stigmata clearly visible on hands and feet, while his side is covered by the upraised arm. In any case, the wound in his side only really began to appear in the iconography of the saint after 1255, the year of Pope Alexander VI's letter *Benigna operatio*, in which the veracity of Francis's stigmata, and in particular that of the wound in his side, was asserted (Frugoni 1993: 209).

The style identifies it as one of the oldest representations of the saint, which can be dated to some time around the 1240s and compared with paintings of Tuscan origin, although it can be differentiated from them because it lacks the harsh physiognomic characterization of Byzantine derivation especially evident in the works of Berlinghiero Berlinghieri, who in the panel in Pescia of 1235 has left us the oldest dated image of Francis.

The illuminator responsible for the decoration of this Bible was very likely an Umbrian, who drew, in the overall formulation of the illuminations, on French models from the 12th century and the Cistercian school, as is suggested by the simplicity of the decoration; choices that can be ascribed to the clients of the manuscript itself (Sesti in Ciardi Dupré 1982: 332–33). Several other manuscripts preserved

in or coming from Umbria have been justifiably assigned to the same scriptorium, in particular MS. 271 in the same Biblioteca del Sacro Convento of Assisi, MS. D 16 in the Biblioteca Porziuncola of Santa Maria degli Angeli, Bible I 70 in the Biblioteca Comunale Augusta in Perugia and yet others in the Bibliothèque Nationale of Paris, a circumstance that supports the hypothesis of a local scriptorium, perhaps located in Assisi itself (see Lunghi in *Carte che ridono* 1987: 263; Sesti 1990: 88–89).

On the stylistic plane, the references from which it seems to take its inspiration lie outside both the courtly "Byzantine" language of Giunta Pisano, who around 1236 painted the lost cross for the Basilica of San Francesco, commissioned by the minister general Friar Elias, and that of the so-called Master of San Francesco, who in the third quarter of the 13th century was the absolute protagonist of the decoration of the nave of the Lower Church with the parallel scenes from the lives of Saint Francis and Christ, and who was responsible for other monumental and significant interventions in the church of San Francesco in Perugia.

The absence of references to Giunta has also been interpreted as a possible *terminus ante quem* for the realization of the volume. If this is the case, it would have to be connected with the generalship of Friar Elias, which lasted from 1232 to 1239 (Ciardi Dupré 1990: 17), and not with the more rigorist current linked to the generalship of John of Parma, as is more often done.

The lack of these references to Giunta, however, does not appear so decisive if we consider that the great painted cross could not have immediately and by itself constituted such a significant model on the stylistic plane for scenes as disparate as the ones presented in this manuscript, all the more so in the absence of an image of Christ Crucified, which would have been able to provide a more reliable indication of the illuminator's utilization or not of the iconographic model of the suffering Christ proposed by Giunta Pisano.

In addition, among the manuscripts attributed to the same workshop for their stylistic affinities with this codex, one, MS. 271 in the Biblioteca del Sacro Convento in Assisi (figs. 4 and 5), should be dated to circa 1263 for reasons of a textual as well as stylistic nature, a fact that leads us to date its activity to years not too distant from then, and unlikely to extend to any time before 1236. Moreover, there is ample documentation in Umbria of a figurative culture that for the whole of the first half of the 13th century presents formal characteristics of expressive immediacy devoid of direct allusions to the properly Byzantine tradition of the early 13th century.

So we are left leaning toward a dating of the manuscript and its decoration to some time around the forties and fifties and thus in line with the traditional reference to the general John of Parma, at a time when the cycle of the Master of San Francesco in the Lower Church was not yet visible.

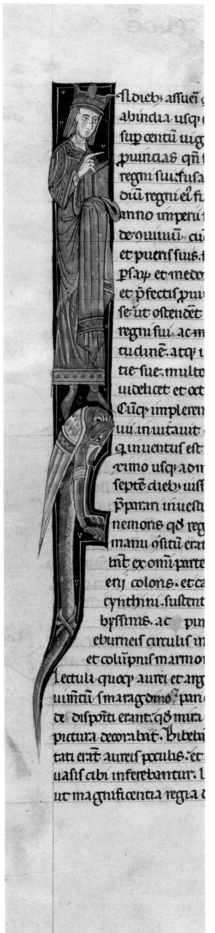

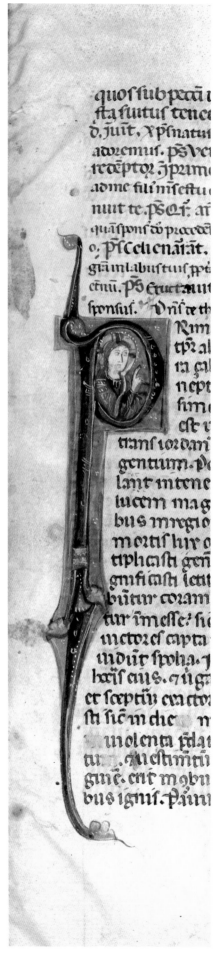

Franciscan Breviary

Enrica Neri Lusanna

Fondo Antico Comunale at the Biblioteca del Sacro Convento, Assisi, MS. 265
Sec. XIV¹ (on f. 171r, in the hand of the copyist: "Scriptum est istud breviarium an|no Domini .m°ccc°xxij°. | Finito libro, referamus gra-tias Christo"; however, the annotation seems to refer to the portion of the book transcribed to that point and not to the following part, al-though it was transcribed, it would seem, by the same copyist), membr., II, 414, I' (two modern numerations: one applied by a mechani-cal stamper from 1 to 411, the second, in pencil, assigned during the volume's restoration, corrected from 1 to 414); 298 × 209 mm. North-ern-Central Italian Gothic writing, by a single hand, laid out in two columns (rr. 38/37 ll.). Numerous painted inhabited and historiated ini-tials from which plant shoots depart, framing the entire justification of the relative pages, many of which have been removed (see below, the note of f. IIr); minor initials in Gothic capitals, inked alternatively in red lead and blue, with extensive filigrees in contrasting colors; head-ings in red lead that correspond to the paragraph marks, invariably in blue. Binding in leather over wooden strips, restored in 1883 by the laboratory of Grottaferrata. On f. IIr, in modern hand: "Spectat ad Sacrarium Huiusce Patriarchalis | S. Francisci; sed hoc in Archivio cus-toditur"; further below: "Fogli 414 in *dice*mbre 1883 | Sonosi rinvenute tagliate le lettere miniate ai fogli [The illuminated initials of the fol-lowing sheets have been cut out]: 27, 28, 31, 42, 107, | 124, 129, 139, 181, 185, 193, 199, 227, 232, 235, 242, 249, 254, | 261, 266, 272, 290, 332. | Restano intere quelle ai fogli [Those of the following sheets remain intact]: 7, 172, 189, 204, 209, 222, 238, 240, 246, | 247, 260, 274, 282, 286, 296, 299, 309, 315, 317, 320, 329, 335, 349, | 353, 354, 358, 377. | 1883." The codex transmits a Franciscan breviary.
(Massimiliano Bassetti)

The manuscript in parchment measures 298 × 209 mm and is comprised of 414 folios. It is dated 1322, as can be inferred from the annotation on f. 171r. The codex is not mentioned in the oldest inventory of the "Secret Library" of 1381. Its belonging to the Sacristy of Saint Francis is at-tested by the note on f. IIr, "Spectat ad Sacrarium Huiusce Patriarchalis S. Francisci; sed Hoc in Archivio custoditur," written in a hand that can be attributed to the second half of the eighteenth century (verbal communication from Cristina Roccaforte). An annotation from 1883, on the same sheet, documents the absence of the twenty-two miniatures that had already been removed by that time (Sesti 1990: 152–161, with preceding bibliography). One of the book's important aspects is the fact that it is the only manuscript dated by the Library; it therefore provides a definite reference for understanding the ten-dencies and the quality of the illuminators working for the Friars Minor in the third decade of the 14th century.

The *Breviary* is amply decorated, with its approximately 45 decorated, inhabited and historiated miniatures, all laid out according to a common scheme: within an illu-minated field of reduced dimensions (no more than 4 cm on each side), the saints are portrayed in half-length, seated or standing, and only in three miniatures is a his-toriated scene portrayed. The depiction, although small, was intended to recall the feast of the day through an image that had to make up for its reduced dimensions with its effectiveness.

The splendor of the miniature's effects, on the other hand, seems to rely deliberately on the decoration of the plant shoots that frame the two columns, in which the text is dis-posed, whether dividing them in the center as they fork in-

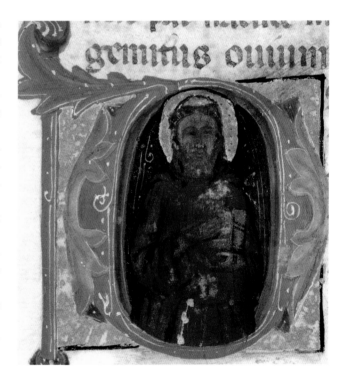

to two racemes at the top (fig. 1), or enveloping them as they develop into broad and fleshy motifs along the exter-nal borders (fig. 2), thereby fulfilling a structural role in the layout of the text. Despite the numerous subtractions, there remains evidence of the imaginative *drôleries* that betray the influence of French miniatures, exalted by a vast range of colors that support a type of shoot articulat-ed both with acutely profiled leaves, which are embell-ished with gold filaments or seals, as well as with fleshy phytomorphic tangles. In its variegated and sumptuous chromaticism, this type of decoration seems to aspire to the

Fig. 1. *Breviarium Fratrum Minorum*, decoration with plant shoots.
Assisi, Fondo Antico Comunale, Biblioteca del Sacro Convento, MS. 265, f. 335v.

On page 132
Fig. 1a. *Breviarium Fratrum Minorum*, miniature with *Saint Francis*.
Assisi, Fondo Antico Comunale, Biblioteca del Sacro Convento, MS. 265, f. 335v (detail).

Fig. 2. *Breviarium Fratrum Minorum*, decoration with plant shoots. Assisi, Fondo Antico Comunale, Biblioteca del Sacro Convento, MS. 265, f. 247v.

results achieved by the major protagonists of fourteenth-century Perugian illuminators, such as the First and Second Perugian illuminators, active within the first two decades of the century, to whom the illustration of the choral manuscripts of Saint Dominic of Perugia is attributed; and it also recalls the work of Venturella di Pietro, an Umbrian illuminator, whose vast production was dedicated to churches of the neighboring territories (Sesti 1990).

Citing Dante, we may say that "più ridon le carte" ("more laughing are the leaves") in this production of the manuscript from the early 14th century, due primarily to its decorative richness and to the masterful treatment of its layout, which both become vehicles for the exaltation of the chromatic effects.

The manuscript is displayed opened to f. 335v (figs. 1–1a), with the image of Saint Francis, who, although the codex reveals a liturgical and illustrative connotation (in the Franciscan sense), has no particular relevance. Nonetheless, despite the flatness in the draping of the pauper's brown robe against the blue background of the illuminated field, the saint, who is holding a book in his hands, is immediately recognizable by the prominence of the three knots in the rope, that contrast with his brown habit (fig. 1a).

Less evident is the face, in which the mouth stands out, rendered with a few red strokes, and the beard, which appears more copious than in the iconography of Saint Francis made popular at the end of the 13th century by the hand of Giotto in Assisi. In this case it is not possible to apply the theory advanced by Bellosi that the presence or absence of the beard in the image of Saint Francis is an ideological choice matured within the Order, which would have led the Conventual friars and the papal sphere to prefer a clean-shaven saint, in accordance with the style and customs of a decent citizen; whereas, on the other hand, the Spiritual friars (and with them the house of Angiò) would have preferred to distinguish him with more transgressive connotations—less "integrated" in the fashion of the time (Bellosi 1985: 3–40). We believe, on the contrary, that the explanation in this case lies perhaps in the individuation of the illuminator's peculiar stylistic trait, in his tendency to arrange the strands of the beard as wooly cotton balls—a trait which we find again in f. 358v, in the portrayal of Saint Martin. This comparison would also lead to the exclusion of any subsequent retouching, despite the consumed state of the miniature, due perhaps to a repeated tactile contact through acts of devotion.

Besides the manner of illuminating with few and efficient compendious traits, there is a sinuous flow to the line (see Saint James and Saint Philip on f. 247v, fig. 2a), which immediately connotes characters and episodes. The distinctive tract of the codex is a style that favors a middle register, denouncing the will to remain within a sphere that is more in line with the mundane, without appearing unadorned (Sesti 1990: 144–50; 152–61). In the three historiated initials—the recurrence of *Saint Clare portrayed before Bishop Guido* (f. 299v), the *Banquet of Herod with the Beheading of the Baptist* (f. 317v, fig. 3) and the *Nativity of the Virgin* (f. 320r)—the technical ability of the illuminator to depict complex scenes within the context of an inhabited initial, proves eloquent indeed, and appears even more admirable in the second miniature, in which he concentrates the two episodes, exploiting the form of the letter without exceeding the customary dimensions; whereas in the third, he employs a closer framing that allows physiognomic characterizations, such as the wrinkled faces of Saint Ann and her handmaid, as well as the de-

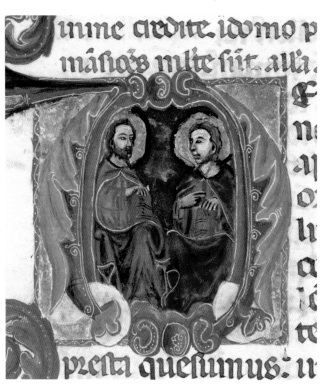

Fig. 2a. *Breviarium Fratrum Minorum*, miniature with *Saint James and Saint Philip*. Assisi, Fondo Antico Comunale, Biblioteca del Sacro Convento, MS. 265, f. 247v.

piction of everyday details (the bed and the coffer). All of the figures present a lively expression, achieved through an elongated modeling of the eye.

Because of these stylistic traits, the illuminator or the manuscript workshop of the *Breviary* (as the miniatures, because of illustrative and qualitative irregularities, do not appear to be the work of a single hand) have been compared by Sesti to Venturella di Pietro, an illuminator working in Perugia and for Assisi (Sesti 1990: 152–61); this comparison was extended by Marina Subbioni to include the author of MS. 50 of the Biblioteca Comunale di Poppi (also from the Sacro Convento di Assisi) (Subbioni 2003: 61), without, however, the proposal of ulterior compensation. And in fact, the comparison to coeval Umbrian illuminators does not appear as convincing as it had in the past. At most, the pregnant narrative, the linearistic accentuation with which the figures' profiles are articulated, the chromatic sensitivity and the study of a more three-dimensional representation may allow for a comparison with the Paciano Master.

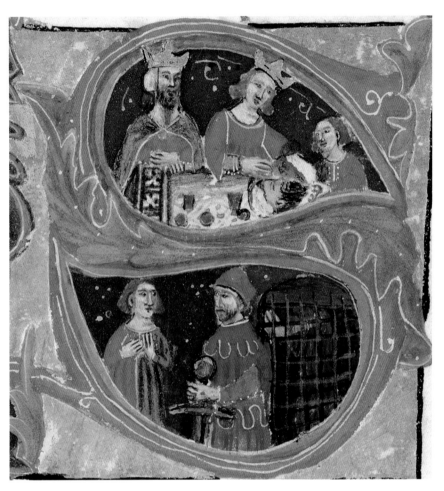

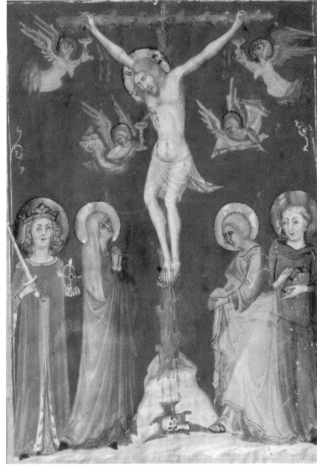

Fig. 3. *Breviarium Fratrum Minorum*, miniature with *Banquet of Herod with the Beheading of the Baptist*. Assisi, Fondo Antico Comunale, Biblioteca del Sacro Convento, MS. 265, f. 317v (detail).

Fig. 4. Maestro di Paciano, miniature with *Crucifixion*, detached leaf (ca. 1340). Private collection.

A painter and an illuminator, the Paciano Master worked in an area which was centered to the North-West of Perugia, toward Tuscany, at the intersection of the highly contrasting, humoral and illustrative Umbrian figurative culture with the more solemn Tuscan models, adopted in the first two decades of the century in the *a fresco* cycles of the Lower Church of Saint Francis. This is demonstrated in his most significant work, the altarpiece for the Oratory of Saint Francis in Perugia, now dismembered among the National Gallery of Umbria, the Diocesan Museum of Pieve del Vescovo and the Teutonic College of Santa Maria in Camposanto in Rome (Piagnani 2008: 123–34).

The comparison of *The Feast of Herod* and the *Crucifixion* (figs. 3–4) in private collection (Günther 1994: 45–51), which was illuminated in Perugia for the Matricola (Registry) of the Confraternity of Saint Benedict by the Paciano Master—whose activity as illuminator was identified by Filippo Todini (Todini 1980)—shows how the illuminators achieved parallel results: an accessible narrative exalted by a chromatic sensitivity and an illustrative effectivness.

If we consider that painting in Assisi developed in two distinct directions, it is not surprising to discover in this codex signs of the dual register of expression that is present in the art of the illuminators working for the Friars Minor in the first half of the century. One is of a high profile, seeking monumentality, classical measure and chromatic elegance, following the path inaugurated by Giotto with his "Scenes from Christ's Childhood," and by Simone Martini, with his work in the Chapel of Saint Martin, both located in the right transept of the Lower Church, up to the work of Puccio Capanna, including upgrades of an elegant Gothic tone; the other is more illustrational and conversational, followed by the painters and illustrators who exhibit a familiarity with the Florentine and Sienese schools, but demonstrate a preference for other masters as well, including Vanni di Baldolo, whose

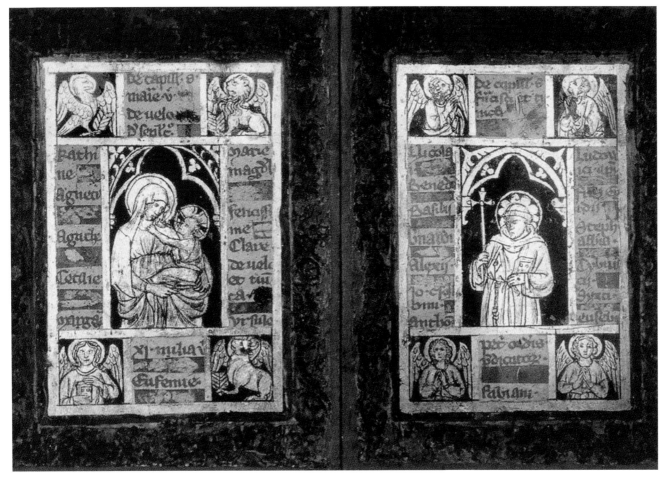

Fig. 5. Fra Pietro Teutonico, *Virgin and Child, Saint Francis*, detail of a reliquary (etched glass, ca. 1330). Gubbio, Museo Comunale.

work is characterized by a continuity with the formal expressive character of Meo da Siena.

It is probable that this trend, which runs parallel and is sometimes interwoven with a cultured art, proves successful because it responds to the need of the friars for images that may serve as an element of prayer and strengthen the faith of the beholder, beyond any canons of luxurious beauty. That this is an ideological choice of the Order is demonstrated by the fact that large and precious goldworks, such as the 13th-century chalice by Guccio di Mannaia, are accompanied in the 14 century by a vast and beautiful to behold, yet serial production of liturgical objects created with "microtechnique" in goldwork and glasswork, which, intended for the display of a copious number of relics, respond to the growing needs of the cult through the manufacturing of objects of various value. Friar Pietro Teutonico becomes a key figure in this trend in applied arts during the third decade of the 14th centu-

ry: his name is linked to a vast production of etched glass for reliquaries, including the Cross-reliquary in Santa Maria degli Angeli in Assisi and the Tabernacle-reliquary of the Municipal Museum of Gubbio (De Benedictis 2010: 70, 88) (fig. 5).

These works, along with the numerous relics and small images of saints, clearly interpret the more "pauperistic" intentions, which would become the norm within the artistic volition of the Order of Friars Minor. The *Breviary* is well placed within the context of this particular ideological and artistic climate, along the same lines as the reliquaries created for the purpose of hosting a significant number of relics; a climate that explains why the Order favoured the diffusion of images through the graphic medium of the miniature or of etched glass, by the hand of minor masters, who were effective in their narration and illustration and capable, at times, of emulating the most illustrious Giottesque and Martinian painting.

Missal

Mirko Santanicchia

Fondo Antico Comunale at the Biblioteca del Sacro Convento, Assisi, MS. 263

Sec. XIV[1], membr., 332, I' (a numbering in pencil made during the restoration of the volume, corrected from 1 to 332); 369 × 250 mm. Northern-Central Italian Gothic script, contrived and large in form, by a single hand and laid out in two columns (rr. 28/27 ll.). Numerous inhabited and historiated initials painted with a brush from which run plant shoots that surround the whole expanse of writing on the page; many of them have been removed (see below the annotation to f. 1r); minor initials in Gothic capitals inked alternatively in red lead and blue with extended filigrees in contrasting colors; headings and legends in red lead, to which correspond paragraph marks invariably in blue. Tri- and tetrachord quadrate notation delineated in red lead on ff. 89ra-90ra, 97vb-98ra, 103v, 119v, 123va-131rb, 143va, 147va-149ra, 149va-158vb, 161va-163ra, 163va, 330rb-331v. Leather binding on wooden strips, restored in 1883 by the Grottaferrata workshop. On f. 1r, in the lower margin and a modern hand: "Spectat ad Sacrarium Huiusce Patriarchalis | S. Francisci; sed hoc in Archivio custoditur"; immediately underneath, in pencil: "Fogli 332 *dice*mbre 1883 – Sono tagliate le lettere miniate ai fogli: 5, 17, 18, 22, 165. | Restano quelle ai fogli: 225, 233, 241, 250, 253, 255, 259, | 262, 268, 269, 273, 308. Altre | ci (sembra di semplice ……..)" [332 folios December 1883 – The illuminated letters on folios: 5, 17, 18, 22, 165 have been cut. | The ones on folios 225, 233, 241, 250, 253, 255, 259, | 262, 268, 269, 273, 308 remain. Others | (seem of simple ……..)]. The codex contains a missal *fratrum heremitarum s. Augustini*.
(*Massimiliano Bassetti*)

The original Augustinian pertinence of this missal is already made clear in the *incipit*, on f. 5, that declares: "In nomine Sanctissime Trinitatis: incipit ordo missalis fratrum heremitarum Sancti Augustini secundum consuetudinem romane curie" (In the name of the Holy Trinity: here begins the missal of the friars of the Order of Hermits of Saint Augustine according to the custom of the papal court).

Its transfer to the Sacro Convento took place almost certainly by 1394, the year in which a supplement was made to the oldest inventory of the sacristy dating from 1338, which records the presence of a total of 18 missals in the sacristy (Alessandri and Pennacchi 1914: 90).

The missal has been dated on the basis of the calendar present in the codex, and with the support of the stylistic evidence, to the period between 1312, the year in which the Feast of the Dedication of the Basilica of Saints Peter & Paul which appears on 18 November was promulgated, and 1334, owing to the absence of the Feast of the Holy Trinity on the eighth day after Pentecost, introduced that year (Sesti 1990: 177).

In addition to the simply rubricated or filigreed letters, there were thirty-three illuminated initials, five of which have been removed (fig. 1). Other illuminations may have decorated pages removed in their entirety, such as the three illuminated initial letters traced in a private collection in Trieste and others in Paris (Sesti 1990: 180–81; Hindman and Bollati 1996). Of the surviving illuminations eleven are figured initials and two historiated ones, concentrated almost all in the part of the Saints' Days Feasts. It is in this section of the codex that, on f. 269v, *In natale Sancti Francisci confessoris*, inside the letter D (Deus), is represented the scene of the *Impression of the Stigmata*

(figs. 2–3), inserted in the liturgical calendar on 17 September during the papacy of Benedict XI (1303–04).

The episode of Francis receiving the stigmata was without doubt one of the most significant and widely represented

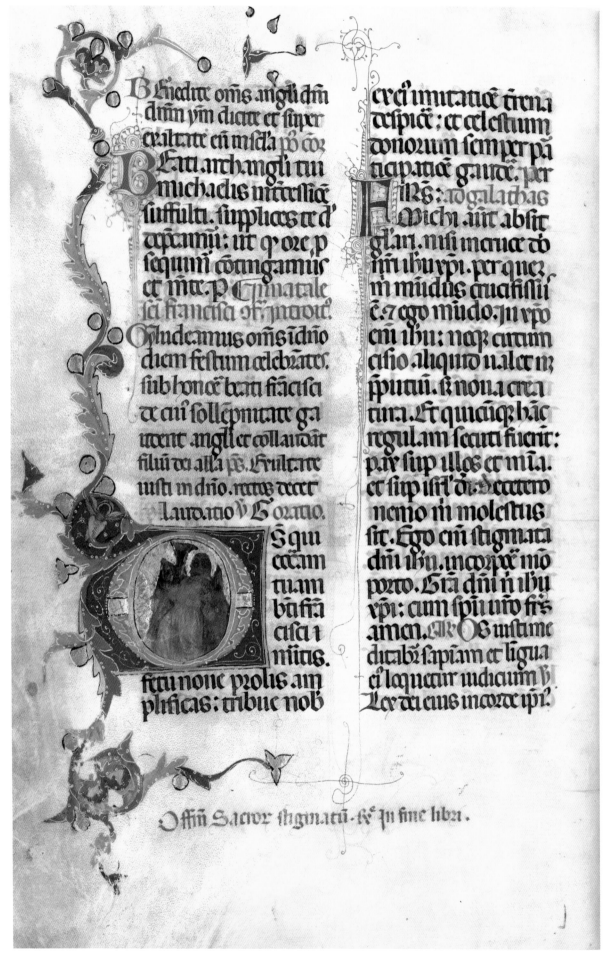

in Minorite iconography, and it is no coincidence that it is present in the oldest dated painting of the saint, the *Saint Francis Dossal* in Pescia (Pistoia) of 1235 by Bonaventura Berlinghieri. The stigmata immediately became the principal iconographic attribute of Saint Francis, and the manner of their miraculous impression, not to mention

their veracity, were at the center of an intense theological debate, that prompted the promulgation of nine papal letters between 1237 and 1291 to declare their authenticity. The essential stages in this process were undoubtedly the official *legendae*, Thomas of Celano's *Vita Beati Francisci* or "First Life" and *Memoriale* or "Second Life" and finally Bonaventure of Bagnoregio's *Legenda maior* fundamental sources that determined the main traits of the contemporary iconographic transpositions of the episode (see Frugoni 1993).

The version of *Francis Receiving the Stigmata* present in this missal also offers precise indications in the respect, notwithstanding its scarce legibility as a result of its poor state of preservation, due significantly to the wear caused by the friars touching the image out of devotion. In the background we see a mountain, identifiable as Monte Penna, the location of La Verna, that stands out against the gold ground, and in the foreground Francis, dressed in the brown habit, kneeling on the ground with his hands stretched upward and toward the left; this is the side on which appears a seraph, whose features – it should be noted – are clearly those of Christ, with his side bare and his arms spread in the gesture of the cross. From his body run five clearly visible golden rays, directed at the hands, feet and side of Francis. It was in Bonaventure's *Legenda maior*, finished and approved in 1263 and from 1266 the only officially authorized biography, that the identification

of the seraph who appeared to Francis with Christ was made explicit, and it is in Giotto's cycle in the upper church that this finds its complete figurative representation (fig. 4) (Frugoni 1993: 210–12).

That scene has in fact been used as a model for the miniature in this missal, although reversed and necessarily

stripped of all its narrative elements, for which there was no room, such as the figure of Friar Leo and the buildings. The familiarity with the Saint Francis cycle on the part of the illuminator of the codex can easily be explained by his probable Umbrian origin, which emerges clearly from the whole decorative scheme of the manuscript, where we can find evident similarities to the style of some of the artistic personalities most active in the region. In particular the Expressionist Master of Santa Chiara (Sesti in Ciardi Dupré 1982: 368; Sesti 1990: 179), one of the most direct Umbrian followers of Giotto – identified by many art historians with the painter Palmerino di Guido from Gubbio – and Puccio Capanna from Assisi, of whom the soft and blurred way of treating the flesh tones in the illuminated initials is reminiscent (fig. 5). The structure of the initials and the decorative scheme recall the manner of the workshops of illuminators active in Perugia, who by this time were also making use of clear Gothic inflections, under the influence of the Master of the Choir Books of San Lorenzo (Todini 1989: 381–82, assigns it to a Perugian illuminator in the years 1330–40; Subbioni 2003: 50, suggests the Master of the Register of Tailors); a fact that induces us to propose its realization by a workshop in the Perugian area around the third or fourth decade of the 14th century.

Fig. 5. *Missale Fratrum Heremitarum Sancti Augustini*, miniature with *Saint Catherine of Alexandria*. Assisi, Fondo Antico Comunale, Biblioteca del Sacro Convento, MS. 263, f. 273v.

Appendix

Abbreviations

Regarding the abbreviations in the historical biographies of Saint Francis and in other Franciscan sources cited in the texts, please see the list of abbreviations in *Francis of Assisi: early documents.* Vol. I: *The Saint*, ed. by R.J. Armstrong, J.A.W. Hellmann, W.J. Short, New York: New City Press, 1999, p. 32.

AH *Analecta Hymnica Medii Aevi*, ed. G.M. Dreves, C. Blume and H.M. Bannister, Leipzig: O.R. Reisland, 1886–1922, 55 voll.

AFH "Archivum Franciscanum Historicum", Quaracchi, then Grottaferrata, 1908– .

AM *Annales Minorum seu Trium Ordinum a S. Francisco institutorum, auctore A. R. P. Luca Waddingo, editio tertia accuratissima auctior et emendatior ad exemplar editionis*, Ad Claras Aquas prope Florentiam, then Quaracchi: ex typ. Collegii S. Bonaventurae, 1931–64, 32 voll.

ASC Archivio storico della Basilica and Sacro Convento di San Francesco in Assisi.

BAI *Biblioteca Agiografica Italiana. Repertorio di testi e manoscritti, secoli XIII-XV*, ed. by J. Dalarun, L. Leonardi et. al., Firenze: Sismel – Edizioni del Galluzzo, 2003, 2 voll. (Archivio romanzo, 4).

BF *Bullarium Franciscanum Romanorum Pontificum constitutiones, epistolas, ac diplomata continens…*, Romae: Typis Sacrae Congregationis de Propaganda Fide, 1759–1904, 7 voll.

FAED *Francis of Assisi: early documents.* Vol. I: *The Saint*; vol. II: *The founder*; vol. III: *The prophet*; [vol. IV:] *Index*, ed. by R.J. Armstrong, J.A.W. Hellmann, W.J. Short, New York: New City Press, 1999–2002, 4 voll.

FAOF *Fonti agiografiche dell'Ordine francescano*, Padova: Editrici francescane, 2014.

Fontes *Fontes franciscani*, ed. by E. Menestò, S. Brufani et. al., Assisi: Porziuncola, 1995 (Medioevo Francescano. Testi, 2).

Mem Thomas de Celano, *Memoriale. Edictio critico-synoptica duarum redactionum ad fidem codicum manuscriptorum*, ed. by F. Accrocca and A. Horowski, Roma: Istituto storico dei Cappuccini, 2011 (Subsidia Franciscalia, 12).

MF "Miscellanea Francescana", Foligno, then Assisi and Roma, 1886– .

Q *Tractatus de miraculis*, in *Legendae S. Francisci Assisiensis saeculis XIII et XIV conscriptae*, Ad Claras Aquas prope Florentiam: ex typ. Collegii S. Bonaventurae, 1926–41 [*sic*, but 1941], 271–30 (Analecta Franciscana, X).

Bibliography

Abate

1930 G. Abate, *La Leggenda Napoletana di S. Francesco e l'Ufficio rimato di Giuliano da Spira secondo un codice umbro*: MF 30 (1930) pp. 129–55.

1941 G. Abate, *La casa dove nacque s. Francesco d'Assisi nella sua documentazione storica*, Gubbio: Oderisi, 1941.

1948 G. Abate, *Storia e leggenda intorno alla nascita di San Francesco*: MF 48 (1948) pp. 515–49.

Actus

1998 *Actus beati Francisci et sociorum eius*, new posthumous edition by J. Cambell, ed. by M. Bigaroni and G. Boccali, Assisi: Edizioni Porziuncola, 1988 (Pubblicazioni della Biblioteca francescana Chiesa Nuova, Assisi, 5).

Alessandri

1906 L. Alessandri, *Inventario dell'antica biblioteca del S. Convento di S. Francesco in Assisi compilato nel 1381 pubblicato con note illustrative e con raffronto ai codici esistenti nella Comunale della stessa città dal bibliotecario Leto Alessandri...*, Assisi: Tip. Metastasio, 1906.

Alessandri and Pennacchi

1914 L. Alessandri – F. Pennacchi, *I più antichi inventari della sacrestia del Sacro Convento di Assisi (1338-1473), (Bibl. Com. di Assisi, Cod. 337)*: AFH 7 (1914) pp. 66–107, 294–340.

1915 L. Alessandri – F. Pennacchi, *Bullarium Pontificium quod extat in Archivio Sacri Conventus S. Francisci Assisiensis (nunc apud publicam Bibliothecam Assisii)*: AFH 8 (1915) pp. 592–617.

Alfonso de' Liguori

1774 Sant'Alfonso de' Liguori, *Traduzione de' Salmi e de' Cantici che si contengono nell'Officio Divino*, Napoli: nella Stamperia de' fratelli di Paci, 1774.

Angeli

1704 F.M. Angeli, *Collis Paradisi amoenitas, seu Sacri Conventus Assisiensis historiae libri 2...*, Montefalisco [Montefiascone]: ex typ. Seminarii, 1704.

Angelo Clareno francescano

2007 *Angelo Clareno francescano*. Atti del XXXIV Convegno internazionale della Società internazionale di Studi francescani e del Centro interuniversitario di studi francescani, Assisi 5-7.10.2006, Spoleto: Fondazione Centro italiano di studi sull'alto Medioevo, 2007 (Atti dei Convegni della Società internazionale di Studi francescani e del Centro interuniversitario di studi francescani, NS, 17).

Assirelli

1988 M. Assirelli, *I manoscritti francesi e inglesi del Duecento*, in *Biblioteca Assisi* 1988: 105–30 (entries: 131–255).

Bartoli Langeli

1997 *Le carte duecentesche del Sacro Convento di Assisi. Instrumenti, 1168-1300*, a. c. di A. Bartoli Langeli, Padova: Centro studi antoniani, 1997 (Fonti e studi francescani, 5).

2012 A. Bartoli Langeli, *La Solet annuere come documento*, in *La Regola di frate Francesco. Eredità e sfida*, ed. by P. Maranesi and F. Accrocca, Padova: Editrici Francescane, 2012, pp. 57–94.

Bellosi

1985 L. Bellosi, *La pecora di Giotto*, Torino: Einaudi, 1985.

Biblioteca Assisi

1988 *La Biblioteca del Sacro Convento di Assisi*. Vol. I: *I libri miniati di età romanica e gotica*, essays and catalogue by M. Assirelli, M. Bernabò and G. Bigalli Lulla, introduction by M.G. Ciardi Duprè Dal Poggetto, Assisi: Casa editrice francescana Assisi, 1988 (Il miracolo di Assisi, 7/I).

1990 *La Biblioteca del Sacro Convento di Assisi*. Vol. II: *I libri miniati del XIII e del XIV secolo*, essays and catalogue by M. Assirelli and E. Sesti, introduction by M.G. Ciardi Duprè Dal Poggetto, Assisi: Casa editrice francescana Assisi, 1990 (Il miracolo di Assisi, 7/II).

Bihl

1908 M. Bihl, *E sermonibus Friderici de Vicecomitibus, archiepiscopi Pisani, de S. Francisco (1263-1267)*: AFH 1 (1908) pp. 652–55.

Boesch Gajano

1999 S. Boesch Gajano, *La Santitá*, Bari: Laterza, 1999.

Bonaventura

1993 Bonaventura da Bagnoregio, *Itinerarium mentis in Deum*, in *Sancti Bonaventurae Opera*. Vol. V/1: *Sermones theologici*, Roma: Città Nuova, 1993, pp. 493–569.

Brufani

1998 S. Brufani, *Agiografia e santità francescana nel Piceno: gli Actus beati Francisci et sociorum eius*, in *Agiografia e culto dei santi nel Piceno. Atti del Convegno di studio svoltosi in occasione della undicesima edizione del "Premio internazionale Ascoli Piceno", Ascoli Piceno 02-03.05.1997*, ed. by E. Menestò, Spoleto: Centro italiano di studi sull'alto Medioevo, 1998, pp. 123–52.

2009 S. Brufani, *Ubertino da Casale e le mistiche umbre «magistri practici»*, in *Santa Chiara da Montefalco monaca agostiniana (1268-1308) nel contesto socio-religioso femminile dei secoli XIII-XIV. Atti del Congresso internazionale in occasione del VII centenario della morte di Chiara da Montefalco (1308–2008)*, Montefalco – Spoleto 25-27.09.2008, ed. by E. Menestò, Spoleto: Centro italiano di studi sull'alto medioevo, 2009, pp. 143–61 (Uomini e mondi medievali, 17).

2010 S. Brufani, *Gli* Actus beati Francisci *e i* Fioretti: *due storie di un testo senza storia*: "Franciscana. Bollettino della Società internazionale di Studi francescani" XII (2010) pp. 193–214.

2013 S. Brufani, *"Ordinem secundum sua statuta reformavit": Francesco d'Assisi nella crisi del '20*: "Franciscana. Bollettino della Società internazionale di Studi francescani" XV (2013) pp. 1–47.

Bruni

1997 F. Bruni, *Volgarizzamenti francescani e dimensioni narrative*, in *Francescanesimo* 1997: 41–93.

Bughetti

1926 B. Bughetti, *Alcune idee fondamentali sui "Fioretti di S. Francesco"*: AFH 19 (1926) pp. 321–33.

1928 B. Bughetti, *Una parziale nuova traduzione degli* Actus *accoppiata ad alcuni capitoli dei* Fioretti: AFH 21 (1928) pp. 515–52; 22 (1929) pp. 63–113.

Burkitt

1922 F.C. Burkitt, *The oldest ms. of S. Francis writings*: "Revue bénédictine" 34 (1922) 199–208.

Burr

2001 D. Burr, *The Spiritual Franciscans. From Protest to Persecution in the Century After Saint Francis*, University Park (PA): The Pennsylvania University Press, 2001.

Callaey

1911 F. Callaey, *L'idéalisme franciscain spirituel au XIVe siècle. Étude sur Ubertin de Casale*, Louvain: Bureau du Recueil, 1911.

1921 F. Callaey, *L'influence et la diffusion de l'Arbor Vitae d'Ubertin de Casale*, Louvain: Bureau de la Revue d'Histoire Ecclésiastique, 1921.

Cariboni

2003 G. Cariboni, *Esenzione cistercense e formazione del Privilegium commune. Osservazio-*

ni a partire dai cenobi dell'Italia settentrionale, in *Papato e monachesimo "esente" nei secoli centrali del Medioevo*, ed. by N. D'Acunto, Firenze: University Press, 2003, pp. 65–107.

Carte che ridono
1987 *Carte che ridono. Immagini di vita politica, sociale ed economica nei documenti miniati e decorati dell'Archivio di Stato di Perugia. Secoli XIII–XVIII.* Exhibition Catalogue, Perugia 1984–85, Foligno: Editoriale Umbra, 1987.

Casolini
1937 *Arbor Vitae Crucifixae Jesu di Ubertino da Casale*, translation and introduction by F. Casolini, Lanciano: Gino Carabba, 1937.

Cenci
1981 C. Cenci, *Bibliotheca manuscripta ad Sacrum Conventum assisiensem*, Assisi: Casa editrice francescana Assisi, 1981, 2 vols.

Châtelet
1998 A. Châtelet, *Pittura dal 1260 al 1400*, in *Enciclopedia dell'Arte Medievale* IX (1998) coll. 500b–525b.

Chesterton
1944 G.K. Chesterton, *St. Francis of Assisi*, London: Hodder, 1944 (or. ed.: 1923).

Chevalier
1900 C.U. Chevalier, *Sacramentaire et martyrologe de l'Abbaye de Saint-Rémy. Martyrologe, calendrier, ordinaires et prosaire de la mètropole de Reims (VIIIe-XIIIe siècles), publiés d'après les manuscrits de Paris, Londres, Reims et Assise*, Paris: Librarie Alphonse Picard, 1900.

Chronica
1897 *Analecta Franciscana*. Vol. III: *Chronica XXIV Generalium ordinis Minorum…*, Ad Claras Aquas prope Florentiam: ex typ. Collegii S. Bonaventurae, 1897.

Ciardi Dupré
1982 M.G. Ciardi Duprè Dal Poggetto, *La miniatura francescana dalle origini alla morte di san Bonaventura*, in *Francesco d'Assisi. Documenti e Archivi, Codici e Biblioteche, Miniature*, Milano: Electa, 1982, pp. 331–50.

1990 M.G. Ciardi Duprè Dal Poggetto, *Introduzione*, in *Biblioteca Assisi* 1990: 13–25.

Ciliberti
2003 G. Ciliberti, *Dagli scriptoria di san Luigi alla corte di Bonifacio VIII: nuove osservazioni sul codice 695 della Biblioteca Comunale di Assisi*: "Acta Musicologica" 75 (2003) pp. 173–99.

Contini
1970 G. Contini, *La letteratura italiana delle origini*, Firenze: Sansoni, 1970.

Cooper
2005 D. Cooper, *'In loco tutissimo et firmissimo': the Tomb of St. Francis in History, Legend and Art*, in *The Art of the Franciscan Order in Italy*, ed. by W.R. Cook, Leiden: Brill, 2005, pp. 1–37.

D'Acunto
2002 N. D'Acunto, *Il vescovo Guido oppure i vescovi Guido? Cronotassi episcopale e fonti francescane*, in Id., *Assisi nel medioevo. Studi di storia ecclesiastica e civile*, Assisi: Accademia Properziana del Subasio, 2002, pp. 103–45.

2003 N. D'Acunto, *I documenti per la storia dell'esenzione monastica in area umbro-marchigiana: aspetti istituzionali e osservazioni diplomatistiche*, in *Papato e monachesimo "esente" nei secoli centrali del Medioevo*, ed. by Id., Firenze: University Press, 2003, pp. 215–26.

n.d. N. D'Acunto, *Forme della centralizzazione stabili e mutevoli degli ordini religiosi nei secoli XII e XIII*, in *Sistema di comunicazione e comunicazione dei sistemi nell'Europa medievale. Monasteri e ordini religiosi nell'Europa del XII e XIII secolo*. Atti del seminario di Villa Vigoni, Menaggio (CO) 02-05.11.2009, ed. by G. Melville, *forthcoming*.

Dalarun
2007 J. Dalarun, *Vers une résolution de la question franciscaine. La Légende ombrienne de Thomas de Celano*, Paris: Fayard, 2007.

2008 J. Dalarun, *Introduction*, in *À l'origine des* Fioretti. *Les Actes du bienheureux François et de ses compagnons*, Paris: Éd.

Franciscaines; Éd. du Cerf, 2008, pp. 7–27.

De Benedictis
2010 C. De Benedictis, *Devozione e produzione artistica in Umbria. Vetri dorati dipinti e graffiti del XIV e XV secolo*, Firenze: Edifir, 2010.

De Luca
1954 G. De Luca, *Introduzione*, in *Prosatori minori del Trecento*. Vol. I: *Scrittori di religione*, ed. by Id., Milano–Napoli: Ricciardi, 1954, pp. XI–XL.

De Sandre Gasparini
2002 G. De Sandre Gasparini, *I luoghi della pietà laicale: ospedali e confraternite*, in *Assisi anno 1300*, ed. by S. Brufani and E. Menestò, Assisi: Porziuncola, 2002, pp. 139–81 (Medioevo francescano. Saggi, 6).

Delcorno
1998 C. Delcorno, *Produzione e circolazione dei volgarizzamenti religiosi tra Medioevo e Rinascimento*, in *La bibbia in italiano tra Medioevo e Rinascimento*. Atti del Convegno internazionale, Firenze, Certosa del Galluzzo 08-09.11.1996, ed. by L. Leonardi, Firenze: Sismel – Edizioni del Galluzzo, 1998, pp. 3–22 (Millennio medievale, 10).

Desbonnets
1986 Th. Desbonnets, *Dall'intuizione all'istituzione. I francescani*, Milano: Edizioni Biblioteca Francescana Provinciale, 1986 (or. fr. ed.: 1983).

Dolso
2001 M.T. Dolso, *Un nuovo manoscritto della* Chronica XXIV *generalium ordinis Minorum. Il codice 142 della Bibliothèque municipale di Strasburgo*: "Franciscana. Bollettino della Società internazionale di Studi francescani" III (2001) pp. 191–210.

2003 M.T. Dolso, *La* Chronica XXIV *generalium. Il difficile percorso dell'unità nella storia francescana*, preface by A. Rigon, Padova: Centro studi antoniani, 2003.

2004 M.T. Dolso, *I codici della* Chronica XXIV generalium ordinis Minorum: "Franciscana. Bollettino della Società internazionale di Studi francescani" VI (2004) pp. 185–261.

Esser and Oliger
1972 K. Esser – R. Oliger, *La tradition manuscrite des Opuscules de saint Fraçois d'Assise. Préliminaires de l'édition critique*, Roma: Istituto Storico dei Cappuccini, 1972 (Subsidia scientifica franciscalia, 3).

Eubel
1908 C. Eubel, *Elenchus Romanorum Pontificum Epistolarum, quae in Archivio Sacri Conventus Assisiensis O. Min. Conv. exstant*: AFH 1 (1908) pp. 601–16.

Everist
1990 M. Everist, *From Paris to St. Andrews: The Origins of W/1*: "Journal of the American Musicological Society" 43 (1990) pp. 119–30.

Fascetti
2009 F. Fascetti, *La tradizione manoscritta tre-quattrocentesca dei Fioretti di san Francesco*: AFH 102 (2009) pp. 419–68; 103 (2010) pp. 41–94.

Fioretti
1902 *I Fioretti di Sancto Francescho secondo la lezione del codice fiorentino scritto da Amaretto Mannelli ora per la prima volta edita pubblicati di nuovo*, ed. by L. Manzoni, Roma: E. Loescher, 1902 (or. ed.: 1900).

Fortini
1959 A. Fortini, *Nova vita di San Francesco*, Assisi: Edizioni Assisi, 1959, 5 vols.

Francescanesimo
1997 *Francescanesimo in volgare (secoli XIII-XIV)*. Atti del XXIV Convegno internazionale della Società internazionale di Studi francescani e del Centro interuniversitario di studi francescani, Assisi 17-19.10.1996, Spoleto: Centro italiano di studi sull'alto Medioevo, 1997 (Atti dei Convegni della Società internazionale di Studi francescani e del Centro interuniversitario di studi francescani, NS, 7).

Fratini
1882 G. Fratini, *Storia della Basilica e del Convento di San Francesco in Assisi*, Prato: Ranieri Guasti, 1882.

Frenz
2008 T. Frenz, *I documenti pontifici nel medioevo e nell'età mo-*

derna, Città del Vaticano: Scuola Vaticana di Paleografia, Diplomatica e Archivistica, 2008 (Littera Antiqua, 6).

Frugoni
1993 C. Frugoni, *Francesco e l'invenzione delle stimmate. Una storia per parole e immagini fino a Bonaventura e Giotto*, Torino: Einaudi, 1993.
1996 C. Frugoni, *Vita di un uomo: Francesco d'Assisi*, Torino: Einaudi, 1996.

Giordano da Giano
2011 J. Schlageter, *Die Chronica des Bruders Jordan von Giano. Einführung und kritische Edition nach den bisher bekannten Handschriften*: AFH 104 (2011) 3–63.

Godet
2005 J.-F. Godet-Calogeras, Amodo sum mortuus vobis: *la Question de la démission de Frère François*: "Franciscana. Bollettino della Società internazionale di Studi francescani" VII (2005) pp. 33–67.
2010 J.-F. Godet-Calogeras, *De la Forma vitae à la Regula bullata et le Testament de Frère François*, in *Regola* 2010: 31–59.

Guenée
1986 B. Guenée, *Lo storico e la compilazione nel XIII secolo*, in *Aspetti della letteratura latina nel secolo XIII. Atti del primo convegno internazionale di studi dell'Associazione per il Medioevo e l'Umanesimo latini, Perugia 03-05.10.1983*, ed. by C. Leonardi and G. Orlandi, Firenze, 1986, pp. 57–76 (Quaderni del Centro per il collegamento degli studi medievali e umanistici dell'Università di Perugia, 15).

Günther
1994 J. Günther, *Mittelalterliche Handschriften und Miniaturen. Kunstschätze im Verborgenen*, Holm b. Hamburg: Herms, 1994.

Heullant-Donat
2005 I. Heullant-Donat, *Des missionaires martyrs au martyrs missionaires. La mémoire des martyrs franciscains au sein de leur ordre au XIIIᵉ et XIVᵉ siècles*, in *Écrire son histoire. Les communautés régulières face à leur passé. Actes du Vᵉ colloque international du CERCOR, Saint-Étienne 06-08.11.2002*, Saint-Étienne: Publications de l'Université de Saint-Étienne, 2005, pp. 171–84 (CERCOR. Travaux et recherches, 18).

Hiley
1981 D. Hiley, *Further Observations on W/1: The Ordinary of Mass Chants and the Sequences*: "Journal of the Plainsong and Medieval Music Society" 4 (1981) pp. 67–80.

Hindman and Bollati
1996 S. Hindman – M. Bollati, *Illuminations, Enluminures, Miniature. B E L Catalogue*, London: Brisigotti Antiques; Paris: Les Enluminures; Lugano: Longari Art, 1996.

Husmann
1964 H. Husmann, *Tropen-und Sequenzenhandschriften*, München-Duisburg: Henle Verlag, 1964 (Repertoire International des Sources Musicales, V/1)

Initienverzeichnis
1978 *Initienverzeichnis zu August Potthast, Regesta pontificum Romanorum (1198-1304)*, München: Monumenta Germaniae Historica, 1978 (MGH. Hilfsmittel, 2).

Iversen
1990 G. Iversen, *Corpus Troporum VII. Tropes de l'Ordinaire de la messe. Tropes du Sanctus*. Stockholm: Almqvist & Wiksell International, 1990 (Studia Latina Stockholmiensia, XXXIV).
n.d. G. Iversen, *Corpus Troporum XII. Tropes de l'Ordinaire de la messe. Tropes du Gloria*, Stockholm: Stockholm University Press, forthcoming, 2 vols. (Studia Latina Stockholmiensia, LX).

Kanter and Palladino
1999 L.B. Kanter – P. Palladino, *Master of the Assisi Choirbooks*, in *The Treasury of St. Francis of Assisi*. Exhibition Catalogue ed. by G. Morello and L.B. Kanter, Milano: Electa, 1999.

Kleinschmidt
1928 B. Kleinschmidt, *Die Basilika San Francesco in Assisi*. Vol. III: *Dokumente und Akten zur Geschichte der Kirche und des Klosters*, Berlin: Verlag Fur Kunstwissenschaft, 1928.

Lempp
1901 E. Lempp, *Frère Élie de Cortone, Étude biographique*, Paris: Fischbacher, 1901 (Collection d'études et de documents sur l'histoire religieuse et littéraire du Moyen âge, 3).

Leonardi
1983 C. Leonardi, *L'eredità di Francesco d'Assisi nei "Fioretti"*, in *Leggienda del beato messer sancto Franciescho d'Assisi. Commenti al manoscritto Gaddi 112 conservato presso la Biblioteca Laurenziana di Firenze*, essays by M.G. Duprè Dal Poggetto, C. Leonardi and E. Menestò, n.p., n.d. [printed: Cinisello Balsamo: Arti grafiche Amilcare Pizzi, 1983], pp. 3–5.

Lunghi
1989 E. Lunghi, *Una 'copia' antica dagli affreschi del Maestro di San Francesco*: "Paragone" XXXIX (1989) 467, pp.12–20.
2004 E. Lunghi, *Maestro del Messale di Deruta/Maestro dei Corali di Assisi*, in *Dizionario biografico dei miniatori italiani, secoli IX-XVI*, ed. by M. Bollati, Milano: Sylvestre Bonnard, 2004, pp. 627–29.

Maleczek
2003 W. Maleczek, *Francesco, Innocenzo III, Onorio III e gli inizi dell'Ordine minoritico. Una nuova riflessione su una questione antica*: "Frate Francesco" 69 (2003) 1, pp. 167–206 (or. ger. ed.: 1998).

Manoscritti datati
2003 *I manoscritti datati del Fondo Palatino della Biblioteca Nazionale Centrale di Firenze*, ed. by S. Bianchi, Firenze: Sismel – Edizioni del Galluzzo, 2003 (Manoscritti datati d'Italia, 9).

Manselli
1965 R. Manselli, *Pietro di Giovanni Olivi ed Ubertino da Casale*: "Studi Medievali", s. 3, VI (1965) pp. 94–121.
1970 R. Manselli, *Ubertino da Casale*, in *Enciclopedia Dantesca* 5 (1976) coll. 782b–783b.

Manzoni
1887 L. Manzoni, *Di una nuova edizione dei Fioretti di S. Francesco secondo il testo di Amaretto Mannelli*, Bologna: Regia Tipografia, 1887.

Martinez Ruiz
2000 C.M. Martinez Ruiz, *De la dramatizacion de los acontencimentos de la Pascua a la Cristologia. El cuarto libro del Arbor Vitae Crucifixae Iesu de Ubertino de Casale*, Roma: Antonianum, 2000.

Menestò
1988 E. Menestò, *Dagli «Actus» al «De Conformitate»: la compilazione come segno della coscienza del francescanesimo trecentesco*, in *I Francescani nel Trecento. Atti del XIV convegno internazionale della Società internazionale di Studi francescani, Assisi 16-18.10.1986*, Perugia: Università degli Studi di Perugia. Centro di Studi francescani, 1988, pp. 41–68.
1995 E. Menestò, *Introduzione* agli *Actus beati Francisci et sociorum eius*, in *Fontes* 2057–84.

Merlo
2003 G.G. Merlo, *Nel nome di san Francesco. Storia dei frati Minori e del francescanesimo sino agli inizi del XVI secolo*, Padova: Editrici Francescane, 2003.
2004 G.G. Merlo, *Questioni intorno al francescanesimo "compilativo" e "letterario"*: "Il Santo. Rivista francescana di storia dottrina arte" 44 (2004) pp. 221–32.
2009 G.G. Merlo, *In the Name of St. Francis: History of the Friars Minor and Franciscanism until the Early Sixteenth Century*. Translated by R. Bonnano. Ed. by R.J. Karris and J.F. Godet-Calogeras. Saint Bonaventure, NY: The Franciscan Institute, 2009.
2010 G.G. Merlo, *A modo di conclusioni: «paucis verbis et simpliciter»*, in *Regola* 2010: 319–41.

Miccoli
2008 G. Miccoli, *Francesco e la Porziuncola*, in *San Francesco e la Porziuncola. Dalla "chiesa piccola e povera" alla Basilica di Santa Maria degli Angeli. Atti del Convegno di studi storici, Assisi 02-03.03.2007*, ed. by P. Messa, Assisi: Edizioni Porziuncola, 2008, pp. 23–40.

Michalczyk
1981 M. Michalczyk, *Une compilation parisienne des sources primitives franciscaines (Paris, Na-*

tionale, ms. latin 12707): AFH 74 (1981) pp. 3–32, 401–55.

Miniature Brera
1997 *Miniature a Brera 1100-1422. Manoscritti dalla Biblioteca Nazionale Braidense e da Collezioni private.* Exhibition Catalogue ed. by M. Boskovits, G. Valagussa and M. Bollati, Milano: F. Motta, 1997.

Montanari
2000 S. Montanari, *Antifonario Graduale Proprio dei santi,* in *Corali miniati di Faenza, Bagnacavallo e Cotignola. Tesori della diocesi,* ed. by F. Lollini, Faenza: Edit Faenza, 2000, pp. 165–66.

Morghen
1923 R. Morghen, *Il Cardinale Matteo Rosso Orsini*: "Archivio della Reale Società Romana di Storia Patria" XLVI (1923) pp. 271–372.

Natale
2013. S. Natale, *Attorno all'edizione critica dei* Fioretti: *riflessioni sulla provenienza di Actus,* Fioretti, *e Considerazioni*: "Franciscana. Bollettino della Società internazionale di Studi francescani" XV (2013) 173–208.

Nessi
1991 S. Nessi, *Inventario e regesti dell'Archivio del Sacro Convento d'Assisi,* Padova: Centro Studi Antoniani, 1991 (Fonti e studi francescani, 3).
1994 S. Nessi, *La basilica di S. Francesco in Assisi e la sua documentazione storica,* 2d updated edition, Assisi: Casa editrice francescana Assisi, 1994 (Il miracolo di Assisi, 5).

Nicolini
1978 U. Nicolini, *La struttura urbana di Assisi,* in *Assisi al tempo di san Francesco.* Atti del V convegno internazionale della Società internazionale di Studi francescani, Assisi 13-16.10.1977, Assisi: Società internazionale di Studi francescani, 1978, pp. 247–70.

Pace
2009 V. Pace, *I codici miniati duecenteschi della cattedrale di Oristano,* in Die ac nocte. *I codici liturgici di Oristano dal Giudicato d'Arborea all'età spagnola (secoli XI-XVII),* ed. by G. Mele, Cagliari: AM&D Edizioni, 2009, pp. 97–140.

Pellegrini
2002 L. Pellegrini, *La raccolta di testi francescani del codice assisano 338. Un manoscritto composito e miscellaneo,* in *Revirescunt chartae codices documenta textus.* Miscellanea in honorem fr. Caesaris Cenci, O.F.M., ed. by A. Cacciotti and P. Sella, Romae: Pontificium Athenaeum Antonianum, vol. I, pp. 289–340.

Petrocchi
1957 G. Petrocchi, *Dagli "Actus beati Francisci" al volgarizzamento dei "Fioretti",* in Id., *Ascesi e mistica trecentesca,* Firenze: F. Le Monnier, 1957, pp. 89–146.
1957a G. Petrocchi, *Inchiesta sulla tradizione manoscritta dei "Fioretti di San Francesco":* "Filologia romanza" IV (1957) pp. 311–25.
1983 G. Petrocchi, *Introduzione,* in *Francesco d'Assisi. Gli scritti e la leggenda,* ed. by Id., notes by I. Di Guardo, Milano: Rusconi, 1983, pp. 5–50.

Piagnani
2008 F. Piagnani, *I lacerti dell'affresco dell'eremo perugino di Santa Maria del Sasso e una ricostruzione per il Maestro di Paciano,* in F. Piagnani – M. Santanicchia, *Storie di pittori tra Perugia e il suo lago,* Morbio Inferiore: Selective Art, 2008, pp. 115–44.

Potestà
1980 G.L. Potestà, *Storia ed escatologia in Ubertino da Casale,* Milano: Vita e Pensiero, 1980.
1992 G.L. Potestà, *Ubertin de Casale,* in *Dictionnaire de Spiritualité* 16 (1992) coll. 3–15.

Potthast
1874 A. Potthast (ed. by), *Regesta Pontificum Romanorum inde ab a. post Christus natum MCXCVIII ad a. MCCCIV,* Berolini: de Decker, 1874–75, 2 vols.

Pratesi
1982 A. Pratesi, *Nolo aliud instrumentum,* in *Francesco d'Assisi. Documenti e archivi. Codici e Biblioteche. Miniature.* Catalogo della mostra per l'VIII centenario della nascita di san Fran-cesco d'Assisi, Milano: Electa, 1982, pp. 11–35.

Regola
2010 *La Regola dei frati Minori.* Atti del XXXVII Convegno internazionale della Società internazionale di Studi francescani e del Centro interuniversitario di studi francescani, Assisi 08-10.10.2009, Spoleto: Fondazione Centro italiano di studi sull'alto Medioevo, 2010 (Atti dei Convegni della Società internazionale di Studi francescani e del Centro interuniversitario di studi francescani, NS, 20).

Rigon
1997 A. Rigon, *Frati Minori e società locali,* in M.P. Alberzoni (et al.), *Francesco d'Assisi e il primo secolo di storia francescana,* Torino, Einaudi, 1997, pp. 259–81 (Biblioteca Einaudi, 1).

Ridolfi da Tossignano
1586 *Historiarum seraphicæ religionis libri tres... a f. Petro Rodulphio Tossinianensi con. fran.,* Venetijs: apud Franciscum de Franciscis Senensem, 1586.

Rusconi
1982 R. Rusconi, *Frate Francesco,* in *Francesco d'Assisi. Storia e arte.* Catalogo della mostra per l'VIII centenario della nascita di san Francesco d'Assisi, Milano: Electa, 1982, pp. 19–35.
1994 R. Rusconi, *"Clerici secundum alios clericos": Francesco d'Assisi e l'istituzione ecclesiastica,* in *Frate Francesco d'Assisi,* Atti del XXI Convegno internazionale della Società internazionale di Studi francescani e del Centro interuniversitario di studi francescani, Assisi, 14-16.10.1993, Spoleto: Centro italiano di studi sull'alto Medioevo, 1994, pp. 71–100 (Atti dei Convegni della Società internazionale di Studi francescani e del Centro interuniversitario di studi francescani, NS, 4).

Sabatier
1902 P. Sabatier, *Préface,* in *Actus beati Francisci et sociorum eius,* ed. by P. Sabatier, Paris: Librairie Fischbacher, 1902, pp. I–XXII (Collection d'ètudes et de documents, 4).

Saint François Documents
1968 *Saint François d'Assise. Documents, écrits et premières bi-ographies,* rassemblés et présentés par les PP. Th. Desbonnets et D. Vorreux O.F.M., Paris: Éditions Franciscaines, 1968.

Salmi
1954 M. Salmi, *Essenza della pittura umbra,* in *L'Umbria nella storia, nella letteratura, nell'arte,* ed. by Accademia di Lettere dell'Università degli Studi di Perugia, Bologna: Zanichelli, 1954, pp. 293–310.

Seay
1957 A. Seay, *Le Manuscrit 695 de la Bibliothèque Communale d'Assise*: "Revue de Musicologie" 39 (1957) pp. 10–35.

Segre
1997 C. Segre, *I "Fioretti di san Francesco" e la novellistica,* in *Francescanesimo in volgare (secoli XIII-XIV).* Atti del XXIV Convegno internazionale della Società internazionale di Studi francescani e del Centro interuniversitario di studi francescani, Assisi 17-19.10.1996, Spoleto: Centro italiano di studi sull'alto Medioevo, 1997, pp. 337–52 (Atti dei Convegni della Società internazionale di Studi francescani e del Centro interuniversitario di studi francescani, NS, 7).

Seraphicae legislationis
1897 *Seraphicae legislationis textus originales...,* Ad Claras Aquas prope Florentiam, ex typ. Collegii S. Bonaventurae, 1897.

Sesti
1990 E. Sesti, *I manoscritti italiani del Duecento e del Trecento,* in *Biblioteca Assisi* 1990: 63–81 (entries: 82–270).

Shinnick
1997 E.J.W. Shinnick, *The Manuscript Assisi, Biblioteca del Sacro Convento, MS. 695: A Codicological and Repertorial Study,* PhD diss., Austin: University of Texas, 1997.

Subbioni
2003 M. Subbioni, *La miniatura perugina del Trecento: contributo alla storia della pittura in Umbria nel quattordicesimo secolo,* Perugia: Ed. Guerra, 2003.

Tabarroni
1990 A. Tabarroni, Paupertas Christi et Apostolorum. *L'ideale francescano in discussione (1322-*

1324), Roma: Istituto Storico Italiano per il Medio Evo, 1990 (Nuovi studi storici, 5).

Tartaro
1972 A. Tartaro, *Scrittori devoti*, in C. Muscetta (ed. by), *La letteratura italiana. Storia e testi*. Vol. II/2: *Il Trecento. Dalla crisi dell'età comunale all'Umanesimo*, Bari: Laterza, 1972, pp. 435–515.

Thomas of Eccleston
1885 Thomas de Eccleston, *Liber de adventu minorum in Angliam*, in *Analecta Franciscana*, Ad Claras Aquas prope Florentiam: ex typ. Collegii S. Bonaventurae, 1897, vol. I, 215–75.

Thomson
1971 W.R. Thomson, *Checklist of Papal Letters relating to the Three Orders of St. Francis. Innocent III-Alexander IV*: AFH 64 (1971) pp. 367–580.

Todini
1980 F. Todini, *Miniature del Maestro di Paciano*: "Esercizi" III (1980) pp. 39–42.
1989 F. Todini, *La pittura umbra dal Duecento al primo Cinquecento*, Milano: Longanesi, 1989, 2 vols.

Ubertino
1961 Ubertino da Casale, *Arbor vitae crucifixae Jesu Christi*, Venetiis: per Andream de Bonettis de Papia, 1485, anastatic reprint with an introduction by C.T. Davis, Torino: Bottega d'Erasmo, 1961.

Ubertino da Casale
2014 *Ubertino da Casale*. Atti del XLI Convegno internazionale della Società internazionale di Studi francescani e del Centro interuniversitario di studi francescani, Assisi, 18-20.10.2013, Spoleto: Fondazione Centro italiano di studi sull'alto Medioevo, 2014 (Atti dei Convegni della Società internazionale di Studi francescani e del Centro interuniversitario di studi francescani, NS, 23).

Van Dijk and Walker
1960 S.J.P. Van Dijk – J.H. Walker, *The Origins of the Modern Roman Liturgy*, London: Darton, Longman & Todd, 1960.

Vasari
1966 G. Vasari, *Le vite de' più ec-cellenti pittori, scultori e architettori nelle redazioni del 1550 e 1568*, text ed. by R. Bettarini, "commento secolare" ed. by di P. Barocchi, Firenze: Sansoni, 1966–87, 9 vols.

Vauchez
1993 A Vauchez, *La spiritualità dell'Occidente medioevale*, introduction by G. Cracco, Milano: Vita e Pensiero, 1993 (Cultura e storia, 9).

Wadding
1623 *B. p. Francisci Assisiatis Opuscula: nunc primum collecta, tribus tomis distincta, notis et commentarijs asceticis illustrata, per fr. Lucam Waddingum...*, Antuerpiæ: ex officina Plantiniana apud Balthasarem Moretum, 1623.

Zaccagnini
2007 G. Zaccagnini, *La spiritualità dell'Arbor Vitae Crucifixae Iesu di Ubertino da Casale*, in *Ubertino da Casale nel VII centenario dell'Arbor Vitae Crucifixae Iesu (1305-2005)*. Atti del convegno di studi, La Verna 15.09.2005, ed. by G. Zaccagnini: "Studi Francescani" 104 (2007) 1–2, pp. 37–97.

Zaccaria
1963 G. Zaccaria, *Diario storico della Basilica e Sacro convento di S. Francesco in Assisi (1220-1927)*: MF 63 (1963) pp. 75–120, 290–361, 495–536.

Zerbi
1982 P. Zerbi, *San Francesco d'Assisi e la Chiesa Romana*, in *Francesco d'Assisi nell'ottavo centenario della nascita*, presentation by G. Lazzati, Milano: Vita e Pensiero, 1982, pp. 241–54.

Ziino
1978 A. Ziino, *Testi religiosi medioevali in notazione mensurale*, in *L'Ars Nova Italiana del Trecento*, ed. by A. Ziino, Certaldo: Centro Studi sull'Ars Nova Italiana del Trecento, 1978, vol. IV, pp. 447–91.
1981 A. Ziino, *Sequenza e laude: nuove tessere musicali per un'ipotesi*, in *Le Laudi drammatiche umbre delle origini*. Atti del V Convegno di Studio, Viterbo 22-25.05.1980, Viterbo: Centro di studi sul teatro medioevale e rinascimentale, 1981, pp. 229–39.

Additional Bibliography to the essay on p. 110 (Cantorinus)

As well as the works expressly referred to in the paper, set out in the general bibliography, listed below are other works which are useful to put the content of the paper into context.

Adam of Saint-Victor, *Sequences*, intr., text, trans. and notes by J. Mousseau, R.S.C.J. with a Foreword by H. Feiss, O.S.B, Leuven et al.: Peeters, 2013 (Dallas Medieval Texts and Translations, 18).

M. Assirelli, *Il movimento francescano e la Francia*, in *Francesco d'Assisi. Documenti e Archivi, Codici e Biblioteche, Miniature*, ed. by A. Bartoli Langeli and C. Cutini, Milano: Electa, 1982, pp. 310–18.

I.D. Bent, *A New Polyphonic "Verbum bonum et suave"*: "Music & Letters" 51 (1970) pp. 227–41.

G. Björkvall, *Corpus Troporum V. Les deux tropaires d'Apt, mss. 17 et 18*, Stockholm: Almqvist & Wiksell International, 1986 (Studia Latina Stockholmiensia, XXXII).

J. Boe, *Beneventanum Troporum Corpus II. Ordinary Chants and Tropes for the Mass from Southern Italy, A.D. 1000-1250. Part 1: Kyrie eleison*, Madison: A-R Editions, 1989 (Recent Researches in the Music of the Middle Ages and Early Renaissance, XIX–XXI).

D. Bosse, *Untersuchung einstimmiger mittelalterlicher Melodien zum "Gloria in excelsis Deo"*, Regensburg: Gustav Bosse Verlag, 1955.

E. Bruning, *De vroegere mis-formulieren op de feesten van sint Franciscus vóór het jaar 1570*: "Collectanea Franciscana Neerlandica" 1 (1927) pp. 87–126.

C.U. Chevalier, *Repertorium Hymnologicum. Catalogue des chants, hymnes, proses, séquences, tropes*, Louvain: Imprimerie Lefever; then Paris: Picard, 1889–1919, 6 vols.
G. Ciliberti, *The Role of the Basilica of St. Francis in the Creation of Polyphonic Music*: "Franciscan Studies" 50 (1990), pp. 83–120.

M.-N. Colette – C. Meyer, *Le Tropaire-Prosaire de Metz: Metz, Mé-diathèque du Pontiffroy, Ms. 452 / Paris, BnF, Lat. 17177*: "Revue de Musicologie" 96 (2010) pp. 131–79.

R.L. Crocker, *Some Ninth-Century Sequences*: "Journal of the American Musicological Society" 20 (1967) pp. 367–402.

R.L. Crocker, *The Early Medieval Sequence*, Berkeley, Los Angeles: University of California Press, 1977.

W. Dalglish, *A Polyphonic Sequence from Rouen*: "Music & Letters" 59 (1978) pp. 10–18.

A. Dennery, *Le Chant postgrégorien: Tropes, Séquences et Prosules*, Paris: Champion, 1989.

N. van Deusen, *The Use and Significance of the Sequence*: "Musica Disciplina" 40 (1986) pp. 5–47.

M. Everist, *Polyphonic Music in Thirteenth-Century France: Aspects of Sources and Distribution*, New York: Garland Press, 1989.

M. Fassler, *Who was Adam of St. Victor? The Evidence of the Sequence Manuscripts*: "Journal of the American Musicological Society" 37 (1984) pp. 233–69.

M. Fassler, *The Role of the Parisian Sequence in the Evolution of Notre-Dame Polyphony*: "Speculum" 62 (1987) pp. 345–74.

M. Fassler, *Gothic Song: Victorine Sequences and Augustinian Reform in Twelfth-Century Paris*, Cambridge: Cambridge University Press, 1993.

K. von Fischer, *Neue Quellen zur Musik des 13., 14. und 15. Jahrhunderts*: "Acta Musicologica" 36 (1964) pp. 79–97.

R. Flotzinger, *Der Diskantussatz im Magnus Liber und seiner Nachfolge*, Wien: Hermann Böhlaus, 1969.

C. Frugoni – F. Manzari, *Immagini di san Francesco in uno Speculum humanae salvationis del Trecento*, Padova: Editrici Francescane, 2006.

F.A. Gallo, *Dai conventi di Salimbene alla corte di Bonifacio VIII*, in *La sequenza medievale*, ed. by A.

Ziino, Lucca: Libreria Musicale Italiana, 1992, pp. 81–86.

B. Gillingham, *Medieval Polyphonic Sequences: An Anthology,* Ottawa: The Institute of Mediaeval Music, 1985.

B. Gillingham, *Lambeth Palace MS. 457: A Reassessment*: "Music & Letters" 68 (1987) pp. 213–21.

N. De Goede, *The Utrecht Prosarium: Liber sequentiarum Ecclesiae Capitularis Sanctae Mariae Ultraiectensis saeculi XIII. Codex Ultraiectensis, Universitatis Bibliotheca, 417,* Amsterdam: Vereniging voor Nederlandse Muziekgeschiedenis, 1965 (Monumenta Musica Neerlandica, 6).

J. Grossfillier, *Les séquences d'Adam de Saint-Victor*, étude littéraire (poétique et rhétorique), textes et traductions, commentaires, Turnhout: Brepols, 2008 (Bibliotheca Victorina, XX).

D. Hiley, *Rouen, Bibliothèque Municipale, MS. 249 (A. 280) and the Early Paris Repertory of Ordinary of Mass Chants and Sequences*: "Music & Letters" 70 (1989) pp. 467–82.

D. Hiley, *Das Repertoire der normanno-sizilischen Tropare I. Die Sequenzen,* Kassel: Bärenreiter, 2001 (Monumenta Monodica Medii Aevi, XIII).

A. Hughes, *Anglo-French Sequelae edited from the papers of the Late Dr. Henry Marriot Bannister*, M.A., London: The Plainsong & Mediaeval Music Society, 1934.

M. Huglo, *Les livres de chant liturgique*, Turnhout: Brepols, 1988.

H. Husmann, *Notre-Dame und Saint-Victor. Repertoire-Studien zur Geschichte der gereimten* Prosen: "Acta Musicologica" 36 (1954) pp. 98–123, 191–221.

H. Husmann, *Sequenz und Prosa*: "Annales Musicologiques" 2 (1954) pp. 61–91.

G. Iversen, *Corpus Troporum IV. Tropes de l'Ordinaire de la messe. Tropes de l'Agnus Dei.* Stockholm: Almqvist & Wiksell International, 1980 (Studia Latina Stockholmiensia, XXVI).

P. Jeffery, *Notre Dame Polyphony in the Library of Pope Boniface VIII*: "Journal of the American Musicological Society" 32 (1979) pp. 118–24.

L. Kruckenberg, *Neumatizing the Sequence: Special Performances of Sequences in the Central Middle Ages*: "Journal of the American Musicological Society" 59 (2006) pp. 243–317.

M. Lütolf, *Die mehrstimmigen Ordinarium Missae-Sätze vom ausgehenden 11. bis zur Wende des 13. zum 14. Jahrhundert*, Bern: Haupt, 1970, 2 vols.

M. Landwehr-Melnicki, *Das einstimmige Kyrie des lateinischen Mittelalters*, Regensburg: Gustav Bosse Verlag, 1955.

K.E. Mixter, *A Newly Discovered Medieval Polyphonic Sequence*: "Musica Disciplina" 44 (1990) pp. 233–53.

D. Norberg, *Introduction à l'étude de la versification latine médiévale*, Stockholm: Almqvist & Wiksell, 1958.

A. Planchart, *The Repertory of Tropes at Winchester*, Princeton (NJ): Princeton University Press, 1977, 2 vols.

G. Reaney, *Manuscripts of Polyphonic Music 11th-Early 14th Century*, München-Duisburg: G. Henle Verlag, 1966 (Répertoire International des Sources Musicales, IV/1).

K. Rönnau, *Die Tropen zum Gloria in excelsis Deo*, Wiesbaden: Breitkopf & Härtel, 1967.

C. Ruini, *Martino e Francesco. Congetture su una sequenza polifonica francescana*: "Annali della Facoltà di Lettere e Filosofia dell'Università degli Studi di Perugia" XX–XXI [NS VI–VII] (1982-84) pp. 113–27.

R.-J. Hesbert (ed. by), *Le Prosaire de la Sainte-Chapelle. Manuscrit du Chapitre de Saint-Nicolas de Bari (vers 1250)*, Mâcon: Protat Frères, 1952.

M. Schildbach, *Das einstimmige Agnus Dei und seine handschriftliche Überlieferung vom 10. bis zum 16. Jahrhundert*, Erlangen: Offsetdruck-Fotodruck J. Hogl, 1967.

K.-H. Schlager, *Trinitas, unitas, deitas – A Trope for the Sanctus of the Mass*: "Journal of the Plainsong and Medieval Music Society" 6 (1983) pp. 8–14.

K.-H. Schlager, *Thematischer Katalog der ältesten Alleluia-Melodien aus Handschriften des 10. und 11. Jahrhunderts*, München: Walter Ricke, 1965.

B. Stäblein, *Notkeriana*: "Archiv fr Musikwissenschaft" XIX–XX (1962–63) pp. 84–99.

P.J. Thannabaur, *Das einstimmige Sanctus der römischen Messe in der handschriftlichen Überlieferung des 11. bis 16. Jahrhunderts*, München: Walter Ricke, 1962.

C. Wright, *Music and Ceremony at Notre Dame of Paris, 500-1500*, Cambridge: Cambridge University Press, 1989.

A. Ziino, *Liturgia e musica francescana nei secoli XIII-XIV*, in *Francesco d'Assisi. Storia e arte*. Catalogo della mostra di Assisi per l'VIII centenario della nascita di Francesco d'Assisi, ed. by R. Rusconi, Milano: Electa, 1982, pp. 127–58.

A. Ziino (ed. by), *La Sequenza medievale*. Atti del Convegno Internazionale, Milano 07-08.04.1984, Lucca: Libreria Musicale Italiana 1992.

A. Ziino, *Dal latino al cumanico, ovvero Osservazioni su una versione trecentesca della sequenza* Sagïnsamen bahasïz kanïnï *in notazione mensurale*, in *Trent'anni di ricerche musicologiche*. Studi in onore di F. Alberto Gallo, ed. by P. Dalla Vecchia and D. Restani, Roma: Edizioni Torre d'Orfeo, 1996, pp. 31–47.

A. Ziino, *Mottetti a due voci in un codice francescano della fine del XIII secolo*, in *Quod ore cantas corde credas. Studi in onore di Giacomo Baroffio Dahnk*, ed. by L. Scappaticci, Città del Vaticano: Libreria Editrice Vaticana, 2013, pp. 521–60.